SYNAGOGUES

of

LONG ISLAND

Hear, O Israel, the Lord our God, the Lord is One

שְׁמַע יִשְׂרָאֵל, יְ־יָ אֱ־לֹהֵינוּ, יְ־יָ אֶחָד.

SYNAGOGUES

of

LONG ISLAND

IRA POLIAKOFF

THE
History
PRESS

Published by The History Press
Charleston, SC
www.historypress.net

First published 2017

Page 2: Prayer recited by all Jews at all services. *Courtesy of Ira A. and Judith L. Poliakoff.*

Manufactured in the United States

ISBN 9781467138369

Library of Congress Control Number: 2017953974

CONTENTS

Contents

Contents

CONTENTS

PREFACE

Reform and Conservative congregations have often disagreed on how to practice Judaism, how to pray and what to offer their members. The philosophical differences between Reform and Conservative congregations and their Orthodox neighbors have not been so subtle. Many Orthodox look at Reform and Conservative congregations as non-entities because, in their belief, only the Orthodox follow true Judaism.

In the late 1970s, the established Reform and Conservative congregations of Nassau and Suffolk faced three impactful changes. The first was a tremendous demographic shift. Inner-ring suburbs that had been filled with Jewish families were now filling with the next series of new immigrants. The suburban enclaves on the eastern half of Long Island, which had no real Jewish population to speak of in the 1950s, were now starting to develop Jewish populations. Villages like the Hamptons, which had only a few Jews as summer residents, now were home to several synagogues. Villages like Rockville Centre, Baldwin and Freeport saw their Jewish populations drop more than 50 percent.

The second change was the outreach program of the Chabad Lubavitch, a movement from within Judaism. Chabad has always accepted the role to minister to anyone interested in the Jewish faith, but in the late 1980s, many young Chabad rabbis were sent to different towns on Long Island with nothing other than a loving rebbetzin and a checkbook. To date, they have opened more than thirty Chabad centers in Nassau and Suffolk Counties, each staffed by at least one rabbi and rebbetzin. Chabad maintains a central office for Long Island in Commack.

Many Reform and Conservative congregations claim to have lost some members to the Chabad movement. Some can be explained by personal epiphanies moving the members to Orthodoxy. Some leaders have told me that some of their members have left the Reform and Conservative synagogues because there is no specific financial commitment needed for a family to affiliate with a Chabad center. It is indeed wonderful that Chabad centers accept anyone for any period and are willing to invest in a family's religious education and well-being, but some believe that it is partially at the expense of "bricks and mortar" synagogues.

The third major impact was the advent of the mobile society. Parents were used to sending their college-bound teens to local colleges. Many followed family traditions by attending branches of CCNY or SUNY. Some went to Hofstra, Post or Adelphi. Starting in the 1970s, going away to Ann Arbor, Michigan, or Atlanta, Georgia, was just as easy as going to Albany for college. Many students left for these places never to return, spreading out Long Island's Jewish population nationwide.

Rabbi Neil S. Cooper of Temple Beth Hillel–Beth El of Wynnewood, Pennsylvania, an inner-ring suburb of Philadelphia, has spent more than twenty-five years facing these same problems. His is one of fourteen congregations within a ten-square-mile area, including two Reform, four Conservative, two Chabad and eight other Orthodox. His synagogue has managed to keep its numbers over the years and, in some years, even increase them. His answer is rather simple: "We work hard at it." He and his colleagues offer myriad complex programs aimed at all arms and age groups of his community. A recent event attended by more than two hundred congregants took more than thirty professionals and lay leaders weeks to plan. Those congregations that have worked extremely hard at programming for and attracting all spheres of membership are going to be the ones to survive. Elisa Blank, Long Island coordinator for the Synergy Project, a synagogue coaching project sponsored by UJA/Federation, has consulted with many Long Island congregations. She is a little upset by "pop up" congregations that have taken off at the expense of existing synagogues. But she agrees with Rabbi Cooper that those that work hard will survive. Examples she sees include (but are not limited to) Bnai Israel of Oakdale, Dix Hills Jewish Center, Beth El of Great Neck and Beth Sholom of Roslyn Heights.

Ed Einhorn, executive director of Temple Beth El of Cedarhurst and a well-known Jewish educator, has seen his community change dramatically over the past twenty-five years. Cedarhust has become a center of Orthodoxy, and as Reform and Conservative families retire and move, they

are replaced by Orthodox families. Beth El and its neighboring Conservative congregations, Congregation Sons of Israel in Woodmere and Temple Hillel in Valley Stream, are facing large challenges maintaining buildings built for five hundred to one thousand families with only a few hundred.

Three places in Nassau County have become centers of Orthodoxy: Long Beach, Great Neck and the Lawrence-Cedarhurst area. Eruvs exist in these communities, making complete practice of Orthodox Judaism possible. Lawrence and Cedarhurst have scores of kosher establishments and retailers catering to the needs of an Orthodox community. Signs in storefronts such as "kosher," "shatnus testing" and "closed on Shabbat" are common. Even though the last Conservative congregation in Long Beach closed several years ago, there has been an increase in the Orthodox population due to the arrival of several young charismatic Orthodox rabbis. There are still strong Reform and Conservative congregations in Great Neck, but there are also many Orthodox synagogues. Great Neck has become the new home for many of the displaced Iranian, Iraqi and Syrian Jewish families who have fled their homelands in the past fifty years. Each of those communities has built at least one large synagogue in Great Neck.

Another issue is the schools in the Lawrence Union Free School District. The district includes Lawrence, Cedarhurst and some parts of a few neighboring villages. Two upstate New York communities, East Ramapo and Kiryas Joel (a community populated only by Satmar Chasidm), have both had long fights in the courts with the New York State Department of Education over control of their schools. The majority Orthodox residents claimed that they don't send their children to public schools and would do something about costs. By block voting, they took control of their local school boards. Both communities wanted the education to be offered according to Orthodox law. Kiryas Joel residents objected to such things as male special education students being transported in buses driven by women and their children's exposure to poor outside influences. Kiryas Joel is a 100 percent Satmar district, but East Ramapo includes many other Jews and non-Jews. These cases will likely continue to be litigated for many years.

In Lawrence, the Orthodox, again by block voting, have assumed control of the school board. Actions have not been as blatant as those upstate, but changes have been made. The board has closed one school and sold it to a local yeshiva, and some non-state-mandated programs have been cut. There continue to be disagreements between the majority Orthodox and minority Reform, Conservative and non-Jewish residents. The result has been a "flight in" of Orthodox residents and a "flight out" of the non-Orthodox.

These negatives are stark realities. The viewpoints from which you look will influence conclusions you draw. The author has great respect for all who self-identify as Jews and sees validity in all points of view. Over the centuries, Jews have suffered at the hands of others. Let us not trample on one another as we try to solve the problems within Judaism.

ACKNOWLEDGEMENTS

Rabbi Elliot Skidell, Central Synagogue–Beth Emeth, Rockville Centre, New York (background)

Dov Schwartzman, president, Fire Island Minyan, Fire Island, New York (history of Fire Island Minyan)

Natalie Naylor, Professor Emerita, Hofstra University, and president, Nassau County Historical Society

Lee Bender, Esq., Wynnewood, Pennsylvania (background on Great Neck, New York Jewish community)

Hazzan Glenn Sherman, Delray Beach, Florida (background on Long Beach, New York Jewish community)

Elisa Blank, manager, Long Island SYNERGY Project of the UJA (background on many synagogues)

Melissa McNichols, reference librarian, Amityville, New York Public Library (background on Amityville Jewish Center)

Barney Levantino, reference librarian, Syosset, New York Public Library (background on Syosset area synagogues)

Caren Zatyk, head librarian, Long Island Room, Smithtown, New York Public Library (background on Smithtown-area synagogues)

James Janis, librarian, Hicksville, New York Public Library, History Archives Section (background on two former synagogues in Hicksville)

Marcia Radcliff, head of reference section, Oceanside, New York Public Library (background on Oceanside synagogues)

Patrice Bennewood, librarian, Uniondale, New York Public Library (background on Uniondale Jewish Center)

Rabbi Mordecai Kamenetzky, Cedarhurst, New York chairman of the Jewish Heritage Society of Five Towns (background on Five Towns–area synagogues and photographs)

Ida Zaharapoulis, head of reference section, Seaford, New York Public Library (background on Seaford Jewish Center)

Richard Skolnik, Bellmore, New York, past international president, United Synagogue of Conservative Judaism (background on many Conservative synagogues)

Sanford Feit, Oceanside, New York, past youth director, METNY region, United Synagogue of Conservative Judaism (background on many Conservative synagogues and pictures)

Norman Korowitz, Mount Sinai, New York, past president, METNY region, United Synagogue of Conservative Judaism (background on Suffolk County synagogues and pictures)

Mark Friedman, Plainview, New York, former youth worker, METNY region, United Synagogue of Conservative Judaism (background on Nassau County synagogues and pictures)

Rabbi Chaim Gelfand, Pearlman Jewish Day School, Wynnewood, Pennsylvania (Hebrew translations)

Eli Spielman, Teaneck, New Jersey, author (background on Amityville Jewish Center)

Allen Robinson, retired assistant school superintendent, Patchogue-Medford School District (background on Temple Beth El of Patchogue)

Carol Rubenstein, Oceanside, New York (background on Ocean Harbor Jewish Center)

Brad Cohen, Woodbury, New York (background on Amityville and Bethpage Jewish Centers)

Rabbi Stuart Paris, Brookville, New York (background on the New Synagogue of Long Island)

Peter Ward, librarian, Brentwood, New York Public Library (background on Brentwood Jewish Center)

Rabbi Simcha Zamir, Temple Sholom, Westbury, New York (background on Temple Sholom of Westbury)

Alene Scoblete, librarian, Rockville Centre, New York Public Library (background on RVC synagogues)

Susan Manor, office manager, Temple Sholom, Westbury, New York (background on Temple Sholom, Westbury)

Michael Lander, Oakdale, New York (author of *Complete History of Temple Beth Israel of Oakdale*)

Rabbi Neil Cooper, Wynnewood, New York (background on the Conservative movement)

Rosalie Wartenberg, Sayville, New York (administrator, Sayville Jewish Center)

Eileen J. Moskowitz, Sag Harbor, New York (temple administrator of Temple Adas Israel, provided history and pictures)

Carole Korowitz, Mount Sinai, New York, past international board member, USCJ, and past president of North Shore Jewish Center (background on many synagogues and pictures)

Mary Coscone, Babylon, New York township historian (background on many synagogues)

Rabbi Pinchas Chatzinoff, Cedarhurst, New York (background on Congregation Tifereth Zvi)

Bronwyn Hannon, Special Collections Department, Hofstra University Library, Hempstead, New York (images)

Alan Garmise, Southold, New York, president, Tifereth Israel of Greenport (images of synagogue)

Paul Birman, Greenport, New York (history of Tifereth Israel)

Leda Goldsmith, Sag Harbor, New York (history of Temple Adas Israel)

Jake Varano, Plainview, New York (photographs)

Brian G. Poliakoff, New York, New York (editorial guidance)

Ed Einhorn, executive director, Temple Beth El, Cedarhurst

INTRODUCTION

While visiting Long Island to do research for this book, I found myself sitting in the office of Temple Sholom on Brookside Court in Westbury. I had the privilege to serve as its youth director forty-five years ago. I was reminiscing with Susan Manor, the office manager, about when the congregation had about four hundred families and a vibrant and active youth group, Sisterhood and Men's Club. Sadly, today, the neighborhood has changed dramatically, and only thirty-some families remain. Most members are over seventy. Due to being able to rent out part of the building and prudent management, Temple Sholom to this day has a full-time rabbi, Simcha Zamir; a part-time office manager; and a part-time custodian. The congregation retains use of the main synagogue, the daily chapel, the auditorium, the office and a well-kept foyer. The building is immaculate, and although the membership is small, the enthusiasm is big.

Rabbi Zamir, who also serves as chaplain of the New York State Fraternal Order of Police, has been in Westbury since July 2004. Prior to his tenure at Temple Sholom, he served Congregation Tiffereth Israel of Glen Cove as educational director and later served as rabbi of the Sayville Jewish Center.

In a later conversation, Rabbi Zamir explained why it is so important to keep this congregation going with only thirty or so families: "It is really not important to me if the synagogue has 40 or 1500 families. These people are Jews who are starving for a connection to Judaism. Many of them are elderly and if Temple Sholom were to close they would have nowhere else to go, therefore, they would be lost. That would be unacceptable. Yes, it would be great if we had more families, but that doesn't change the fact that these people that are here are in need. It's not about, me, the Rabbi, but it's about them."

Temple Sholom is one of the many congregations in Nassau and Suffolk Counties that have faced closure or have closed. A dedicated rabbi, smart planning and a little luck have helped. As you will see in this volume, other congregations have not been so fortunate.

I grew up in the Conservative movement. My maternal grandparents, Max and Augusta Greenberg, were active members of two of the earliest Conservative congregations in New York City, Forest Hills Jewish Center and, later, Shaare Zedek on 93rd Street in Manhattan.

My parents, Dr. Harvey and Grace Poliakoff, moved to Rockville Centre when I was still in preschool in the late 1940s. My mother insisted on membership in a Conservative congregation, so the answer was Temple Bnai Sholom. My father, a family physician, happened to have the rabbi of the local Reform congregation, Central Synagogue of Nassau County, as his patient. I was fortunate to have had guidance from both Rabbi Max Routtenberg of Bnai Sholom and Rabbi George Lieberman of Central Synagogue, whose daughter attended school with me. Although my Jewish education was at Bnai Sholom, I was a Bar Mitzvah at Shaare Zedek in Manhattan because of my mother's love and admiration for the late rabbis Elias Solomon and Morris Goldberg. Rabbi Goldberg later served Hewlett–East Rockaway Jewish Center.

In the late 1960s, I had the opportunity to work part time for the United Synagogue of America (now the USCJ), New York Metropolitan Area, as a youth field worker in Suffolk County. At that time, Conservative Judaism was very strong in Nassau County, but it was just getting a real toehold in Suffolk County. There were small but strong congregations in Babylon, Bay Shore, Amityville, Patchogue, Ronkonkoma, Sayville, Huntington, Lindenhurst, Riverhead and East Setauket. A few others were on the drawing board.

I also served as youth director at Oceanside Jewish Center in the mid-1960s and at Queensboro Hill Jewish Center (Flushing) in the 1970s. In 1973, I married Judith Lynne Braude of Philadelphia. Judith also was a youth worker at Conservative synagogues. In fact, we met at a National Convention of USY, the national youth movement of Conservative Judaism. We lived in Oakdale for a year and then moved to Wynnewood, Pennsylvania, where we have been active members of Temple Beth Hillel–Beth El.

I have always been a history buff. After moving to Pennsylvania, I lost touch with the "synagogue scene" on Long Island. In 2015, I started researching the subject after retiring from a career in business. I am amazed at the number of synagogues that have closed, the smaller number that have opened and those that have merged. We have seen the growth of Orthodoxy

on Long Island, spurred by the outreach program of Chabad. We have seen the move eastward to areas that had no Jews in the early 1960s, particularly the Hamptons. The reasons for change here are the same as everywhere else: changing demographics, our mobile society and the growth of new forces within Judaism itself.

After World War II, hundreds of thousands of Jewish men returned from the war to Manhattan, Brooklyn, Queens and the Bronx. They all had three things in mind: (1) a piece of suburbia, (2) a wife or girlfriend and (3) an escape from Orthodoxy to Reform or Conservative Judaism. Conservative Judaism saw this movement coming. Rabbi Elias Solomon called a meeting of Conservative rabbis from the area at Congregation Anshei Chesed on West End Avenue at 100th Street in Manhattan (still a very active synagogue) in January 1946 to map out a plan for Conservative Judaism on Long Island. The goal was a Conservative shul at every South Shore Long Island Railroad stop from Valley Stream to Patchogue. New synagogues were added to existing congregations in Lynbrook, Rockville Centre, Baldwin, Amityville, Babylon and Patchogue, most between 1946 and 1956. Smaller congregations also were present in Cedarhurst, Woodmere, Hempstead, Floral Park and Greenport.

Although there was no set plan, Reform Judaism took hold as well. Central Synagogue of Nassau County in Rockville Centre and Beth El in Great Neck both grew to more than one thousand families. New Reform congregations sprang up all over both counties, with larger groups in Manhasset, Oceanside, Long Beach, Freeport, Plainview, Oakdale and Huntington. Two areas became home to large Orthodox communities, Long Beach and the Five Towns. Great Neck would later also become a large Orthodox center.

It seemed that the growth would never stop. But alas, the late 1980s saw a change in the demographics of Long Island's population. Reform and Conservative synagogue membership was deeply affected by the mobile society. Many Jewish kids went off to college out of town, never to return to Long Island. The growth of the Chabad movement also attracted families away from existing non-Orthodox congregations. Chabad now has more than thirty active Chabad centers in Nassau and Suffolk Counties. They have been joined by many new Young Israel, AISH and other modern Orthodox synagogues, fueling a resurgence of Orthodoxy on Long Island.

This book will mention every "brick and mortar" synagogue that has ever existed on Long Island, from the oldest, like Neta Szarchea in Lindenhurst, the oldest continuously operating, and Temple Adas Israel in Sag Harbor to the newest, like the beautiful new building built by the Sephardic Synagogue

of Plainview in 2016. We will visit congregations that have come and gone. We will view the magnificent pictures made available by the Special Collections Department of the Hofstra University Library; Eileen J. Moskowitz, temple administrator of Temple Adas Israel of Sag Harbor; Mark Friedman, a board member of Midway Jewish Center in Syosset; Norman and Carole Korowitz, longtime members of North Shore Jewish Center in Port Jefferson Station; Alan Garmise, president of Tifereth Israel of Greenport; Sandy Feit of Oceanside, an active member of Hewlett–East Rockaway Jewish Center; Rabbis Simcha Zamir of Westbury and Elliot Skidell of Rockville Centre; and many other individuals I have thanked in the acknowledgements section. We will examine the histories of those congregations whose histories are available. Last, we will take a quick look at the influences that have changed Long Island's "synagogue scene" forever.

If I have left out any synagogue, I truly apologize. It is never my intent to offend anyone. Please notify me of any errors so I may correct them in future editions. Individual histories come from many sources. Some are from previously published books, some from oral histories and most have been researched and written by the author. Consult the acknowledgements and bibliography for sources.

I want to dedicate this volume to my loving family: my wife of more than forty years, Judith; my children, Amanda Miller (and Michael) and Brian Poliakoff (and Kristen); and my grandchildren, Hailey and Ethan Miller. I also wish to acknowledge the clergy who have had a positive effect on my life: Rabbis Elias Solomon and Morris Goldberg of Shaare Zedek (93rd Street in Manhattan); Rabbi George Lieberman of Central Synagogue in Rockville Centre; Rabbi Max Routtenberg of Temple Bnai Sholom in Rockville Centre; Rabbi Jonathan Kremer of Congregation Shirat Hayam, Ventnor, New Jersey; Rabbis Neil Cooper and Mark Israel of Temple Beth Hillel–Beth El, Wynnewood, Pennsylvania; and Hazzan Eugene Rosner of Beth Hillel–Beth El.

Please note that after each synagogue there is a letter indication:

R = Reform
C = Conservative
O = Orthodox
REC = Reconstructionist

Unaffiliated congregations are also noted.

THE SYNAGOGUES
OF LONG ISLAND

AMITYVILLE

AMITYVILLE JEWISH CENTER (FORMERLY BETH SHOLOM CONGREGATION), 79 County Line Road, Amityville, New York, 11701 *C* (Closed)

The early Jewish community of Amityville has its beginnings near the turn of the century. Being few, the earliest families were not able to provide a central place for services. It became customary for the families to gather in private homes for religious observances.

One of the earliest families in Amityville, the Edelmans, frequently hosted these gatherings in their home on Broadway where the sacred Torah Scroll was kept. In these early days, it was not unusual for Amityville's Jewish families to walk to neighboring Lindenhurst to observe rituals at the Lindenhurst Hebrew Congregation. Two Lindenhurst families, the Diamonds and the Friedmans, often hosted services.

As the number of Jewish families grew in Amityville, it became possible to rent a room in the old Telephone Company Building on Greene Avenue, just west of Phannemiller's Drug Store. That room afforded a central meeting space and the beginnings of what would become the Amityville Jewish Center. In later years, the Odd Fellows Hall, also on Greene Street, was purchased as a more permanent home. A part-time rabbi was engaged to instruct the young people.

Following World War II, the Jewish population of the Amityville area expanded, and the need for a full-time rabbi became apparent. The Odd Fellows Hall took on a new appearance with a new stone front and arched stained-glass windows. On the lower floor, a place was provided for meetings and social gatherings. The second floor was refurbished to become the sanctuary. The synagogue became formally known as the Amityville Jewish Center. In the summer of 1967, Jerry Seinfeld had his Bar Mitzvah here. His father, Kal, was a vice-president of the synagogue and always blew the shofar on the High Holy Days.

By 1976, the congregation had outgrown the old building. A larger building opened on County Line Road in 1957. The new building included classrooms, offices, a library, a kitchen and a large room for both services and social occasions. Ten years later, the building was expanded to include a permanent sanctuary. The name Beth Sholom was adopted officially when the group moved to County Line Road.

As the 1980s arrived, the membership was shrinking dramatically due to demographic changes. This was in the middle of the fifty-three-year tenure of Rabbi Leon Spielman, one of Suffolk County's longest-tenured and most admired rabbis. Rabbi Spielman is the father of Eli Spielman, the famous author and sports producer for radio and television. Eli told me, "Amityville was a wonderful, caring place to grow up as a Jew." In 2002, the center was forced to close. The building was sold to the Center for Science and Spirituality, and the proceeds were used to settle the congregation's debts. The Torahs went to several different synagogues. Most of the memorial plaques went to Bethpage Jewish Center. Later, when Bethpage Jewish Center also closed, according to Brad Cohen, "most of the plaques were transferred to Midway Jewish Center in Syosset."

BABYLON

CONGREGATION BETH SHOLOM, 441 Deer Park Avenue, Babylon, New York, 11702 (631-587-5650) C

This independent Conservative congregation is led by Rabbi Abraham Axelrud. It was established in 1924 at a meeting held at Hebrew Association Hall. The first building was completed in 1930 at 54 George Street; it was later a church and now is home to an environmental services company. The current building opened in 1963.

The congregation holds Erev Shabbat services every Friday night except during July and August. Shabbat morning services are held every Saturday morning. The congregation has an adult education program, a Hebrew school and special programs for seniors. The synagogue also has a modern ballroom for social events.

Baldwin

Baldwin Jewish Center, 885 Seaman Avenue, Baldwin, New York, 11510 C (Closed)

The Baldwin Jewish Center was the first synagogue in Baldwin, predating World War II. It was founded by a group of sewing circle members that changed its name to the Baldwin Jewish Center Sisterhood in the fall of 1927. One year later, nine men formed the actual Baldwin Jewish Center. The early meetings and services were held in the Veterans of Foreign Wars Hall on Seaman Avenue. The actual synagogue was built in 1948.

In 2010, declining membership forced the congregation to sell the building to the Christian Family Worship Center and, under an agreement with the new owner of the building, continued to hold services in the lower level. In 2014, the congregation merged with South Baldwin Jewish Center, where its Torah Scrolls and memorial plaques were transferred. Oddly enough, the South Baldwin Jewish Center was started by families who broke away from the original Baldwin Jewish Center.

South Baldwin Jewish Center, 2959 Grand Avenue, Baldwin, 11510 C

South Baldwin Jewish Center, also known as Congregation Shaarei Shalom, was formed in 1955, holding services in the Baldwin American Legion Hall on Grand Avenue. In 1957, the congregation rented a storefront at 908 Atlantic Avenue and held its first service there that March. High Holy Day services were held on Merrick Road in the First Methodist Church. By the end of 1957, the congregation had purchased land at 2959 Grand Avenue. High Holy Day services were held on this property under a tent during 1959 and 1960. Groundbreaking for the current building took place on November 6, 1960, and the building was formally dedicated in September 1962. South Baldwin Jewish Center absorbed Baldwin Jewish Center through a merger in 2014.

The congregation is an affiliate of the United Synagogue of Conservative Judaism and has been since its inception. There is a Hebrew school, an adult education program, Sisterhood and a Men's Club.

TEMPLE EMANU EL, Grand Avenue, Baldwin, 11510 *R* (Closed)

Temple Emanu El Reform Congregation was started by a small group of former members of Central Synagogue of Rockville Centre, wanting a Reform congregation closer to their Baldwin homes. They rented a storefront on Grand Avenue in early 1962. The group never really got off the ground and merged with Union Reform Temple in Freeport on February 25, 1966.

BAY SHORE

BAY SHORE JEWISH CENTER, 34 North Clinton Avenue, Bay Shore, 11706 *C*

Bay Shore Jewish Center is an independent, egalitarian Conservative synagogue. At one time, the group was affiliated with the United Synagogue of Conservative Judaism. A group of fourteen men organized the Bay Shore United Hebrew Benevolent Association in 1897. High Holy Day services were held in a school building rented by the group. The United Hebrew Congregation was incorporated in 1919 and purchased the former firehouse on 2nd Avenue, converting it to a synagogue by March 1920. In September 1933, four groups came together—including the United Hebrew Congregation, Bay Shore Jewish Alliance, Ladies Aid Society and the Junior League—to create the Bay Shore Jewish Center. The merger was commemorated with a social gathering at the Bay Shore Community Memorial Building. The synagogue was located at 4 4th Avenue. In 1942, the group purchased property at 34 North Clinton Avenue and used the existing wood-frame building as a synagogue.

On July 23, 1950, the congregation broke ground on its current building, which was formally dedicated on September 23, 1951. The Hebrew school was added in 1956 at 26 North Clinton Avenue. Services are led by Rabbi Marvin Dement, Gabbi Al Beja, Ritual Director Solomon Pardes and Cantor Arlene Zucker. To this day, a free religious school is available.

Chabad of Islip Township, 14 Doral Lane, Bay Shore, 11706 *O*

This is an outreach center of Chabad of Long Island. Rabbi Shimon Stillerman and Mrs. Stillerman lead this congregation. In addition to services, this Chabad center offers educational opportunities for both children and adults and some social activities.

Sinai Reform Temple, 39 Brentwood Road, Bay Shore, 11706 *R* (Closed)

Sinai Reform Temple was founded in 1948 by a group of thirty-five Jewish families living in Western Suffolk County wishing to affiliate with a liberal Jewish congregation. They called themselves the "South Shore Discussion Group" and later the South Shore Reform Temple; finally, Sinai Reform Temple was adopted as the name in 1960. Early meetings were held in the Bay Shore Community Building.

During the early years, Sabbath services were held each Friday evening in the Community Building, with members bringing chairs, prayer books, the Holy Ark and a Torah to and from services each week. A religious school was added, and the membership had grown to more than fifty families by 1952. In late 1948, the group purchased its first home, a building at the corner of Brentwood Road and Union Boulevard in Bay Shore.

The synagogue broke ground for its first "built from scratch" temple on January 6, 1963, and opened it on January 24, 1964. In November 1990, an arsonist's fire destroyed the building. With the help of the Bay Shore community, services continued at the Spirit Alive Center, St. Patrick's Church, Bay Shore Jewish Center and at the Interfaith Chapel of the New York Institute of Technology in Central Islip.

A replacement building was started in May 1992 and dedicated in December 1993. The architect was Dennis Noskin. The temple was affiliated with the Union for Reform Judaism for more than sixty years. In 2014, facing a large decline in membership to only forty families, the group sold the building and rented space from the Bay Shore Jewish Center on North Clinton Avenue. In October 2015, the group merged with Bnai Israel Reform Congregation in Oakdale. The proceeds of the sale of the building are being used to pay the dues of former Temple Sinai members to Bnai Israel. The memorial plaques and Torah Scrolls also were removed to Bnai Israel. The building at 39 Brentwood Road was deconsecrated and torn down, and construction began on a new medical office building.

Bellmore

Congregation Beth Ohr, 2550 Centre Avenue, Bellmore, 11710 *C*

Congregation Beth Ohr represents the merger of Bellmore Jewish Center and Congregation Beth El of Massapequa. Bellmore Jewish Center was founded in 1958 as the Jewish population of Bellmore started to grow with the construction of many new homes south of Merrick Road. In January 1959, the congregation was formally incorporated, and it purchased a private home at 2538 South Centre Avenue and converted it to a synagogue. As more families joined, it quickly outgrew the building, lovingly referred to as the "Little House of Worship."

On November 20, 1961, a momentous meeting was held at the Winthrop Avenue School. The congregation expressed its faith in the future by voting to construct a new building on its recently purchased adjacent property at 2550 Centre Avenue. The new building was occupied for Rosh Hashanah services in September 1962. The group went by the name South Shore Jewish Center (a name later adopted by the Island Park Jewish Center) until changing its name to Bellmore Jewish Center in the mid-1960s. It is a Conservative congregation affiliated with the United Synagogue of Conservative Judaism and led by Rabbi Dahlia Bernstein and Cantor Elliot Yavneh. The name was changed to Congregation Beth Ohr on July 1, 2016, when Beth El of Massapequa was merged with the former Bellmore Jewish Center. (See the "Massapequa" section for history of Beth El of Massapequa.)

East Bay Reform Temple, 2442 Merrick Road, Bellmore, 11710 *R* (Closed)

East Bay Reform Temple, also known as Congregation Shaarei Shalom, was founded in 1970. In 1973, East Bay hired Rabbi Paul Kushner as its part-time spiritual leader. In 1979, he was promoted to full-time rabbi. That same year, the building was consecrated on Merrick Road. In 1978, Cantor Lynn Karpo was hired as the first full-time cantor. The temple, an affiliate of the Union for Reform Judaism, had 250 families in 1986 and grew to more than 300 in 1991. The late 1990s and early 2000s saw a rapid decline in membership to about 100. In 2011, the temple merged with Temple Beth Am in Merrick. The former building is now occupied by the Ebenezer Brethren Assembly Church.

BETHPAGE

BETHPAGE JEWISH CENTER, 600 Broadway, Bethpage, 11714 *C* (Closed)

Bethpage Jewish Center was formed and chartered by the State of New York in September 1955. The congregation met rent-free in the Assembly of God Church of Bethpage and later purchased the building on Stewart Avenue. In 1957, the group purchased land at 600 Broadway and dedicated a new synagogue building on April 24, 1960. On October 25, 1969, a fire destroyed the synagogue. The building was almost completely rebuilt and rededicated on April 23, 1972. The center was a constituent of the United Synagogue of Conservative Judaism and had almost 250 families in its prime, 1975. Facing a rapidly declining Jewish population in Bethpage, the group merged with Midway Jewish Center in Syosset in 2007. Its memorial plaques, and many of those of the former Amityville Jewish Center, which it housed, were moved to the Midway building. Its former building is now a community center and is sometimes used for services by MaKom, a local Chabad outreach center.

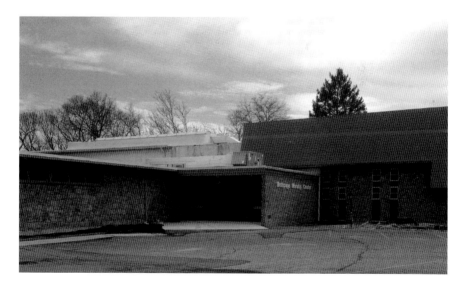

Former home of Bethpage Jewish Center, now a community building. *Photograph by Mark Friedman.*

Brentwood

Brentwood Jewish Center (Temple Beth Am), 28 6th Avenue, Brentwood, 11717 *C* (Closed)

This synagogue was founded as Brentwood Jewish Center at 771 Suffolk Avenue circa 1959. It held its first High Holy Day services in its new, partially completed building at 28 6th Avenue in 1962. It became known formally as Temple Beth Am circa 1962. Most of the facts presented herein come from an oral history interview conducted in June and July 2012 by the staff of the Brentwood Public Library with Esther and Martin Stein, former congregation members.

Prior to the erection of the Brentwood Jewish Center, Howard Brodsky taught Hebrew classes in a storefront at 771 Suffolk Avenue. Mr. Brodsky was a public school teacher in Brentwood and prepared quite a few students for their Bnai Mitzvaot. The Brentwood Jewish Center came into being through the efforts of many people, but Mr. Stein remembered three men in particular. Dr. Morris Molinoff, Dr. Madowitz and Arthur Floch were originally members of the Bay Shore Jewish Center. All three lived in Brentwood and thought that Brentwood should have its own congregation.

Dr. Molinoff had property on 6th Avenue. He donated land for the purpose of building the Brentwood Jewish Center. Originally, it was an Orthodox synagogue, but it later affiliated with the Conservative movement. Rabbi Goldman was the first rabbi. He was also the Jewish chaplain at Pilgrim State Hospital.

The building had one large room. The congregation was small, but at its height, the membership was 250 people. The number of children kept growing. Hebrew school classes were held at the Brentwood Presbyterian Church.

Over the ensuing years, the Jewish population of Brentwood started declining. Eventually, the congregation merged with Congregation Etz Hayyim of Central Islip. Both congregations kept their buildings. Services were held in Brentwood, and Hebrew school and adult education took place in Central Islip; this arrangement endured for fifteen years. In 2006, the Brentwood building was sold to La Segrada Palabra Church. The proceeds of this sale and the sale of Central Islip's building were given to Commack Jewish Center, into which the members had merged. Commack Jewish Center itself merged with Dix Hills Jewish Center in 2015.

BRIDGEHAMPTON

THE CONSERVATIVE SYNAGOGUE OF THE HAMPTONS, PO Box 1196, Bridgehampton, 11911 *C*

The Conservative Synagogue of the Hamptons was founded in 1999 by its rabbi, Jan Uhrbach, who spent her summers in Bridgehampton. This was the first Conservative presence on extreme eastern Long Island. The congregation does not own a building; instead, it has met in various buildings in the Bridgehampton and Sag Harbor areas. Rabbi Uhrbach is a nationally known figure in Conservative Judaism. She was the associate editor of the movement's new Shabbat prayer book, *Machzor Lev Shalem*. She was also on the editorial board for its High Holy Day prayer book. The clergy is a second career for the rabbi, as she is an attorney with a law degree from Harvard University. She is also on the faculty of the Conservative movement's rabbinical school, the Jewish Theological Seminary of America, of which she is a graduate. The congregation is a member of the United Synagogue of Conservative Judaism and is active from Memorial Day until the High Holy Days each year.

BROOKVILLE

CHABAD OF BROOKVILLE, 1447 Cedar Swamp Road, Brookville, 11545 *O*

Chabad of Brookville is an affiliate of Chabad of Long Island. The center is under the leadership of Rabbi Mendy Haber, a dynamic and young leader, and his wife, Mrs. Shifra Haber. The center offers daily services, adult and children's education, a Chabad Woman's Circle and social activities.

JEWISH CONGREGATION OF BROOKVILLE, 2 Brookville Road, Brookville, 11545 *R* (Closed)

The Jewish Congregation of Brookville was formed in 1997. The group never had a building and met in members' homes, Jericho Jewish Center and the Brookville Reform Church. The Reform group merged with the Oyster Bay Jewish Center in 2015 to form Congregation L'dor V'Dor.

THE NEW SYNAGOGUE OF LONG ISLAND, 2 Brookville Road, Brookville, 11545
Unaffiliated

The New Synagogue of Long Island was founded in 2010 by Rabbi Stuart Paris, a protégé of Rabbi Joseph Gelberman. Gelberman was among the first modern rabbis to preach to inter-faith marrieds and welcome them to Judaism. He operated the All Faiths Seminary in New York, which is among the places where Rabbi Paris studied. Rabbi Paris follows that tradition and is among the leaders in recognizing and encouraging inter-faith couples. The cantor is Irene Failenbogen. Services are held the first Friday night of each month and on Jewish Holy Days. The congregation shares the building it occupies on the Brookville Inter-Faith Campus with the Brookville Reform Church and a Muslim teaching center.

Rabbi Paris described the congregation as "spiritual in nature." They are not affiliated with any particular arm of Judaism. They are different and proud of it. Kabbalah and mysticism are important parts of Rabbi Paris's teachings. The principals of the synagogues are:

- We affirm the beauty, value and the significance of the Jewish faith as the primary source of our spiritual teachings.
- We believe that, from the beginning, the Jewish faith has evolved to meet changing historical conditions.
- We believe in the One God of all humanity.
- We believe that meditation, inward spiritual working and song are instruments of attuning to the Divine Presence that is at the very core of our human nature.
- We emphasize affirmative power rather than petitionary power.
- We believe that new and renewed forms of individual and communal prayer such as meditations, visualizations, affirmations and music can enhance the real purpose of the prayer experience.
- We hold that one of the most important purposes of religion is healing.
- We affirm that each human being is part of this healing process, called in the tradition "Tikun Olam," the healing of the worlds.
- We affirm the extraordinary, rich teachings of the Jewish faith as, for us, the most important aspect of Judaism.
- We believe that a Judaism that emphasizes the spiritual facet of our faith is an authentic Jewish expression that has its roots in the Bible.

Close contact today among the diverse ethnic, cultural, racial and religious groups of humanity leads us to a deeper sense of the oneness of humanity. Spiritual Judaism is a non-dogmatic, non-legalistic, liberal spiritual path that welcomes all people who ask to attune to the presence of God in their lives as the source of health, abundance, joy, love and wholeness.

What Is Going On in Cedarhurst and the Five Towns?

In 2015, the Jewish Heritage Society of the Five Towns published a book titled *The Jewish Communities of the Five Towns and the Rockaways*. The "Five Towns" are Cedarhurst, Lawrence, Hewlett, Woodmere and Inwood. These towns are all in the southeastern corner of Nassau County along the Queens County Border, except Inwood, which is partially in Queens County. In the book, the authors describe a community with few Jews prior to World War II. This same community today, in less than sixty years, has become a center of Orthodox Jewish life. After the Brooklyn borough of New York City and Kiryas Joel in upstate New York, it has the third-largest Orthodox Jewish population in the United States today, estimated at more than twenty thousand.

Numerous congregations are located in these towns. There are a few Reform and Conservative synagogues, but almost all congregations are Orthodox.

The Five Towns are one of the few areas of Long Island that have seen growth in the Jewish population over the past forth years. This is primarily due to the outreach of many Orthodox rabbis and communities that have settled in the area. The area has attracted thousands of young Jewish families who want to live and raise their children in a kosher environment away from the hustle and bustle of New York City but still wish to be close enough to commute. In addition to important Sephardic, Chabad and Young Israel Orthodox congregations, there are at least thirty other Orthodox synagogues.

There is one issue that is setting the Orthodox residents of Lawrence and Cedarhurst against not only their non-Jewish brethren but against the Reform and Conservative communities as well. Not long ago, the Orthodox residents ran a united slate against the sitting school board. They won the election and took control of the local public schools. The Orthodox children do not attend public schools, instead choosing to attend one of the many yeshivot in the area. The new school board was made up of such residents

and immediately enacted a plan to reduce taxes by reducing services. Many non-state-mandated services were cut. One of the elementary schools was closed and sold to a yeshiva. Both some Jewish and non-Jewish residents were very unhappy about what some called "the dismantling of their schools." The Reform and Conservative congregations have all suffered a drop in their memberships. The same is true for local churches. As soon as a house goes on the market, there are ready and eager Orthodox buyers.

Despite this issue, the Five Towns are a large Orthodox community. One can walk down the streets of Cedarhurst's business district and see such signs as "kosher," "shatnas testing" and "closed on Shabbat."

CEDARHURST

AGUDAT ISRAEL OF THE FIVE TOWNS, 508 Peninsula Boulevard, Cedarhurst, 11516 *O*

Agudat Israel is a traditional Orthodox congregation led by Rabbi Frankle. The current building was completed in 2010. Rabbi Frankel has published commentaries on the Chumash with Judaica Press. The synagogue also offers a complete youth program.

BAIS MIDRASH OF CEDARHURST, 504 West Broadway, Cedarhurst, 11516 *O*

Bias Midrash was formed in 1972. The original synagogue was located in the home of Rabbi Dovid Spiegel, a follower of the Lubavitcher Rebbe. Its current home, an attractive building, was opened in 2010 adjacent to the original home. The congregation offers daily minyanim, women's and children's activities and social events.

CHABAD OF THE FIVE TOWNS, 74 Maple Avenue, Cedarhurst, 11516 *O*

Chabad of the Five Towns is an affiliate of Chabad of Long Island. In September 1995, Rabbi Zelman Willowick and his wife, Chania, arrived in the Five Towns with the goal of establishing a Chabad center. In the eighteen years they have been here, the energetic Willowicks have turned the local Chabad center into one of Long Island's largest. In 2004, Rabbi

Meir and Mrs. Hadassah Gilinsky joined the Willowicks in their mission to make meaningful Judaism an accessible reality to all Jews. In addition to daily minyanim, this Chabad center offers many activities for men, women and children. It sponsors a summer day camp for children, children's classes throughout the year and a unique father-and-son study group.

Chofetz Chaim Torah Center (The Blue Shul), 7 Derby Avenue, Cedarhurst, 11516 *O*

Chofetz Chaim opened in 2001. Construction of the building, known as "the Blue Shul," started in 2008 and was completed in 2010. Rave Arya Zev Ginsberg is the rabbi.

Congregation Tifereth Tzvi, 26 Columbia Avenue, Cedarhurst, 11516 *O*

Rabbi Nuchim Tzvi Kornmehl was the rabbi of Young Israel of Lawrence and Cedarhurst from 1963 until 1992. Shortly thereafter, several of the rabbi's students began to daven on Shabbat in his former home, which was the original Young Israel and now was the Bais Midrash of Yeshiva Zichron Aryeh. In 1996, his former students formed the congregation, named Tifereth Tzvi in his honor. When the yeshiva moved to nearby Bayswater in Far Rockaway in 2002, the building became a full-time, full-service synagogue.

Since 1996, the rabbi has been Pinchas Chatzinoff. He was a close student of Rabbi Kornmehl for several years. CTZ has about sixty-five families and emphasizes close-knit families, serious services and love of Torah.

The Herrick Minyan, 445 Central Avenue, Cedarhurst, 11516 *O*

The Herrick Minyan is a traditional Orthodox minyan.

Kehilas Ahavas Yisroel, 568 Peninsula Boulevard, Cedarhurst, 11516 *O*

Kehilas Ahavas Yisroel is a traditional Orthodox group. Its Torah sustained serious damage from Hurricane Sandy. A new Torah was donated to the congregation by Congregation Kehillah Israel in Kansas City, Kansas.

Kehilas Bais Yehudah Tzvi (The Red Shul), 391 Oakland Avenue, Cedarhurst, 11516 *O*

Kehillahs Bias Yehudah Tzvi, also known as Congregation Eats Chaim and as "the Red Shul," was founded in 1996. It recently moved into its new building. The congregation is led by Rabbi Yaakov Reitman.

Kehilas Bais Yisroel, 352 West Broadway, Cedarhurst, 11516 *O*

Kehilas Bais Israel is a small Orthodox traditional congregation.

The Sephardic Temple, 775 Branch Boulevard, Cedarhurst, 11516 *C*

The Sephardic Temple was begun as Congregation Emeth VeShalom by a transplanted group of Sephardim from the New Lots section of Brooklyn. Early in the 1950s, they had organized a synagogue in New Lots called the United Sephardim of Brooklyn. It emphasized youth programs and services for young adults and operated from the Williams Avenue Synagogue and the Malta Street Synagogue.

Although the congregation flourished and achieved distinction in the Sephardic community, by the late 1950s, the neighborhood in which it was situated had begun to change. Synagogue vice-president Irving Rousso was asked to head a committee to establish a new congregation in the Five Towns, and the Sephardic Temple was created by a group of eighty-four families in 1963.

A tract of land was acquired on Branch Boulevard in Cedarhurst, and the building, a stunning Byzantine edifice, was built and opened in time for Pesach of 1964. Many consider it the most unusual and beautiful of synagogues on Long Island.

The synagogue has a Sisterhood that sponsors many social events and donates time and resources to the Sephardic Home for the Aged. Very often, the Sephardic Temple, Long Island's largest Sephardic congregation, plays host to distinguished members of the international Sephardic community.

The synagogue's Sevy Memorial Library contains a Ladino book that is more than four hundred years old, as well as a collection of bicentennial Ladino books. In the sanctuary, visitors will find a Megillot Esther that is more than two hundred years old and a shofar from Turkey that dates

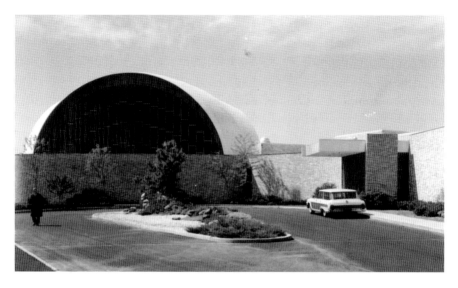

The Sephardic Temple, Cedarhurst. *Courtesy of Jewish Heritage Society of the Five Towns.*

back to 1810. There are also Yedim (Torah Pointers) from the Old City of Jerusalem.

In 1985, the congregation reported 460 member families. Today's numbers are around 300. Rabbi Arnold Marans is assisted by Rabbi Steven Golden. The cantor is Yair Yonati, and Lloyd Denenberg is the executive director.

SHAARE EMUNAH (THE SEPHARDIC CONGREGATION OF THE FIVE TOWNS), 539 Oakland Avenue, Cedarhurst, 11516 *O*

Share Emunah was established in 1997 by a group that envisioned the need for an Orthodox Sephardic congregation in Cedarhurst as opposed to the Sephardic Temple on Branch Boulevard, which it considered too liberal. The group purchased a property on Oakland Avenue and built the present structure shortly thereafter. The synagogue consists of more than one hundred member families who prefer to retain their Sephardic customs, traditions and prayers. They are led by Rabbi Mordechai Ben-Haim.

TEMPLE BETH EL, 46 Locust Avenue, Cedarhurst, 11516 *C*

Temple Beth El was founded in 1922. This the second-oldest Conservative congregation on Nassau County's South Shore. It is a longtime affiliate of the United Synagogue of Conservative Judaism.

The congregation first held worship services in the Lawrence Fire House on Washington Avenue. It was not until 1933 that the congregants were able to raise enough money to buy land and break ground for a new synagogue at 46 Locust Avenue.

The structure is an imposing building with a Greek façade, complete with six columns supporting a large portico. A monumental brass menorah stands at the Central Avenue entrance. The synagogue, which peaked at 1,100 families in 1960, fell to about 850 in 1980. In 1997, it reported 480 families. Today, the numbers are smaller, but the enthusiasm is still great. It has always been a leader in the Jewish social justice movement and maintains a religious education program.

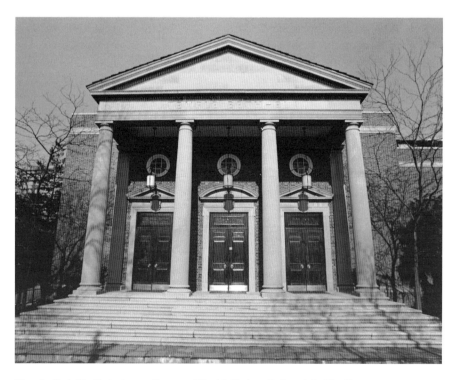

Temple Beth El, Cedarhurst. *Courtesy of Jewish Heritage Society of the Five Towns.*

The congregation is led by Rabbi Matthew Futterman, Cantor Ethen Leifer and executive and religious school director Dr. Ed Edelstein. Rabbi Sholom Stern is Rabbi Emeritus. The congregation also sponsors a Men's Club and a Sisterhood.

White Drive Minyan, 508 Broadway, Cedarhurst, 11516 *O*

This is a traditional Orthodox minyan, meeting in the home of Rabbi Glass.

Young Israel of Lawrence–Cedarhurst, 8 Spruce Street, Cedarhurst, 11516 *O*

This congregation was formed in 1963 under the leadership of Rabbi Nachum Kornmehl. The original home was 26 Columbia Avenue, now home to Congregation Tifereth Tzvi. In the mid-1980s, the shul hired Rabbi Moshe Tannenbaum as assistant to Rabbi Kornmehl. When Rabbi Kornmehl passed away in 1992, Rabbi Tannenbaum was elected to the position of Morah D'asra of the congregation. The current shul was built in 1986 and expanded in both 1993 and 2005. Young Israel now has a membership of more than 420 families. Rabbi Yaakov Trump is the assistant rabbi. Rabbi Gershon Kramer leads the Teen Minyan, Mr. Marvin Schenker is the executive director and Ms. Alyssa Schechter serves as youth director.

Center Moriches

Jewish Center of the Moriches, 2217 Main Street, Center Moriches, 11934 *C*

The Jewish Center of the Moriches is an independent Conservative synagogue. As early as 1938, Jewish families prayed together in the homes in the Moriches area. The congregation was organized in 1943 as the Jewish Men's Club of the Moriches, originally known as Temple Beth Sholom. In 1950, this small group of local farmers, merchants and friends purchased the home of the late state assemblyman J.L. Havens and made the site into the home of the Jewish Center of the Moriches.

The twenty-five original members dedicated the home as a synagogue on July 22, 1952. During the later years, the founders, and the new members they attracted, purchased the two adjoining lots and constructed a new building that was dedicated on August 14, 1966. The religious leader since 2009 has been Cantor Zachary Konigsberg.

CENTRAL ISLIP

TEMPLE ETZ HAYIIM (CENTRAL ISLIP JEWISH CENTER), 312 East Suffolk Avenue, Central Islip, 11722 *C* (Closed)

This group was formed in 1958 and located at 27 West Clift Street. It moved to 125 West Clift Street in 1963 to a building now occupied by a Spanish church. Groundbreaking on its last building at 213 East Suffolk Avenue was held on April 13, 1969. The building was consecrated in February 1970. The group later joined with Brentwood Jewish Center, and eventually the two congregations were forced to disband, with the proceeds from the sale of the buildings going to the Commack Jewish Center, where most of the remaining members affiliated.

COLD SPRING HARBOR

KEHILLATH SHALOM SYNAGOGUE, 58 Goose Hill Road, Cold Spring Harbor, 11724 *REC*

Kehillath Shalom Synagogue first met on April 30, 1969, at the Italian American Hall at 214 Wall Street in Huntington. The synagogue was later established in the home of Mrs. Anthony Buzzelli, who deeded her property to this new Reconstructionist congregation. The congregation is led by Rabbi Elisa Goldberg and Cantor Judy Merrick.

COMMACK

CHABAD CENTER OF MID-SUFFOLK, 318 Veterans Highway, Commack, 11725 *O*

Rabbi Mendel and Mrs. Brocha Teldon lead this Chabad center. They offer daily minyanim, adult and children's education, spiritual and study groups, youth activities and a supplementary Hebrew school and social activities.

CHABAD LONG ISLAND (ADMINISTRATIVE OFFICE), 65 Valleywood Road, Commack, New York, 11725 *O*

Chabad Lubavitch of Long Island was established by the Lubavetcher Rebbe in 1977 with the arrival of Rabbi and Mrs. Tuvia Teldon on Long Island. It is the local branch of the Lubavitch Youth Organization and the international Chabad Lubavitch movement. Since then, more than thirty centers have been established staffed by forty-five rabbis and their wives, servicing tens of thousands of Jews across Long Island.

Whatever the need, whether for a collegian in Stony Brook, a single mother in Yaphank or a child in Mineola, "Chabad is there to reach out and offer a helping hand," according to its website. "The dedication of our staff had made Chabad a household name on Long Island, and created one of the fastest growing Jewish organizations and Nassau and Suffolk."

Chabad operates more than thirty centers with more than forty-five rabbis and rebbetzin. Most of the centers offer regular synagogue services and Hebrew schools. Nine centers offer nursery schools, and eight offer Friendship Circles. They operate six mikvaot, six summer camps and two day schools. They also offer campus programs at Stony Brook State and Hofstra Universities. In addition, Chabad sponsors prison, nursing home and chaplaincy outreach programs.

Each of the more than thirty Chabad centers is independently operated under the umbrella organization and offers a variety of programs, many times reflecting the personalities of the individual Chabad rabbis. Each center expands over time to the level of financial support it receives from its local community Today, Long Island's Chabad centers are part of an international network of more than two thousand sites.

COMMACK JEWISH CENTER, 83 Shirley Court, Commack, 11725 *C* (Closed)

The Commack Jewish Center was founded by twenty families meeting in a storefront in the Mayfair Shopping Center in 1958. They incorporated in the middle of 1959. They moved from their storefront to a home at

51 Walter Court in 1961 and affiliated with the United Synagogue of Conservative Judaism. In 1964, the congregation first occupied its building on Shirley Court. The building was enlarged in 1970 and renovated in 2005 when both Brentwood and Central Islip's Conservative synagogues merged with Commack. In 2015, the congregation sold its building to a church and merged with the Dix Hills Jewish Center.

TEMPLE BETH DAVID, 100 Hauppauge Road, Commack, 11725 *R*

This affiliate of the Union for Reform Judaism was founded in 1961 by a small group of families dreaming of a warm congregation. They met at Christ Lutheran Church on Burr Road in East Northport for services and religious classes. In 1963, the group purchased the property at 40 Scholar Lane, with the split-level home located there serving as its new home. The current synagogue on Hauppague Road was dedicated in September 1971. Beth David is led by Rabbi Beth Klafter and Cantor Audrey Halpern. They temple includes a Brotherhood, Sisterhood, Senior Society, Hebrew school and a youth activities program.

YOUNG ISRAEL OF COMMACK (ETZ CHAIM), 40 Kings Park Road, Commack, 11725 *O*

Young Israel of Commack was founded in 1970 in a small house in neighboring Kings Park. The present location is on a five-acre campus, including the synagogue and a preschool, a special-needs preschool and a gymnastics school. There is also a supplementary Hebrew school on Sunday mornings. It is led by Rabbi Raphael Wizman.

COPIAGUE

COPIAGUE JEWISH CENTER (Closed)

Although no history could be found for the Copiague Jewish Center, several newspaper stories refer to the possibility of there being a synagogue in Copiague in the '50s and '60s. The author is not sure and welcomes comments on this possibility.

CORAM

CHABAD HOUSE OF CORAM, 87 Mount Sinai–Coram Road, Coram, 11727 *O*

Chabad House of Coram is a constituent of Chabad of Long Island. It is led by Rabbi and Mrs. Mendy and Rochel Goldberg. The center offers daily minyanim, adult and children's classes and Brotherhood.

YOUNG ISRAEL OF CORAM (CORAM JEWISH CENTER), 981 Old Town Road, Coram, 11727 *O*

Young Israel of Coram is led by Rabbi Mordechai Golshevsky. It has a modern building that was consecrated in 1977. In addition to services, the congregation offers adult and children's education and social activities. Rabbi Golshevsky also produces an outreach television program for the local cable network.

CUTCHOGUE

NORTH FORK REFORM SYNAGOGUE, 27245 Main Road, Cutchogue, 11935 *R*

North Fork Reform Synagogue is an affiliate of the Union for Reform Judaism and was founded in 1992. It first rented space at the Cutchogue Presbyterian Church and now shares the building with it. The congregation is led by Student Rabbi Tobias Moss, who will receive his ordination from Hebrew Union College in 2019. Summer services are held outdoors on Friday nights at Kenny's Beach in nearby Southold.

North Fork Reform Synagogue, Cutchogue. *Photograph by Norman Korowitz/ Carole Korowiz/ Jake Verano.*

North Fork Reform Synagogue. *Image from congregational website.*

DEER PARK

SUFFOLK JEWISH CENTER, 330 Central Avenue, Deer Park, 11729, *C* (Closed)

Suffolk Jewish Center was formed in 1957 by a group wishing for a synagogue closer than the Bay Shore Jewish Center where they were members. In the early years, the group used members' homes for prayer and religious school until building on Central Avenue. Rabbi Gabriel Maza was installed in July 1963 and served the congregation until 2004, when it merged with Dix Hills Jewish Center. Rabbi Maza is still held in high esteem by the members of Dix Hills. He is the brother of the famous comic Jackie Mason. The congregation was an affiliate of the United Synagogue of Conservative Judaism.

DIX HILLS

CHAI CENTER OF DIX HILLS, 501 Vanderbilt Parkway, Dix Hills, 11740 *O*

Chai Center of Dix Hills is an affiliate of Chabad Long Island. In addition to services, the synagogue provides adult and children's education, social activities and an educational program for children with special needs. The center is under the direction of Rabbi Yaakov Sacks and Associate Rabbi Dovid Weinbaum. Mrs. Zoey Sacks oversees the educational programs.

DIX HILLS JEWISH CENTER, 555 Vanderbilt Parkway, Dix Hills, 11740 *C*

In the winter of 1957, Dix Hills had a population of about five thousand families. The few Jewish families attended services in nearby Huntington. A meeting was called to discuss the idea of creating a Dix Hills Jewish Center. Each time a vote was taken as to which movement to affiliate with, the vote was evenly split between Conservative and Reform. Finding a rabbi was satisfied when the United Synagogue of Conservative Judaism promised to send out a rabbi or student rabbi from New York each Shabbat, provided the congregation would house and feed him. Thus, the decision to affiliate with the United Synagogue was made. The Park Shore Day Camp on Deer Park Avenue allowed the congregation to hold services there on Friday night and Saturday mornings, provided the congregants cleaned up.

On August 8, 1978, more than seventy families became "founding members." Their names are inscribed on the founder's plaque hanging in the lobby of the synagogue.

Now, many years later, Dix Hills is one of the largest and most influential synagogues in Suffolk County. Over the years, Suffolk Jewish Center of Deer Park, Brentwood Jewish Center, Central Islip Jewish Center and, most recently, Commack Jewish Center have merged with Dix Hills. The current rabbi is Howard Buechler. The cantor is Steven Hevenstone, and the educational director is Ricky Tadmor. The executive director is Ed Ward. Rabbi Gabriel Maza, formerly of the Suffolk Jewish Center of Deer Park, which merged with Dix Hills, is still honored here regularly. The congregation is one of the cornerstone congregations of the United Synagogue in Suffolk County.

EAST HAMPTON

CHABAD OF THE HAMPTONS, 13 Woods Lane, East Hampton, 11937 *O*

Chabad of the Hamptons is an affiliate of Chabad of Long Island. It is under the direction of Rabbi Leibel Baumgarten and his wife, Mrs. Goldie Baumgarten. Rabbi Baumgarten was just eighteen years old when he began traveling to Long Island as part of Chabad's outreach program to bolster Jewish youth. One of his first projects was to set up Jewish youth clubs throughout the island. He visited many Hebrew schools to spread the

word about many programs and get-togethers. By the end of the decade, rabbinical students and seminary girls were commuting regularly to Long Island to run successful youth programs of their own as part of Chabad's outreach program. The hard work paid off, and now there are more than thirty Chabad centers on Long Island.

In 1887, Rabbi Baumgarten learned of a New York investor who wanted to establish a weekly Shabbat service in the Hamptons, where he owned property. Rabbi Baumgarten, at that time based in Commack, ran a newspaper advertisement to "feel the tide." An East Hampton family offered their home to serve as a temporary synagogue. At the start, the young minyan operated from Shavuot to Rosh Hashanah, reflecting that East Hampton is a summer retreat and did not have many year-round residents. For more than three months each year, Rabbi Baumgarten would leave his family in Commack each Shabbat and travel to East Hampton to lead services. It was not an ideal arrangement, but they could not find housing for the entire family.

After seventeen years, the community was big enough to support a full-time Chabad center. In 2004, Rabbi Baumgarten and his family moved permanently to East Hampton. They immediately erected a mikvah, a "must" for an Orthodox congregation. They also erected a tent in the rear yard for the large adult crowd they expected for Rosh Hashanah and Yom Kippur and turned over the synagogue to the youth.

Rabbi and Mrs. Baumgarten are truly "rock stars" among the rich and famous in East Hampton. It took seventeen years, but Chabad of the Hamptons is truly a gem.

JEWISH CENTER OF THE HAMPTONS, 44 Woods Lane, East Hampton, 11937 *R*

This group formed after a meeting in a private home in July 1957. The congregation first held services in the East Hampton Presbyterian Church. In 1959, the congregation purchased two acres on Montauk Highway and used the private home on the property as its first synagogue. In 1981, it broke ground on its current building, located on the former Borden estate. The building was designed by Norman Jaffe, inspired by the wooden synagogues of eastern Europe. It was dedicated in 1986 and given the Award of Merit by the American Institute of Architects and a

Logo of the Orthodox Union.

Certificate of Excellence in Design by the New York State AIA. The rabbi is Sheldon Zimmerman, and the associate rabbi is Hanniel Levenson. The cantor is Debra Stein. Diane Weiner is the executive director. The congregation has attracted as many as one thousand people to Rosh Hashanah services.

EAST HILLS

CHABAD JEWISH LEARNING CENTER, 210 Forest Drive, East Hills, 11548 *O*

This is a constituent of Chabad of Long Island. It consists of a Hebrew school directed by Rabbi and Mrs. Reiter and a preschool under the direction of Ms. Charnie Konokov.

EAST MEADOW

EAST MEADOW JEWISH CENTER, 1400 Prospect Avenue, East Meadow, 11554 *C*

East Meadow Jewish Center has been led by Rabbi Ronald Androphy since September 1983. The congregation was founded on July 9, 1953. In the next few months, the congregation hired a rabbi, Israel Nobel, and established a Sisterhood. The 1953 High Holy Day services were held at the East Meadow Republican Club. A Hebrew school was established at the Prospect Avenue School. The group rented a storefront at 295 Newbridge Road starting in March 1954. It purchased the site of its current building on January 24, 1955, and broke ground for the current building in February 1956. The building was dedicated in January 1957. In 1960, a Youth House was added. Over the years, there have been several modernizations. The congregation has always been an affiliate of the United Synagogue of Conservative Judaism.

Membership grew to a peak of more than six hundred families in 1964, and the religious school had almost eight hundred students. In 1965, an addition to the building included the sanctuary. The congregation, although not near its numbers of 1964, remains strong and vital to this day.

SUBURBAN PARK JEWISH CENTER, 400 Old Westbury Road, East Meadow, 11554 *O*

Suburban Park Jewish Center was formed by a group of ten families who split from East Meadow Jewish Center in 1958 and met in a house converted into a small synagogue. High Holy Day services were held in the large rear yard of a member.

In 1981, the synagogue moved into its permanent home at 400 Old Westbury Road and turned the former private home into a home for the rabbi. The membership peaked at about 140 families in 1987, when the nearby Uniondale Jewish Center (also known as Congregation Lev Torah), closed and merged with Suburban Park. This congregation started out as Conservative but now is considered Modern Orthodox.

TEMPLE EMANU EL, 123 Merrick Road, East Meadow, 11554 *R*

Temple Emanu El was born in a meeting at the home of Emanuel Frankfort, a victim of the famous Long Island Rail Road crash of 1950 in Rockville Centre. Friends and neighbors who made up the Shiva Minyan became the founders of Temple Emanu El, East Meadow's oldest synagogue.

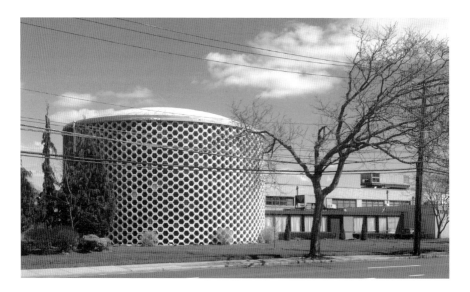

Temple Emanu El, East Meadow. *Photograph by Mark Friedman.*

Early on, services were held in local fire halls, in a tent on the land they purchased on Merrick Road and, finally, in their own building, completed partially by 1956. In 1957, the beautiful sanctuary was dedicated. Many consider its "glass circles" design one of the world's most unique for synagogue sanctuaries. Since demographics are changing in its neighborhood, Emanu El was (at the time of the publication of this volume) entering into merger talks with a nearby synagogue. Temple Emanu El is led by Rabbi Daniel Bar-Nahum and Cantor Ellen B. Weinberg. Albert J. Lowenberg is Rabbi Emeritus.

East Northport

East Northport Jewish Center, 328 Elwood Avenue, East Northport, 11731 *C*

In June 1956, seventy-five families met to form a Conservative synagogue in East Northport. They chose the name Temple Beth Sholom and rented a storefront at 27 Larkfield Road for meetings and services. On September 11, 1956, the congregation formally adopted the name East Northport Jewish Center. In 1959, it moved to a slightly larger storefront at 82 Larkfield Road. Its first building was an A-frame building constructed at 357 Clay Pitts Road and dedicated on September 29, 1963. The current building was constructed in 1977 and has since undergone several expansions and renovations. The congregation has been an affiliate of the United Synagogue of Conservative Judaism for sixty years. The current rabbi is Ian Sherman, and Ian Nussbaum is cantor/educational director.

Young Israel of East Northport, 7 Hooper Street, East Northport, 11731 *O*

Founded in 1976 by Rabbi Chaim Bausk, this congregation recently completed a $150,000 fundraising campaign to enlarge and modernize its building.

EAST NORWICH

CHABAD OF MID-NASSAU JEWISH LEARNING CENTER, 3 Johnson Street, east Norwich, 11732 *O*

This center is affiliated with Chabad of Long Island. It was founded in 1996 at 1350 Oyster Bay Road by Rabbi Aaron and Mrs. Charna Shane. The congregation moved to its current location a few years later and is now led by Rabbi Mendy and Mrs. Devorah Brownstein. It offers a full program of daily services, as well as adult and children's educational programs. The center is also known as Chabad of Oyster Bay and Jericho.

EAST ROCKAWAY

HEWLETT–EAST ROCKAWAY JEWISH CENTER, 295 Main Street, East Rockaway *C*

The Hewlett-East Rockaway Jewish Center, also known as Congregation Etz Chaim, was founded in 1949 by a group of fifteen former members of the Lynbrook and Rockville Centre Conservative congregations who wanted a synagogue in East Rockaway. They met in various homes and a storefront on Main Street until 1955, when they purchased the Tameling estate land and buildings on Main Street. The current building was dedicated in September 1955 and has since been added to and renovated at least twice. Rabbi Andrew Warmflash leads the congregation along with Cantor Bonnie Streigold, Educational Director David Woolfe and nursery school director

Congregation Etz Chaim, the Hewlett–East Rockaway Jewish Center, East Rockaway. *Photograph by Sandy Feit.*

Congregation Etz Chaim, the Hewlett–East Rockaway Jewish Center. *Photograph by Sandy Feit.*

Cheryl Krug. The late Rabbi Morris Goldberg served this congregation for many years. It has been affiliated with the United Synagogue of Conservative Judaism since 1950.

EAST SETAUKET

AGUDAT ACHIM SYNAGOGUE, 152 Main Street, East Setauket, 11733 *O* (Closed)

Agudat Achim (the Brothers of Israel) Synagogue was founded in 1887. It became the forebear of the North shore Jewish Center in Port Jefferson Station. See the "Port Jefferson Station" section.

KEHILLATH CHOVEVI TZION, 764 Route 25A, East Setauket, 11733 *C*

Kehillath Chovevi Tzion was formed by a small group that broke away from North Shore Jewish Center in 1993 for political reasons. The group celebrates all holy days, offers many educational programs and celebrates all chugim. The congregation follows Conservative ritual.

Elmont

Elmont Jewish Center, 500 Elmont Road, Elmont, 11003 *O*

Elmont Jewish Center was founded in 1948 by 18 families looking to establish a Conservative synagogue. They hired Student Rabbi Samuel Z. Glaser, and in just seven years, he was given life tenure—the youngest rabbi in the United States to receive that distinction. After moving from several rented locations, a building was erected in 1955, and the group affiliated with the United Synagogue of Conservative Judaism. The membership peaked at 440 families in 1966, and the building was expanded.

Membership started to decline in the late 1970s as the demographics of the area were changing. In 1988, Rabbi Glaser retired. Shortly thereafter, the congregation changed from Conservative to Orthodox under Rabbi Joseph Ozarowski. To date, lively services are held in this building under Rabbi Chaim Blachman of the Chabad movement. The congregation has been operated by a partnership with the Ohel Chabad Lubavitch Center of Cambria Heights since 2012. It remains an important and vibrant part of Elmont.

Temple Bnai Israel, 471 Elmont Road, Elmont, 11003 *R*

Temple Bnai Israel is a Reform congregation located just at the Queens County border with Nassau County. It was founded by 40 families 1948. They met in members' homes until 1951, when the synagogue was built. By 1985, membership was up to 140 families, and it peaked at almost 400 by 1988. The congregation currently has about 100 families and is very proud of its large collection of Judaica. Several of its own Bnai Mitvaot have gone on to become rabbis.

Farmingdale

Farmingdale Jewish Center, 425 Fulton Street, Farmingdale, 11735 *C* (Closed)

Farmingdale Jewish Center goes back to the Farmingdale Hebrew Association, circa 1900. Aaron Stern opened his famous pickle plant here

in 1899. Services were first held in the home of Jacob Kranzler and later at the Veterans Hall and the Masonic Hall. Eventually, the group moved into the American Legion Post Hall on eastern Parkway. The group was incorporated on November 19, 1926, as the First Hebrew Congregation of Farmingdale. The first president was Osias Karp, and Aaron Stern was elected secretary. The group hired Rabbi Alter Brauer and affiliated with the United Synagogue of Conservative Judaism. By 1935, the congregation was holding monthly business meetings at the Fulton Hotel, later the site of the Ho-Wah Restaurant, and dues were twelve dollars per year.

In 1944, the congregation bought its first building at 4 Columbia Street and changed its name to the Farmingdale Jewish Center. One year later, it started construction of its last building at 425 Fulton Street, which was formally dedicated on November 30, 1948. Joseph Stern, who had served as president from 1937 to 1939, was the master of ceremonies at the dedication, and he also served as president from 1949 and 1951 and again from 1956 to 1957. During his last term, plans were made for an expansion. The building was expanded and rededicated on May 5, 1968. The rededicated building was designed by the architectural firm of Scheiner & Swit. In 1959, additional land was purchased on Fulton Street,

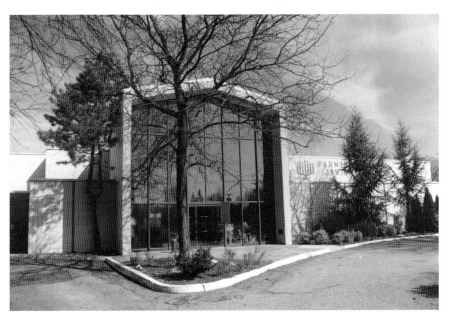

Former Farmingdale Jewish Center, Farmingdale, now a mosque. *Courtesy of Special Collections Department, Hofstra University Library.*

and discussions were held regarding another expansion. A few years later, an architect was hired to design the synagogue. Groundbreaking was held on March 12, 1967, and on May 5, 1968, the building was dedicated. During the construction, High Holy Day services were moved from a tent that had been erected on the grounds to a factory building on Eastern Parkway. Membership peaked at 400 in 1971. By 1986, it had dropped to 325, and by 1991, it was below 200.

In 1972, the first discussions were held regarding the role of women in services, and in 1975, Ann Shore became the congregation's first female president. Under her direction, women were granted a greater role in ritual functions, something first incorporated during Simchat Torah services in 1976. Another major change during Mrs. Shore's administration was the combining of the congregation's Hebrew high school with that of Congregation Beth El of Massapequa. Both congregations continued to run their own lower schools.

In 2012, the Fulton Street building was sold to Masjid Balil Mosque, and the congregation merged with the Wantagh Jewish Center to form the Farmingdale-Wantagh Jewish Center in Wantagh's building. A few years later, the Israel Community Center of Levittown joined the merger, and the new synagogue that emerged was renamed Congregation Beth Tikvah; it meets in the former Wantagh Jewish Center building in Wantagh.

FAR ROCKAWAY (QUEENS COUNTY)

AGUDATH ISRAEL OF WEST LAWRENCE, 631 Lanett Avenue, Far Rockaway, 11691 *O*

Agudath Israel of west Lawrence is under the leadership of Rabbi Moshe Brown. Avi Polinsky is the gabbai, and Tuvia Fried is the executive director.

BAYSWATER JEWISH CENTER, 2355 Healy Avenue, Far Rockaway, 11691 *C*

Bayswater Jewish Center is a longtime affiliate of the United Synagogue of Conservative Judaism. Rabbi Eliyahu Wanunu is the spiritual leader. The congregation is in its fifty-fifth year.

CONGREGATION DERECH EMUNAH *C/O* (Closed)

This was one of the original twenty-two United Synagogue of Conservative Judaism congregations in the early 1900s. It was located in the Averne section. It is long closed.

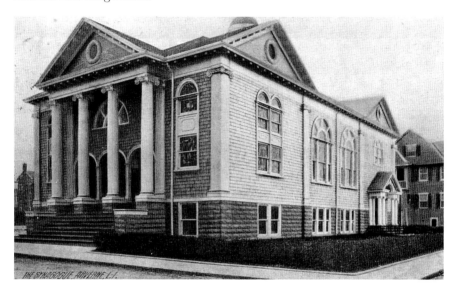

Congregation Derech Emunah in the Averne section of Far Rockaway. Derech Emunah was the only one of the original twenty-two United Synagogue (Conservative) congregations located on Long Island. Shortly after the founding, Tifereth Israel of Glen Cove and Bnai Sholom of Rockville Centre joined. Derech Emunah later left the Conservative movement and adopted Orthodox ritual. The synagogue has disbanded. *Courtesy of Jewish Heritage Society of the Five Towns.*

CONGREGATION KEHILAS JACOB, 821 Roosevelt Street, Far Rockaway, 11691 *O* (Closed)

Reported closed in 2015.

CONGREGATION KENESETH ISRAEL, 728 Empire Avenue, Far Rockaway, 11691 *O*

Congregation Keneseth Israel, an Orthodox congregation, is also known as "the White Shul." Rabbi Pelcovitz recently celebrated sixty-five years

with the synagogue. Numerous other rabbis are part of the staff and faculty at this congregation.

CONGREGATION SHAARE TEFILA *O*

This building burned down in 1969. The congregation moved to Lawrence.

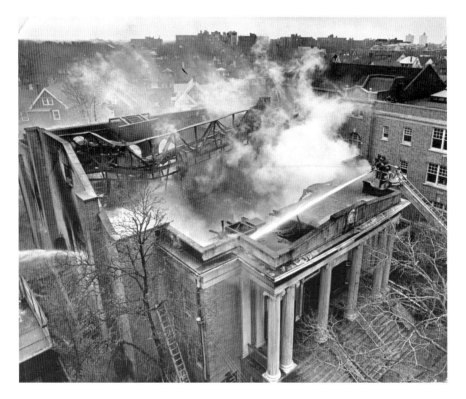

Above: Congregation Shaare Tefila, Far Rockaway. On January 3, 1969, sixty years after construction, a disastrous fire raged through the sanctuary. *Courtesy of Shaare Tefilah and the Jewish Heritage Society of the Five Towns.*

Opposite: Another view of the fire at Shaare Tefila, Far Rockaway. *Courtesy of Jewish Heritage Society of the Five Towns.*

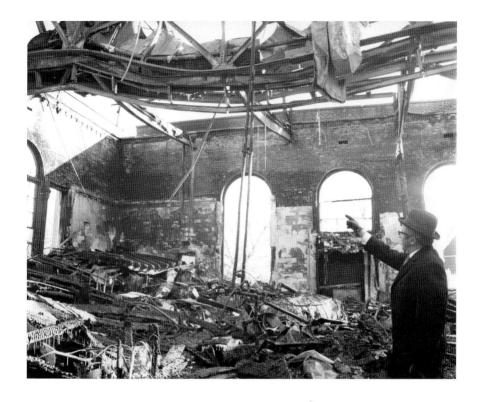

CONGREGATION SHAARE ZEDEK OF EDGEMERE, 315 Beach 30th Street, Far Rockaway, 11691 *O*

Shaare Zedek was founded in 1918.

KOLEL ANSHEI CHESED, 814 Caffrey Avenue, Far Rockaway, 11691 *O*

No information is available.

YOUNG ISRAEL OF FAR ROCKAWAY, 2715 Healy Avenue, Far Rockaway, 11691 *O*

Rabbi Eliezer Feuer leads this Young Israel affiliate. Rabbis Kraus and Rabinowitz are also on the staff.

FIRE ISLAND

FIRE ISLAND HOLIDAY MINYAN, 109 Broadway, Saltaire, Fire Island, 11770 *R* (Seasonal)

The Fire Island Holiday Minyan meets each year on the High Holy Days at St. Andrews by the Sea Church to conduct services per Reform ritual. It also holds other services and special events throughout the summer.

FIRE ISLAND MINYAN, Box 43, Homesite and Bayview Walk, Seaview, Fire Island, 11770 *O* (Seasonal)

The Fire Island Minyan is a seasonal summer minyan operating per modern Orthodox ritual. This congregation was formed in 1990 after the Fire Island Synagogue voted to become egalitarian. It rented a house for its synagogue starting in 1993 and purchased it three years later. The first Jews to come to Fire Island exhibited little religious identity and lived in the Ocean Bay Park and Seaview neighborhoods on a seasonal basis. While predominantly Jewish today, Seaview was restricted to white/Protestant homeowners until 1938, when the "ban against Jews" was lifted. Ralph Levy was the first Jewish resident of Seaview and was quickly followed by Walter Weisman. During the period from 1940 to 1965, many Jewish summer residents arrived, including Mel Brooks, Ethel Merman and Tony Randall.

Probably the most overtly Jewish summer resident of Fire Island was Rabbi David de Sola Pool, rabbi of Congregation Shearith Israel, the Spanish and Portuguese Synagogue in Manhattan. The first minyanim were held on the porch of the rabbi's home. In 1959, after Rabbi de Sola Pool's death, the group rented a home for services big enough to also be the home of their new leader, Rabbi Tendler. Rabbi Tendler's father-in-law, the famous Rabbi Moshe Feinstein, visited several times.

A meeting was held at the home of the famous author Herman Wouk on the ocean at "B" Street. There an appeal was made for funds. As the congregation has now broken away from the Fire Island Synagogue, there was a need for a more permanent building than the home it had purchased. The current building was acquired in 1999. The major benefactor was Mr. Jack Minor, a supporter of the Lubavitcher Rebbe and, respectful of his own family tradition, a Conservative Jew. Through a succession

of seasonal rabbis, the congregation, which was founded in Orthodoxy, has evolved into an egalitarian group following Conservative ritual. At various times, the congregation was also known as Rodfei Shemesh and Anshe Chof.

Fire Island Synagogue, Central Walk/Beechwald Street, Seaview, Fire Island, 11770 *C* (Seasonal)

The Fire Island Synagogue is a seasonal summer congregation. Fire Island's first Jewish group was founded in 1950 and met in members' homes. Services were held on the porch of a member's home with a Torah borrowed from the Bay Shore Jewish Center. In 1954, the Fire Island Jewish Center was officially founded. Construction on the present building was started in July 1972, and the consecration was held on July 8, 1973. At the time, Herman Wouk was a vice-president of the congregation.

Floral Park

Floral Park Jewish Center, 26 North Tyson Avenue, Floral Park, 11004 *C* (Closed)

On October 22, 1928, a group of eleven men met at the home of Dr. Aaron Brown to organize a Jewish center in Floral Park. At a second meeting on November 3, 1928, the first officers of the center were elected as follows: Dr. Aaron Brown, president; Dr. Arthur E. Goldfarb and Alfred J. Loew, vice-presidents; Jacob Oshansky, treasurer; and Herman Shanin, secretary.

On December 5, 1928, the former telephone company building on North Tyson Avenue was purchased for $22,500. A constitution and bylaws of the center and Sisterhood were adopted on February 4, 1929, and in June of that year, with an impressive ceremony, the Floral Park Jewish Center was formally dedicated by Rabbi Stephen S. Wise. The good fortune of such an auspicious start was not to last. The stock market crash in October of that year and the ensuing depression plunged the congregation into troubling times. There were nights when services were attended in heavy coats to conserve oil. Rabbis came out from New York City only on weekends, and at one time, the entire support of the congregation was due to only eighteen families.

With the end of World War II, conditions began to improve, with an era of prosperity ahead. In 1945, an Orthodox Jewish group in Floral Park met with officials at the center and worked out an agreement to merge as a Conservative temple. In August 1946, the union took place and lasted until the final days of the congregation.

In January 1958, a large extension was added to the temple, the interior was modernized with rooms for social and cultural programming and the entire building was air conditioned.

In September 1957, Rabbi Maurice Lamm came to Floral Park to succeed Rabbi Bernard Rubenstein, who served from 1953 to 1957. Prior to Rabbi Lamm, Rabbis David Schwartz and Abraham Goodman served the Floral Park Jewish Center.

Starting in the mid-1960s, the demographics of Floral Park started to slowly change. Membership dropped slowly year after year. Finally, the congregation was forced sell its building in the '80s and merge with the neighboring New Hyde Park Jewish Center. Later, that center also closed and merged with the Shelter Rock Jewish Center.

ORTHODOX CONGREGATION OF FLORAL PARK, 26 North Tyson Avenue, Floral Park, 11004 *O* (Closed)

This group met for a short time from 1940 to 1946 in various rented locations, including the Floral Park Jewish Center. In August 1946, it formally merged with Floral Park Jewish Center, a Conservative congregation.

TEMPLE SHOLOM, 262–22 Union Turnpike, Floral Park, 11004 *R* (Moved)

In 1955, a group of residents started meeting for services in private homes. They moved into a storefront and conducted services per Reform ritual. They were affiliated with the Union for Reform Judaism. In 1958, the synagogue built its home at the corner of Union Turnpike and 263rd Street on the Queens side of Floral Park.

In 2004, Temple Sholom, facing a demographic shift, opted to downsize rather than merge. It sold its building and now rents space in the Jewish Center of Oak Hills, 5035 Cloverdale Boulevard, in the Oakland Gardens section of Queens County. Today, the congregation is led by Cantor Josee Wolff.

Franklin Square

Franklin Square Jewish Center, 47 Pacific Street, Franklin Square, 11010 *C* (Closed)

In 1942, fifteen families joined to form the Franklin Square Jewish Center. It was to be a Conservative synagogue affiliated with the United Synagogue of Conservative Judaism. The building at 47 Pacific Street was completed in 1951. In 1967, the group reached a peak membership of 250 families. By 1985 membership was 125, and by 1999, only 60 families remained. In 2014, the membership voted to merge with the JCC of West Hempstead to form the Franklin Square–West Hempstead Jewish Center in West Hempstead's building. Shortly thereafter, the name was changed to Congregation Shaare Shamayim, and the building on Pacific Street was sold to the Christ Assembly of God Church.

Former Franklin Square Jewish Center, Franklin Square. *Courtesy of Special Collections Department, Hofstra University Library.*

Freeport

Congregation Bnai Israel, 91 North Bayview Avenue, Freeport, 11520 *C*

Bnai Israel was formed and elected its first officers on September 12, 1915. Services and religious school classes were held in Brooklyn Hall. In October 1916, ground was broken for its first building at the corner of Mount Avenue and Broadway. The cornerstone was laid on August 22, 1920, by the oldest member of the group, Morris Miller. The architect was Christian P. Kern.

The current building at 91 North Bayview Avenue was dedicated in 1959 by Katriel Katz, the ambassador to the United Nations of Israel. The old building was sold to the Refuge Apostolic Church of Christ. Membership peaked at 450 families in 1965. By 1984, even with many members of the closed Roosevelt Jewish Center joining Bnai Israel, membership was down to 350. Today, about 150 families worship with Rabbi Tamar Crystal. A Sefer Torah from Slany, Czechoslovakia, is displayed in the synagogue. There are stained-glass windows representing many of the fifty-four Sidrot of the Torah as well.

UNION REFORM TEMPLE, 475 North Brookside Avenue, Freeport, 11520 *R* (Closed)

Union Reform Temple was founded by ten families in 1953. It was formed to serve Freeport and Roosevelt. Its first home was the vacant First Baptist Church, 74 South Grove Avenue, which it rented for services and a Hebrew school. In August 1954, the group purchased property at 475 North Brookside

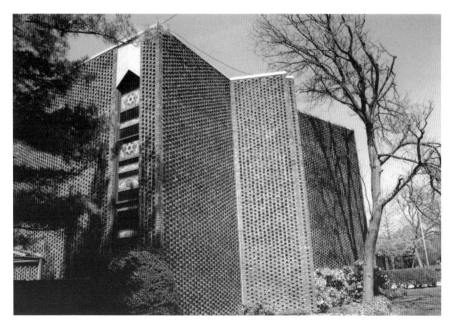

Former Union Reform Temple in Freeport, now Centro Christiano Ranacer Church. *Courtesy of Special Collections Department, Hofstra University Library.*

Avenue. In 1960, it broke ground for its own synagogue and dedicated the building in September 1961. Many consider this edifice among the most eye-pleasing of the Reform synagogue buildings on Long Island.

On February 25, 1966, Temple Emanu El, a small Reform congregation in Baldwin, merged with Union Reform Temple, bringing in fifty additional families. Membership slowly declined as the demographics of Freeport changed. In April 2000, the group merged with Temple Avodah of Oceanside. The building was sold to the Centro Christiano–Reborn Christian Center Church.

Garden City

Chabad of Adelphi University, 411 Hempstead Turnpike, West Hempstead, 11542 *O*

This Chabad is affiliated with Chabad of Long Island. The group is led by Rabbi and Mrs. Yankel Lipskier and is directed at Adelphi University students. Some local residents join them for prayer and other activities.

Garden City Jewish Center, 168 Nassau Boulevard, Garden City, 11530 *R*

Garden City Jewish Center is led by Rabbi Stephen Wise Goodman and is affiliated with the Union for Reform Judaism. The congregation was founded in 1953 and held its first High Holy Day services in the Cathedral House of the Cathedral of the Incarnation. Regular Friday evening services were first held in private homes and shortly thereafter in Blodgett Hall of Adelphi University.

Prior to World War II, Garden City was known as a "restricted" community, meaning restricted to white Protestants. By 1954, the group had grown to more than forty families. On January 20, 1956, the land for the site of the present synagogue was bought. The Garden City Board of Zoning Appeals gave the congregation a terrible time, but the New York State Supreme Court in Mineola finally approved the use of the grounds and building as a synagogue. On March 8, 1958, after some serious renovations, the large house on the grounds was officially dedicated as Garden City Jewish Center, with Rabbi Morris Rose presiding. In 1958, the congregation hired Cantor Gerald Manuta.

In 1952, the first full-time rabbi, Ralph Kingsley, joined the congregation. By 1965, membership was more than one hundred families, and a new wing with school classrooms, a social hall and offices was added.

On September 5, 1970, after twenty years as a rabbi in South Africa, Rabbi Meyer Miller succeeded Rabbi Kingsley. In 1986, the congregation reported seventy-five members; Rabbi Stephen Wise Goodman was the now "part-time" rabbi, and Cantor Joy Holtzberg was the "part-time" cantor. Today, membership is back over one hundred families, and Rabbi Goodman remains with the congregation. Rabbi Goodman is married to Rabbi Linda Goodman, spiritual leader of the Union Temple in Brooklyn, New York.

GLEN COVE

CONGREGATION TIFERETH ISRAEL, 40 Hill Street, Glen Cove, 11543 *C*

The Sandmans were the first Jewish residents in Glen Cove, settling there in 1868. Mr. Sandman, who was in the real estate business, was soon followed by Benjamin Cohen and then Barry Friedman, who owned his own general store, in the early 1870s. Issac Bessel and his wife, Esther, moved to the community in 1883. For the next twenty years, these four families were the only Jewish families in Glen Cove.

Bessel, who was to become the first president of Congregation Tifereth Israel, had a feed and grain business and sold horses. Jewish peddlers unable to reach their own homes for the Shabbat often spent it with the Bessels. The couple had two sons: James, who died of influenza in 1916, and Sam. Sam owned his own furniture store, and he and his wife, Yetta, had five children. Two of those children, Bessie and Anne, became the first Jewish teachers in Glen Cove's public schools. These early Jewish settlers left such an impact on the community that there is still today a Bessel's Lane and a Cohen's Corner in Glen Cove.

The community's Jewish population began to increase with the first large immigration of Jews from Europe in the late 1880s and early 1890s. Phil and Joe Bernstein emigrated from Lithuania in 1896. They were followed in 1902 by another brother, Walter, who opened Bernstein's Men's Wear. Two other Berman brothers, Sam and Udel, moved to the community later.

Among the other Jewish settlers were Theodore Jospe, who operated a jewelry store; Jacob Feinberg, a baker; and Smith Levine and Harry Lifshitz,

who were schochetim, or ritual slaughterers. Together, they provided the chickens for the Jewish community, and they traveled to New York City at least twice a week to bring back meat in their ice wagons.

Some of the meat they prepared and sold themselves was bought from Pinchas Cohen, who settled in Glen Cove in 1893. It is said that Cohen's last name was really Parisky, but when he was processed at Ellis Island, he identified himself as Cohen because he was a Kohen and there were no immigration officers who could spell his real name correctly.

By the year 1897, the Jewish community of Glen Cove had grown large enough to be able to establish a synagogue. Benjamin Cohen was the founding president of the synagogue, Congregation Tifereth Israel. When elections were held in 1906, Bessel became its first elected president. His home and those of other members were the sites of religious services in those first years. A meetinghouse was also used. Lifshitz, who was also a mohel in addition to being a butcher, often read the Torah.

In 1900, the congregation was firmly established and growing, and there was a need to open a religious school and find facilities large enough to accommodate all the members. The congregation bought the opera house of Continental Place. They renovated it, converting the dressing room into the sanctuary and building a small adjoining building for use by the religious school. On the High Holy Days, the congregation moved into the opera house hall itself because of the numerous visitors and Jews from neighboring communities who wished to attend. In the mid-1920s, the congregation rented out the building for the staging of beauty shows, and it later became the first movie theater in Glen Cove.

In 1902, Bernard Singer, a Hebrew scholar, moved to Glen Cove after finding anti-Semitism in Hicksville, where he had lived for the preceding four years after emigrating from Lithuania. He had no trade and earned a living as a peddler, transporting his wares with a horse and wagon. After a few months in Glen Cove, he opened a store on School Street. He died in 1913, and his children, Ben and Becky, left school to run the store. The store was closed on Shabbat, and it was not uncommon to find broken store windows when they returned to open on Sunday.

Among the other Jewish settlers was Morris Steisel, who came in 1910 and was the only synagogue secretary to take minutes in Hebrew and Yiddish. At about this time, Julius Ain, who would become an extremely active member of the congregation, moved to Glen Cove. He was a plumber and worked on building St. Patrick's Church. His son, Jack, was born on Glen Street and attended the first Hebrew school on Continental Place.

Irma Lindheim, who had a summer house on Crescent Beach Road, organized a Zionist Club in Glen Cove after she returned from Palestine in 1925. After the death of Henrietta Szold, the founder of Hadassah, Lindheim became its second president.

S.J. Bernstein came to Glen Cove in 1919 at a time when there were seventy-five Jewish families there. He later became president of the congregation and spearheaded the drive for a new synagogue building. With a $5,000 donation from Benjamin Stern of Glen Head (the owner of Stern's Department Stores), the opera house was razed in 1926 and a new building erected in its place. Stern was given the honor of laying the cornerstone when the building was dedicated the following year. Originally estimated to cost $50,000, the final price was $65,000. During the construction, services were held in Pembroke Hall on School Street.

Lighting fixtures for the new synagogue, as well as a chandelier and furniture for the bima, were bought at auction from the old Waldorf Astoria Hotel in Manhattan, which was then on the site of the Empire State Building.

In 1928, Tifereth Israel hired its first full-time rabbi, Emanuel Rackman, who had just graduated from Yeshiva University. He was paid seventy-five dollars per week and remained for a year. Rackman went on to become president of Bar Ilan University in Israel.

Members of the congregation took leadership positions in the Jewish community. During the 1920s, Jamaica, Queens, was the central meeting place of the Jewish community, and in the late 1930s, the focus switched to Mineola. Two of the group's members, Silas Goldberg and S.J. Bernstein, teamed up to help form the United Jewish Appeal on Long Island.

Among the congregation's other prominent rabbis over the years were David Blumenthal, who went on to head the Holocaust Memorial Project in New York, and Joseph Sternstein, who was later rabbi of Beth Sholom in Roslyn Heights and president of the Zionist Organization of America. In 1948, the congregation left its Orthodox leanings and affiliated with the United Synagogue of Conservative Judaism, of which it remains an active member.

In 1955, Tifereth Israel bought a fourteen-acre plot on Landing Road for construction of a new synagogue building. Three years later, the wing for the religious school was built, and in 1961, the entire new building was completed.

During the period from the late 1980s until the early 2000s, the congregation suffered a large drop in membership from its high of 450 families. In 2006, Rabbi Irwin Huberman, for whom the rabbinate is a

second career, arrived. Rabbi Huberman seems to have had quite a positive effect on the community, and the membership is again climbing. Tifereth Israel continues as a leader on social justice issues among Nassau County synagogues. Cantor Gustavo Gitlin, a native of Argentina, has developed a reputation for being not only a fine cantor but also the leader of a robust Bichor Cholom (visiting the sick) program.

NORTH COUNTRY REFORM TEMPLE, 86 Crescent Beach Road, Glen Cove, 11543 *R*

North Country Reform Temple was founded by a group of Glen Cove residents who were traveling to Temple Sinai in Roslyn for Reform services. At the suggestion of Rabbi Alvin Rubin of Temple Sinai, thirty-five of those families met in the home of Paul Ressler on December 5, 1955, and began a new Reform congregation.

Those who signed the contract establishing North Country Reform Temple were Lester Barth, Kalman Mackin, Herman Meltzer, Paul Ressler, Al Silver, Bernard Steinberg and Leon Sher. These seven men were joined by other charter members, including Robert and Dorothy Ficker Asch, George and Debbie Brown, Arthur and Rhoda Finer, Monroe Fink, Charles and Rae Litchman, Jerry and Bernice Levy, Jack and Norman Tayne, Sid and Adele Traus, Joe and Harriet Unger and Ray and Selmajean Zurer. Kalman Mackin served as the first president. Susan Cort served as the first female president, elected in 1978. The first Sisterhood president was Florence Cohen.

The following February, services were held at the Friends Academy on Duck Pond Road. About 100 families attended the first services led by Rabbi Daniel Davis and Cantor Albert Baum, who were sent by the Union for Reform Judaism to help the fledgling congregation. One month later, Rabbi Milton Schlager arrived and stayed until illness forced his early retirement in 1959. Rabbi Alton Winters arrived in 1959 and stayed for twelve years. Rabbi Morton Kaplan served from 1972 to 1974. In 1974, Lawrence Kotok was elected as rabbi and served for twenty-two years. In 1996, the congregation elected its first female rabbi, Dr. Janet B. Liss, who continues to serve today. On May 19, 1957, with the congregation now 120 members strong, work began immediately to convert the large house into a synagogue. In 1982, the synagogue's kitchen was undergoing renovation as part of a three-year project. On February 18, 1982, a fire raced through the building.

Nearby Congregation Tifereth Israel immediately offered the group a worship space. The religious school was housed by St. Paul's Episcopal Church on Highland Avenue. The office operated from a trailer parked behind the ruined building. On August 21, 1983, ground was broken for the current building, and the dedication was held on February 10, 1985. At that time, the congregation had 325 families. The congregation is also sometimes referred to as Congregation Ner Tamid and remains very strong and vibrant. The current student cantor is Alex Kurland.

GLEN HEAD

JEWISH CONGREGATION OF BROOKVILLE, 333 Glen Head Road, Glen Head, 11579 *R* (Closed)

This group merged with Oyster Bay Jewish Center to form Congregation L'dor V'dor in Oyster Bay's building. It never had an actual building and met in members' homes and an office building.

GREAT NECK

Great Neck is home to more than twenty "brick and mortar" synagogues and numerous minyanim. Although a Jewish presence goes back to 1892, the first organized congregation was Temple Beth El, a Reform temple that traces its roots back to 1928. Today, Great Neck has a large Orthodox community, with a large population of Iranian and Iraqi Jews.

BABYLONIAN JEWISH CENTER, 440 Great Neck Road, Great Neck, 11021 *O*

The Babylonian Jewish Center was formed by a group of Jews with Iraqi heritage in 1997. They completed their own building in 1998 and are led by Rabbi Nir Sholom and Cantor Jacob Bitton.

BEIT MIDRASH MESORAS MOSHE, 31 North Station Plaza, Great Neck, 11021 *O*

This small Orthodox congregation was incorporated on March 7, 1997.

CHABAD OF GREAT NECK, 400 East Shore Road, Great Neck, 11024 *O*

Chabad of Great Neck is a large Chabad center affiliated with Chabad of Long Island. In addition to services, the center offers a large children's religious school, adult education programs, women's programs and many social activities.

CHABAD OF LAKE SUCCESS, 2214 Lakeville Road, Great Neck, 11021 *O*

Chabad of Lake Success is an affiliate of Chabad of Long Island. The center is led by Rabbi Dovid and Mrs. Chumy Ezagni. The center offers Chabad's usual array of programs.

CHERRY LANE MINYAN, 16 Cherry Lane, Great Neck, 11024 *O*

This minyan is located on the Cherry Lane Campus of North Shore Hebrew Academy. The academy has three other campuses in Great Neck. This minyan dates to 1992.

CONGREGATION BETH ELIYAHU, 211 Middle Neck Road, Great Neck, 11021 *O*

This is a small Orthodox congregation.

CONGREGATION SHAARE TORAH, 813 Middle Neck Road, Great Neck, 11021 *O*

This synagogue was formerly at 695 Middle Neck Road. Its current location was previously a hardware store.

CONGREGATION SHIRA CHADASHA, 695 Middle Neck Road, Great Neck, 11021 *O*

This congregation originally met at 35 Station Plaza. Its building on Middle Neck Road was previously home to Congregation Shaare Torah. Shira

Chadasha totally remodeled the building, which includes a stained-glass dome. It is led by Rabbi Shlomo Shoub, a graduate of Ner Israel Rabbinical College of Baltimore.

GREAT NECK SYNAGOGUE, 28 Old Mill Road, Great Neck, 11023 *O*

The Great Neck Synagogue was founded in 1948. Great Neck's oldest Orthodox congregation started with a few members in a room above the old Squire Movie Theatre. High Holy Day services were held at the Veterans Memorial Hall on Great Neck Road. In 1950, the group moved to a small frame house on the site of the present building. Morris Tendler was the first rabbi. Rabbi Ephraim Wolf arrived as spiritual leader in 1954 and helped the congregation found the North Shore Hebrew Academy, a yeshiva school that was located within the synagogue. Today, North Shore Hebrew Academy educates almost one thousand children from preschool to high school on four different campuses in Great Neck. The middle school (grades six through eight) campus is on the grounds of the synagogue.

A new building on the site of the frame house was dedicated in September 1955. In 1991, the congregation purchased an additional four acres and built its current home, which was dedicated in 1967.

IRANIAN JEWISH CENTER (BETH HADASSAH SYNAGOGUE), 160 Steamboat Road, Great Neck, 11021 *O*

The Iranian Jewish Center is a Sephardic congregation in which most members are of Iranian descent. It was founded in 1979, with High Holy

Iranian Jewish Center (Beth Hadassah), Great Neck. *Courtesy of Special Collections Department, Hofstra University Library.*

Day services conducted at Great Neck Synagogue on Old Mill Road. It continued to rent from Great Neck Synagogue until 1983 and then rented from Temple Beth El from 1983 to 1985. It rented a movie theater on Middle Neck Road from 1985 to 1992, at which time it constructed its own building on the site of a former tennis court on Steamboat Road.

KOL YISRAEL ACHIM, 429 Middle Neck Road, Great Neck, 11021 *O*

Kol Yisrael Achim is a small Orthodox congregation led by the former rabbi of the Babylonian Jewish Center, Rabbi Alon. The congregation started when Rabbi Alon left the nearby Babylonian Jewish Center, which he led, over a disagreement on Kashrut. On the advice of his mentor, he started a new minyan group just down the street from the current location. According to Rabbi Alon, since its formation, Kol Yisrael Achim has produced thirty-one engaged and married couples, started a kollel and conducts daily services and social activities.

KOLLEL OHR HAEMET, 112 Steamboat Road, Great Neck, 11021 *O*

Kollel Ohr Haemet, an Orthodox congregation, was founded in 1996. The founding rabbi and spiritual mentor is Eliezer Ben-David, who now lives in Israel. Rabbi Daniel Shaileshbno is the current rabbi and executive director. The Rosh Chavurah is Rabbi Simcha Sperling. Other instructing rabbis are Rabbi Menashe Kalatizadeh, Rabbi Ben Kaniel and Rabbi Yitzchak Malka.

The congregation holds three morning minyanim and two evening minyanim daily. Mrs. Avigail Shaileshbno offers classes for women twice a week. Fourteen Torah scholars call this kollel home. (A kollel is a study center for Jewish scholars.) Besides the rigorous studying these men do every day, they make themselves available to members of the community as teachers. They also have a youth program for their yeshiva students.

LAKE SUCCESS JEWISH CENTER, 354 Lakeville Road, Great Neck, 11020 *C*

Lake Success Jewish Center was founded in 1960 by a group of forty-five families desiring a Conservative congregation in their neighborhood. It was originally known as the North Shore Jewish Center. In 1964, the group

purchased a house and land on Lakeville Road (the former Wander Estate). In 1966, Rabbi Seymour Baumrind was hired. The group renovated the huge home and used it for a synagogue and Hebrew school until it completed a new building on the same grounds in 1975. It had received two additional acres of land from the State of New York when a small portion of its ground was annexed for construction of the Northern State Parkway.

The new building has two unique features. Its eastern wall was built to resemble the Kotel, or Western Wall, and the Holy Ark was designed to resemble the portable ark the Jews carried with them during their forty years in the desert. The membership peaked at 300 families in 1983. In 1985, the membership was 285. Today, it is a level 250 families, providing a strong base for this United Synagogue of Conservative Judaism–affiliated congregation. The rabbi is Michael Klayman, and the cantor is Shmully Biesofsky.

NORTH SHORE SEPHARDIC SYNAGOGUE, 130 Cutter Mill Road, Great Neck, 11021 *O*

The North Shore Sephardic Synagogue was founded in 1968 as a Sephardic minyan within the Great Neck Synagogue. It opened its building in 1993 and has magnificent stained-glass windows.

OHR ESTHER/YOUNG MASHADI JEWISH CENTER, 130 Steamboat Road, Great Neck, 11021 *O*

This is a small Orthodox congregation.

RECONSTRUCTIONIST SYNAGOGUE OF GREAT Neck, 2 Park Circle, Great Neck, 11021 *REC* (Closed)

This group met for a few years in the 1980s.

SHAARE SHALOM (THE MASHADI JEWISH CENTER), 54 Steamboat Road, Great Neck, 11024 *O*

This Orthodox synagogue opened circa 1998.

SHAARE ZION OF GREAT NECK, 225 Middle Neck Road, Great Neck, 11021 *O*

Shaare Zion is a small Orthodox congregation.

TEMPLE BETH EL, 5 Old Mill Road, Great Neck, 11021 *R*

Temple Beth El was the first synagogue in Great Neck, founded in 1928. Originally, the congregation met at the Community House and the All Saints Church. Since it was the only synagogue in Great Neck at the time, Reform, Conservative and even Orthodox Jews attended, but they were to adopt Reform ritual and affiliate with the Union for Reform Judaism. At the time of its formation, the Reform movement did not use cantors. A Beth El member, Maurice Spear, with his own money, hired a cantor to satisfy the more traditional tastes of some of the members. Rabbi Jacob Rubin served the congregation for forty-one years, from 1935 to 1976. Today, Rabbis Meir and Tara Feldman, husband and wife, are the co-senior rabbis. Rabbi Elle Muhlbaum is associate rabbi. The cantor is Vladimir Lapin. Jerome Davidson is Rabbi Emeritus, and Lisa Hest was recently named Cantor Emerita.

The building was completed in September 1932. A second synagogue, designed by Armand Bartos, was dedicated in 1970. Numerous renovations and additions have been necessary over the years, as the membership today is at its all-time high, 750 families.

TEMPLE EMANU EL, 150 Hicks Lane, Great Neck, 11024 *R*

Temple Emanu El was established in 1953 and was formally incorporated on January 25, 1954. In October 1954, the group purchased a six-acre property and converted the Main House into a sanctuary. In May 1958, it broke ground for the present building, which was consecrated on April 17, 1959. Dr. Robert S. Widom has been rabbi since 1969. Rabbi Ronnie Kehati is associate rabbi.

TEMPLE ISAIAH OF GREAT NECK, 1 Chelsea Place, Great Neck, 11021 *R*

Temple Isaiah of Great Neck was founded in 1967 at 35 Bond Street. Worship took place at the Community Church of Great Neck at 2-A

Stoner Avenue for more than forty years. Rabbi Judith Lewis served the congregation from 1983 to 1985. She later was rabbi of the Riverdale Temple in the Bronx and at Temple Israel in Manhattan. Rabbi Bonnie Steinberg, who previously was the Hillel director at Hofstra University, led the congregation in the 1990s.

In September 2008, the congregation opened its new building on Chelsea Place. Rabbi Theodore Tsurouka, a Jew by Choice, leads the congregation along with Cantor Leslie Friedlander.

TEMPLE ISRAEL OF GREAT NECK, 108 Old Mill Road, Great Neck, 11021 *C*

Temple Israel was formed in 1941 by ten families who wanted a Conservative synagogue in Great Neck. They purchased a home at 10 Preston and converted it to a synagogue, classrooms and an office. During 1947, the group broke ground for a new building on the two-and-a-half-acre plot it had purchased on Old Mill Road. The building opened for Rosh Hashanah services in 1949.

Rabbi Mordecai Waxman arrived in August 1947, starting more than fifty years of service. Rabbi Waxman and his wife, Ruth, devoted countless hours to building and shaping Temple Israel according to the vision of Rabbi Solomon Schechter. It became one of the cornerstone congregations of the United Synagogue of Conservative Judaism. The Waxmans were joined by Cantor Benjamin Siegel, who served with distinction from 1950 until retiring in 1984.

Today, the congregation has a membership of over seven hundred families. They are led by Senior Rabbi Howard A. Stecker, Associate Rabbi Daniel Schweber and Cantor Raphael Frieder. Rabbi Amy Roth is director of Congregational Schools, Ms. Rachel Mathless is nursery school director and the Hebrew high school is led by Mr. David Mishkin. Mr. Leon J. Silverberg serves as executive director.

TORAH OHR HEBREW ACADEMY/SHUL, 575 Middle Neck Road, Great Neck, 11021 *O*

Torah Ohr Hebrew Academy and Shul offers minyanim at least three times daily from morning services to Avrit. Morning minyanim are followed by breakfast and Torah learning. The congregation offers separate

youth programs for boys and girls. The girls' program is unique, as most Orthodox congregations do not develop serious youth programs for girls.

The senior rabbi is Avraham Kohan. He is assisted by two associates, Eli Livian and Yoni Chamani. The women lecturers are Ms. Amit Yaghoubi and Ms. Orah Goykadosh.

Torah Va'danesh Congregation, 575 Middle Neck Road, Great Neck, 11021 *O*

This is a small, Sephardic Orthodox congregation meeting at Torah Ohr Academy.

Young Israel of Great Neck, 236 Middle Neck Road, Great Neck, 11021 *O*

Young Israel of Great Neck was founded in 1974 by 6 local Orthodox families. By 1990, the group had 140 families under the leadership of Rabbi Yaacov Lerner and erected a building. It has been added on to and modernized several times since.

Children of members attend the nearby North Shore Hebrew Academy. The synagogue sponsors an adult education program and a full supplementary youth program. Today, the congregation has grown to 250 families.

Greenport

Congregation Tifereth Israel, 519 4th Street, Greenport, 11944

Tifereth Israel of Greenport is one of Long Island's oldest continuously operating synagogues. The mid- to late 1800s forged America's "melting pot," welcoming immigrants from Ireland, Germany, Italy, Poland, Lithuania and Russia. Beginning in the 1800s, more than 2 million of these hopeful pilgrims were eastern European Jews. Most remained in the cities, where the bright colors of the American Dream often faded under grinding gray poverty. Some were determined to find a better way. Many headed west, but a few came east, to rural Long Island.

Those hardy souls struck out along the roads and railroad tracks of Long Island, peddling such items as needles and thread, ribbons and combs.

Eventually, they found a spot to their liking and settled down. One of those places was Greenport. There is no precise record of when the first Jewish immigrants came to Greenport, but it is known that several Jewish families lived here before 1880. The family names were Kaplan, Merzbach, Appelt, Sandman, Smith and Jaeger. Apparently, there were no organized services—no congregation, no synagogue, no home services.

Between 1880 and 1890, several more Jewish families arrived in Greenport and went into various business ventures. When that trend continued into the century's last decade, the time was right for area Jews to begin gathering for worship.

The first service was held on Rosh Hashanah of 1892 in the home of Louis Kobre. Later, regular services were held in the home of Fanny Levine. In 1900, a small group of men assembled in the home of Nathan Goldin to organize the Jewish families of Greenport into a formal congregation.

Left: Tifereth Israel historical marker, Greenport. *Photograph by Alan Garmise.*

Below: Sign welcoming you to Tifereth Israel, Greenport. *Photograph by Alan Garmise.*

Holy Ark (Aron Kodesh), Tifereth Israel, Greenport. *Photograph by Alan Garmise.*

Samuel Levine, in a history of the first fifty years of Temple Tifereth Israel, wrote that "their assets were mainly faith, as they were certainly poor in world possessions."

The groundwork now laid, the new congregation started the task of building the temple. Minutes of the congregation's second meeting note that the "committee that was appointed to select a site reported there is a lot on 4th Street, 50' x 150' and that the asking price is $200, but [they] will try and get it a little cheaper." Finally, a different site, where the Temple stands today, was selected. The parcel was purchased from J. Madison Wells for $300.

The original building contained the sanctuary with a balcony for female congregants, a small kitchen and a mikvah and a classroom. The mikvah is now covered by the reconstruction of the bathroom facilities that took place in 2001, but relics from it were salvaged and are now on display in the lobby area. The formal dedication of the building was held on January 11, 1904, conducted by Rabbi Spiegel of New York City.

An addition was made in 1964 enlarging the kitchen and adding a reception room. In 1968, the congregation purchased the house across the street as living quarters for the rabbi and his family.

In 2000 and 2001, Congregation Tifereth Israel completed an extension on the south side of the social hall to provide classroom space for the Hebrew School, modern washrooms, an office and additional worship space for the High Holy Days. The dedication of this new facility was on July 8, 2001.

In 2003, the congregation withstood a year of trouble. Its rabbi, Rabbi Gary Moskowitz, had a vision of transforming Greenport into a new Catskills and enlarging the synagogue. He wanted to attract Jewish tourists for weekend getaways, play host to retreats for other congregations and lure Jewish singles as well. Quarrels ensued over spending, community activities and the proper uses of the synagogue. The congregation finally changed the locks on the building, and Rabbi Moskowitz was asked to leave. Moskowitz now lives in Queens and runs a "wellness" synagogue out of his home. Today, the rejuvenated congregation is led by an exciting young rabbi, Gadi Capela. The congregation is a longtime affiliate of the United Synagogue of Conservative Judaism and is vibrant.

HAUPPAUGE

TEMPLE BETH CHAI, 870 Townline Road, Hauppague 11788 *C*

Temple Beth Chai is a small, egalitarian Conservative synagogue affiliated with the United Synagogue of Conservative Judaism. The group originally met at the Hauppague Animal Hospital at 521 Townline Road. The current building was opened in 1972. Rabbi Rhonda Nebel leads the congregation.

HEMPSTEAD

CHABAD OF HOFSTRA UNIVERSITY, 100 Courtenay Road, Hempstead, New York, 11550 *O*

Chabad of Hofstra University is affiliated with Chabad of Long Island and serves not only the large campus of more than twenty thousand students at Hofstra University but the surrounding area as well. Rabbi Shmuel Lieberman leads the center along with his wife, Chavie.

CONGREGATION BETH ISRAEL, 141 Hilton Avenue, Hempstead, New York, 11550 *C*

By the turn of the century, there was a handful of Jewish storekeepers in the village of Hempstead. Among the earliest settlers was Barnett Salke,

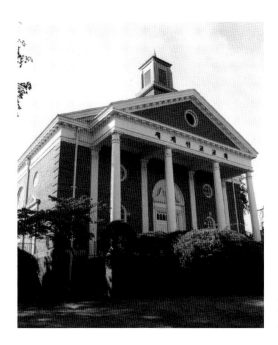

Former Congregation Beth Israel, Hempstead, now a Korean church. *Courtesy of Special Collections Department, Hofstra University Library.*

who had moved to the community during the Civil War. It wasn't until 1901 that Adolph Rosenthal brought them together in Rockville Centre to discuss starting a congregation. That initial attempt failed because of an inability to round up the necessary minyan.

The desire to establish a synagogue still burned in the hearts of many of the Jews of Hempstead, and they continued to try to organize a congregation. In 1908, the first minyan was formed, and a charter authorizing the formation of a congregation was brought from New York City so that High Holy Days services could begin that year.

Services were held at various spots in Hempstead during the months that followed. Among the sites were the Old Liberty Hall at the corner of Front and Liberty Streets, a site over Louis Cohen's department store on Main Street, one in the Odd Fellow's Hall, one in the Utawanna Hall and even a spot in the old Hempstead Bank building. Some regulars at these services traveled from Rockville Centre and Freeport.

In 1910, Minnie Morrison and her sister started a Sunday school to provide religious instruction to children. Later, a paid teacher was hired who traveled to Hempstead each week from Manhattan.

As more persons became involved in the minyan and the Jewish community continued to expand, talk increased about formally establishing a synagogue. Several of the wives even organized a Sisterhood before the

congregation was formally organized. That happened in 1914, when the Hempstead Hebrew Congregation was formally incorporated and a plot of land for the erection of a synagogue was bought on Center Street. Louis Cohen became the group's first president, and his wife was elected first president of the Sisterhood.

It wasn't until 1919 that enough money was raised for the groundbreaking. The construction took three years to complete, and at its dedication, the congregation was renamed Congregation Beth Israel. In 1930, an annex was built to house four classrooms.

The congregation grew to a membership of four hundred families, with an active Sisterhood and Men's Club. Rabbi Harry Schwartz led the congregation from 1933 until his retirement in 1968. The religious school thrived, and the congregation became a dynamic force in the community under the rabbi.

The expanding congregation soon outgrew its synagogue building, and in October 1944, a fundraising dinner was held to raise money for the purchase of the Onderdonk property on West Fulton Street. A groundbreaking ceremony was held on March 21, 1947, and Harry Wolff, a former president who had chaired the expansion of the Center Street building, oversaw construction of the new building.

In the spring of 1948, the congregation bought the Allaire property adjoining its newly acquired site on Fulton Avenue for use as a temporary school building and later as a community house.

Dedication of the new synagogue, whose sanctuary could comfortably seat seven hundred, was held on March 26, 1950. The focal point of the sanctuary was the Aron Kodesh (Holy Ark), which was moved from the Center Street building.

Several years later, a new three-story building was added to the synagogue, as well as a large social hall/ballroom. The completed new building was the most imposing synagogue on Long Island at the time. Membership peaked at 625 families in 1963, with congregants coming from all nearby communities. The congregation was an affiliate of the United Synagogue of Conservative Judaism, but today it operates as an independent, egalitarian Conservative synagogue.

The 1970s witnessed a change in the demographics of the area. Some neighboring communities now had their own congregations, and Hempstead itself was attracting fewer and fewer Jewish families. Membership in 1975 fell to about 170 families, and the large building was sold to the Korean Methodist Church.

Current home of Congregation Beth Israel, Hempstead. *Image by author.*

Under the leadership of Rabbi Morton Gross, the congregation bought a private home at 141 Hilton Avenue and remodeled the living room into a sanctuary This new home was just the right size for the new membership numbers. Later, a disastrous fire ran through the remodeled synagogue. It has been completely rebuilt and today is led by Rabbi Michael Eisenstein. The numbers may be smaller, but the enthusiasm remains high.

CONGREGATION DERECH YOSHER (also known as Beth Sholom) *O* (Closed)

A few newspaper references in the period from 1930 to 1943 are all the information I could find on this group.

HEWLETT

AHAVAT YISROEL (YOUNG ISRAEL) CONGREGATION, 1 Piedmont Avenue, Hewlett, New York, 11557 *O*

Ahavat Yisroel Congregation was founded in 1985 by twenty-five families seeking a traditional Orthodox form of worship. They named Rabbi Abraham Mandelbaum as their spiritual leader. First, services were held in private homes, but soon they moved to a building of their own at 1742 Union Avenue. The congregation is an affiliate of the Union of Orthodox Congregations. The congregation has since moved to a larger, more modern building at 1 Piedmont Avenue.

CHABAD OF HEWLETT, 44 Everit Avenue, Hewlett, 11557 *O*

This is an affiliate of Chabad of Long Island, offering daily minyanim and adult and children's educational programs.

CONGREGATION BETH EMETH, 36 Franklin Avenue, Hewlett, 11557, *REC* (Closed)

Beth Emeth was founded in June 1953 as the Hewlett Temple, a Conservative congregation. The Franklin Avenue building opened in 1960. In 1994, a close vote changed the congregation's affiliation to the Reconstructionist movement. In 2012, the building was sold, and the congregation moved to Rockville Centre and rented space from Central Synagogue on DeMott Avenue. In 2016, the two congregations merged, forming Beth Emeth–Central Synagogue at 430 DeMott Avenue, Rockville Centre.

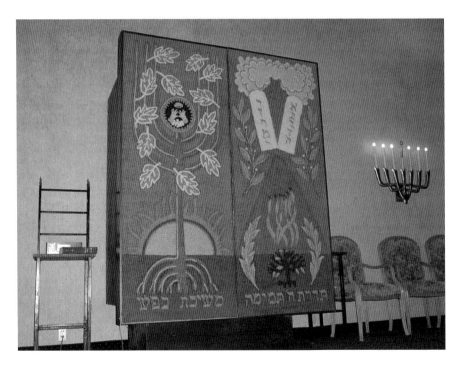

Holy Ark of the original Congregation Beth Emeth, Hewlett, now in Rockville Centre. *Courtesy of Rabbi Elliot Skidell.*

HEWLETT–EAST ROCKAWAY JEWISH CENTER

See the "East Rockaway" section.

TORAH CHAIM CONGREGATION, 1170 William Street, Hewlett, New York, 11557 *O*

Torah Chaim Congregation is a small, traditional Orthodox synagogue located within the Toras Chaim Yeshiva.

HICKSVILLE

CONGREGATION SHAARE ZEDEK, 16 New South Road, Hicksville, New York, 11801 *O* (Closed)

Congregation Shaare Zedek was an Orthodox congregation dating back to the late 1920s. It constructed its first building in 1930 at 80 East Barclay Street. The second synagogue was built in 1964 on New South Road. The congregation closed in 1999, and the building became the Jewish Heritage Society headquarters. The building is currently vacant.

Image of early Congregation Shaare Zedek, Hicksville. *Courtesy of Hicksville Public Library.*

Image of later home of Congregation Shaare Zedek, Hicksville. *Courtesy of Hicksville Public Library.*

HICKSVILLE JEWISH CENTER, Jerusalem Avenue and Maglie Drive, Hicksville, New York, 11801 *C* (Closed)

Hicksville Jewish Center was founded by fifty families in 1955. It was a Conservative synagogue affiliated with the United Synagogue of Conservative Judaism. The building it occupied on Jerusalem Avenue was completed in 1958. In 1965, a social hall and permanent sanctuary were added.

The peak membership was 190 families in 1965. The spiritual leader through the 1980s and 1990s was Rabbi Joseph Grossman. Unfortunately,

Former Hicksville Jewish Center. *Courtesy of Hicksville Public Library.*

the congregation, like many others, shrank when Jewish families moved away; it was forced to merge with the Plainview Jewish Center in 1997. The building now houses a Pentecostal church.

HUNTINGTON

CHABAD OF HUNTINGTON VILLAGE, 23 Fairview Street, Huntington, 11743 *O*

This Chabad of Long Island affiliate was formerly located at 5 Briarwood Drive.

CHABAD—YOUNG ISRAEL OF HUNTINGTON, 598 Park Avenue, Huntington, New York, 11743 *O*

Young Israel of Huntington is affiliated with Chabad of Long Island and is under the direction of Rabbi and Mrs. Adelman. The synagogue was founded by four Huntington families. They joined with others to commit to building an Orthodox synagogue in Huntington. Today, they offer services, adult and children's activities and a women's program.

HUNTINGTON JEWISH CENTER, 510 Park Avenue, Huntington, New York, 11743 *C*

This congregation was originally known as the Huntington Hebrew Congregation and was incorporated on March 6, 1907, as Orthodox. The land for its first synagogue was purchased in January 1913, and the cornerstone was placed on July 20, 1913, at what is now 11-A Church Street. The building opened on September 28 in time for Rosh Hashanah. There were fifty members. The second synagogue was designed by the architectural firm of Ungarlleder & Schlanger at the corner of Nassau and Woodhill Roads. Ground was broken on April 16, 1933, and the cornerstone was placed on September 10, 1933. The formal dedication was held on November 26, 1939. The current and third building on Park Avenue was started on April 19, 1959, and was ready for Shabbat on April 21, 1961. The formal dedication took place on May 17, 1962.

Huntington Jewish Center is led by Rabbi David Barnett. The cantor is Israel Gordon, the executive director is Ilene Brown and Maxine

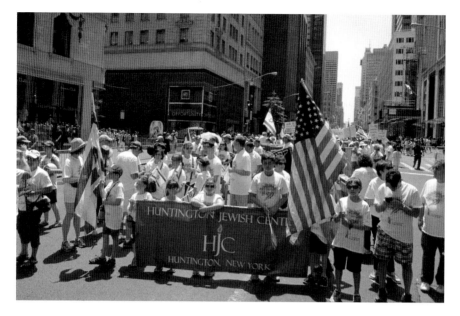

Members of Huntington Jewish Center marching in the Israel Independence Day Parade, New York City, 2016. *Couresty of Huntington Jewish Center.*

Fisher is the religious school director. Rabbi Neil Kurshan is Rabbi Emeritus. The synagogue is a longtime affiliate of the United Synagogue of Conservative Judaism.

TEMPLE BETH EL, 660 Park Avenue, Huntington, New York, 11743 *R*

Temple Beth El is a congregation of more than four hundred families following Reform ritual and is affiliated with the Union for Reform Judaism. Rabbi Jeff Clopper is the spiritual leader, and the cantor is Alison Lopatin. The temple welcomes all who are interested in praying and learning more about Judaism. The membership includes traditional and non-traditional lifestyles, interfaith families and LGBT and multicultural individuals and groups.

The first meeting was held on August 26, 1952. The first Friday night service was two weeks later in the American Legion Hall on Mill Sam Road. Services continued there for about a year and then moved to the Old First Church on East Main Street, starting with Rosh Hashanah of 1953. The current building was dedicated on December 4, 1955, and was designed by the architectural firm of Scheiner & Swit.

WEST HILLS TORAH CENTER, 352 West Hills Road, Huntington, New York, 11743 *O*

The West Hills Torah Center is affiliated with Chabad of Long Island and is a traditional Chabad-Lubavitcher Orthodox congregation.

INWOOD

BAIS TEFILLAH OF INWOOD, 433 Dougherty Boulevard, Inwood, 11096 *O*

Bais Tefillah is a traditional Orthodox congregation under the leadership of Rabbi Pinchus Weinberger. It is situated within the Far Rockaway–Lawrence Eruv. The congregation is aimed at young traditional families and offers not only services but also learning and social opportunities for adults and children.

INWOOD JEWISH CENTER, 44 Bayswater Boulevard, Inwood, 11096 *O*

Also known as Congregation Beth Hadar, this congregation was founded in 1952. The original location was a former home on Sheridan Boulevard donated by the Peninsula National Bank. The current location was dedicated on September 7, 1958. On September 5, 2011, a horrific fire destroyed much of the building.

ISLAND PARK

SOUTH SHORE JEWISH CENTER, 191 Long Beach Road, Island Park, 11558 *C*

The South Shore Jewish Center represents the 2011 merger of Island Park Jewish Center and East End Synagogue (Beth Sholom) of Long Beach. The congregation was founded in 1950, and the current building opened in 1952. An addition was built in 1959. The addition is no longer needed and is rented to the Harvest on the Atlantic Church. The group also includes some members of the former Ocean Harbor (Oceanside) Jewish Center, which is also now closed. Rabbi Paul Hoffman is the spiritual leader.

JERICHO

JERICHO JEWISH CENTER, 430 North Broadway, Jericho, 11753 *C*

Jericho Jewish Center was founded in 1954 and initially used a farmhouse as a synagogue. The current building was constructed in 1960 and has since been added to and renovated several times. The congregation is an affiliate of the United Synagogue of Conservative Judaism. Membership peaked during the tenure of Rabbi Stanley Steinhardt in 1973 with 650 families. Membership today is leveled at about 325. The rabbi is Ben Herman, with Marvin Richardson as Rabbi Emeritus.

Jericho Jewish Center, Jericho. *Photograph by Mark Friedman.*

TEMPLE OR ELOHIM, 18 Tobie Lane, Jericho, 11753 *R*

Or Elohim is a Reform congregation affiliated with the Union for Reform Judaism. Bringing Reform Judaism to the Jericho community, where few of the residents were raised in Reform families, proved no simple task, after a handful of residents first broached the subject in January 1957.

With the help of the New York Federation of Reform Synagogues, a planning meeting that was attended by twenty-three families was held at

the Seaman School on March 19, 1957. Charles Morgenstern was elected president pro tem after a resolution was passed establishing a Reform congregation. At the next meeting on April 11, fifty congregants and potential congregants gathered at the home of Otto Babik and voted to name their congregation Or Elohim (Light of God).

The following month, the first official meeting of the congregation was held in a model home in East Birchwood. A constitution was adopted, and Morgenstern was elected the first president.

The most difficult problem facing the group was where to locate its building. When community opposition killed plans to locate in the model home, Friday evening services were initially held in the homes of members, and High Holy Day services that year were held in an empty store in the Birchwood Shopping Center.

For six weeks, services were held in the East Norwich Wesleyan Methodist Church before space could be rented in an office building near the Jericho railroad station. That site proved to be poor, as the noise from the trains made services impossible. For the next two years, the congregants returned to the practice of holding services in the homes of members and, later, in a vacant store in the Mid-Island Shopping Plaza. Finally, a temporary home was found at the Jericho Country Club, which is now the site of the Manors at Jericho.

The group next zeroed in on a permanent home on Route 106 near the Jericho Cider Mill. When the Muttontown Zoning Board announced that

Temple Or Elohim, Jericho. *Photograph by Mark Friedman.*

it would fight those plans in court, the plans were set aside. The search for a home finally ended on March 16, 1960, when a contract for the purchase of 3.65 acres on Tobie Lane was signed. This time, the plans sailed through the local zoning board. On August 28, 1960, the cornerstone of a modest building was set in place.

After a few years, it became apparent that for the congregation to grow, additional space would be needed. This meant that a large addition would have to be built, and it was dedicated on December 17, 1965. To this date, Or Elohim remains a strong and vibrant congregation of several hundred families with a Hebrew school, a Brotherhood and a Sisterhood. Rabbi Harvey Abramovitz and Cantor David A. Katz lead the congregation. It is a member of the Union for Reform Judaism.

KINGS PARK

KINGS PARK JEWISH CENTER, 94 East Main Street, Kings Park, 11754 *C*

The Kings Park Jewish Brotherhood, spearheaded by members of the Patiky family, was organized in 1904. The first synagogue was built on Patiky Street, a few feet away from the home of Elias Patiky, circa 1907. That building burned down in a fire on May 28, 1962, and the group relocated to 18 Patiky Street. Construction began on the present synagogue on East Main Street in 1964, and the name was changed to Kings Park Jewish Center. This synagogue is affiliated with the United Synagogue of Conservative Judaism. The new building was formally dedicated in early 1967. The congregation is led by Rabbi Abe Rabinovitch.

LAKE GROVE

CHABAD OF LAKE GROVE (CHABAD AT STONY BROOK UNIVERSITY), 821 Hawkins Avenue, Lake Grove, 11755 *O*

Chabad of Lake Grove was dedicated on September 17, 1989, in the building that formerly housed the Ronkonkoma Jewish Center in the Lake Grove section that was previously known as Lake Ronkonkoma. The center is affiliated with Chabad of Long Island and is led by Rabbi Chaim Grossman. His wife, Mrs. Revie Grossman, leads the preschool and the

Hebrew school. Rabbi Adam and Mrs. Esther Stein are on the staff to coordinate activities at the nearby State University of New York–Stony Brook. Rabbi Shalom Bar Cohen leads the adult education program, and Mrs. Charnie Cohen, Rabbi Motti Grossman, Mrs. Chava Grossman and Mrs. Rivka Itzhaky fill out the professional staff.

LAKE RONKONKOMA

RONKONKOMA JEWISH CENTER, 821 Hawkins Avenue, Lake Ronkonkoma, 11755 *C* (Closed)

The Ronkonkoma Jewish Center was formed in 1955, with initial services held at Liberty Hall on Ocean Avenue. Later, the group met in a vacant store on the corner of Hawkins and Railroad Avenues. The land at 821 Hawkins Avenue was purchased on July 28, 1956. Groundbreaking was held on May 20, 1962, and the building was dedicated in early 1963. The congregation was an affiliate of the United Synagogue of Conservative Judaism. The congregation disbanded in 1988, and the building was transferred to Chabad of Lake Grove.

LAWRENCE

BAIS MIDRASH HARBORVIEW/BAIS PINCHAS, 214 Harborview South, Lawrence, 11559 *O*

No information is available.

BAIS MIDRASH HERSCHEL DAVID, 215 Central Avenue, Lawrence, 11559 *O*

No information is available.

BOSTONER BAIS MIDRASH, 1109 Doughty Boulevard, Lawrence, 11559 *O*

Bostoner Bais Midrash of Lawrence was founded in 1992 by Rabbi Yaakov Horowitz, son of the Bostoner Rebbe in Boro Park, Brooklyn. The synagogue

is known for innovation and has introduced such programs as a father-and-son learning program, choir activities, Purim costume competitions and late-night minyanim.

CONGREGATION BAIS MIDRASH HARAV, 3 Beechwood Drive, Lawrence, 11559 *O*

No information is available.

CONGREGATION BETH ABRAHAM, 2 Rockaway Turnpike, Lawrence, 11559 *O*

Beth Abraham is a small traditional Orthodox congregation.

CONGREGATION SHAARE TEFILAH, 25 Central Avenue, Lawrence, New York, 11559 *O*

This is one of Long Island's oldest Orthodox congregations, even though its roots were in Far Rockaway, Queens, a few miles away. Its history can be traced to 1909, when a group of sixteen men gathered in the home of Max Rubin to discuss organizational plans. The first sermon preached to the congregation was by Rabbi Mordechai Kaplan, founder of the Reconstructionist movement, who was largely responsible for helping Shaare Tefilah get off the ground. Rabbi Perera Mended of the Spanish and Portuguese Synagogue in Manhattan also preached regularly to the congregation. All activities were held in various rented quarters.

The first spiritual leader was Benjamin Lichter. He had been serving as rabbi at the Touro Synagogue in Newport, Rhode Island, America's oldest synagogue. He arrived just before Rosh Hashanah of 1910. In 1914, an active building fund appeal took shape, and the group incorporated under the name Congregation Gates of Prayer of Far Rockaway. During the same year, an afternoon Hebrew school was established in the Willet Building on the corner of Mott and Central Avenues in Far Rockaway. A proposal was made to construct a new building following the plan of New York's Spanish and Portuguese Synagogue, which permitted each worshiper to view his neighbor, but men and women were kept separate. This proposal was adopted by all.

The cornerstone for the congregation's building was laid on July 21, 1915. Rabbi Kaplan was the keynote speaker. The building was ready for Rosh Hashanah that year. So many wanted to attend those first services that an overflow service was held at Esenberg's Hotel in Wave Crest.

In 1925, an additional building was erected for expanded educational, social and administrative functions. The new building included a gymnasium and four bowling alleys. It was dedicated on March 25.

In the late 1940s, full-scale renovations and the building of an addition were accomplished. A few years later, other modernizations took place, and the new building was formally dedicated in the spring of 1961.

On Friday morning, January 3, 1969, disaster struck. A fire raced through and destroyed the synagogue building. All the Torahs were carried to safety, the last one by Emanuel Lasser, who attended the morning minyan that day. Just after he raced out of the burning building, the roof caved in (see images on pages 54 and 55).

Word of the catastrophe spread throughout the community, and by that evening, more than one thousand persons had jammed the center building for a special Sabbath service. Rabbi Walter Wurzburger, who became the congregation's spiritual leader two years earlier, told the worshipers that the synagogue would be rebuilt, adding that it was said of the "Temple of old that it was destroyed by fire and it will be rebuilt by fire."

But as plans were made to rebuild, leaders recognized that it would make sense to relocate, as most members no longer lived in Far Rockaway. A vote of the membership agreed that a new location in Lawrence should be sought.

A committee launched a fundraising drive and within four months amassed $1 million. For the next six years, the congregation met with obstacle after obstacle, from neighbors and the zoning committee of Lawrence, to obtain the necessary village permits for its new building. A building permit was finally issued on November 18, 1976, and construction began at 25 Central Avenue in Lawrence.

The outer shell of the new synagogue was completed and enclosed on September 24, 1978, and on March 16, 1980, the building was dedicated with a ceremony that included a procession from the old to the new building. In the ceremony, the Torahs were paraded along Central Avenue to the accompaniment of a band. More than one thousand people participated.

In 1993, the congregation reported a membership of more than three hundred families. Today, the rabbi is Uri Orliam. There is no religious school, as most of the children attend nearby Jewish Yeshivot or Jewish day schools.

K'HAL ZICHRON MEIR MOSHE, 250 Longwood Crossing (Carriage House), Lawrence, 11559 *O*

No information is available.

TEMPLE BETH SHOLOM, 390 Broadway, Lawrence, 11559 *O*

Beth Sholom was founded in 1928 as Congregation Derech Yosher (the Way of Righteousness). When it was first established, the communities of Lawrence and Cedarhurst were marked by large estates, swamplands and few concentrations of homes. The Jewish population was small, and consequently, membership was small.

The congregation's first meeting took place in a store on Central Avenue. Regular meetings were often canceled due to lack of a quorum. During the Great Depression, in 1929, the congregants stuck together and managed to buy a house for use as a synagogue. When it was found to be too small, another house was purchased at 131 Washington Avenue. This building at the corner of Mary Lane was to be the congregational home for the next twenty years. It later housed Temple Sinai and now is home to a yeshiva.

Soon, the congregation began to grow in membership, and it was decided to expand the building. A new wing was added to the rear of

Congregation Beth Sholom, Lawrence. *Courtesy of Jewish Heritage Society of the Five Towns.*

the building to house a new sanctuary. The older wing was converted to classrooms, an office and a social hall.

During the 1930s, the population of the Five Towns grew, and Jews with more diverse backgrounds began moving in. To attract them, the congregation modified its traditional Orthodox service to include sermons in English and congregational singing. At this time, the name was changed to Congregation Beth Sholom.

During the early 1940s, membership climbed, and for the third time in fifteen years, the group had outgrown its building. The congregation bought a tract of land at 390 Broadway and in 1944 launched a building fund. Groundbreaking for the new synagogue was in 1949, and on September 17, 1950, the dedication ceremony was held under the new rabbi, Gilbert Klaperman. A few days later, the new building was used for High Holy Day services. Although the walls were still rough, the seats were temporary, the floors dusty and not yet sanded, few noticed because of the sheer jubilation of the event.

It was under Rabbi Klaperman that many significant events took place to help the Orthodox community in the entire Five Towns area. He helped establish a Vaad Hakashrut to provide rabbinic supervision for kosher establishments. In addition, he helped establish an eruv in 1973. He also was behind the Hillel school, the first Jewish day school on Long Island. The congregation remains a large, vital Orthodox congregation to this day.

TEMPLE ISRAEL, 140 Central Avenue, Lawrence, 11559 *R*

Temple Israel was founded in 1908 and was then known as Temple Israel of Far Rockaway. Members originally met in rented quarters. A temple was then built at the corner of Roanoke and State Streets in Far Rockaway. It was a lovely, white, colonial-style building that is still standing and is now occupied by another Jewish congregation. It is today known in the area as "the White Shul."

The present building of Temple Israel was dedicated in 1930, at which time the name Temple Israel of Lawrence was adopted. It was designed by S. Brian Baylinson, an award-winning architect. A member of the New York Historical Buildings Committee, he created a sanctuary for Temple Israel that is acknowledged as one of the most distinguished worship centers in the country.

In 1948, as part of the fortieth-anniversary celebration, a school center was created to better serve the needs of a large and expanding religious school. The center was officially dedicated in 1950.

In 1966, following a major fundraising campaign, a larger religious school and new social facilities were added. The nursery school has a gymnasium and two outdoor in-ground swimming pools.

Temple Israel is affiliated with the Union for Reform Judaism. The spiritual leader is Rabbi Jay Rosenbaum, and the cantor is Galena Paliy.

TEMPLE SINAI OF LONG ISLAND, 131 Washington Avenue, Lawrence, 11559
O (Closed)

Temple Sinai, a Reform Congregation that was affiliated with the Union for Reform Judaism, was founded in 1951 by about twenty families wishing to break away from Temple Israel. They initially moved into a converted private home that had been used by Congregation Beth Sholom, a neighboring Orthodox congregation. By 1967, they had grown to more than three hundred families and had outgrown their quarters. In 1970, the old building was razed, and a larger simple brick building was erected in its place. Rabbi Leon Adler served the congregation in its founding year. Rabbi Abram Goodman came to its pulpit in 1952 and served until 1968, when he retired and was elected Rabbi Emeritus.

In 1968, Temple Sinai was hit by controversy when its rabbi, Morris Siegel, authored a book that some congregants thought was funny but most viewed as inappropriate. In 1971, he was asked to leave, and more than one hundred families left to protest his ouster.

The following year, Rabbi Stet was hired, and during his fifteen years of leadership, membership doubled. By the time he moved on in 1986, it had climbed to 452 families. Because the building was not meant for so many people, some services were overcrowded. Rabbi Robert Rozenberg was hired shortly after Rabbi Stet left. As time passed, membership dropped due to the increasing Orthodox and decreasing Reform population, and Temple Sinai merged with Temple Emanu El of Lynbrook to form Temple Am Echad. The building is now Mesivta Ateres Yaakov, a yeshiva high school.

YESHIVA YOR YOSHUV, 1 Cedarhurst Avenue, Lawrence, 11559 *O*

Yeshiva Yor Yoshuv began in 1967 as a vision. It is now a renowned yeshiva and a Jewish community. The rosh haYeshiva (principal) is Rabbi Naftali Jaeger. The yeshiva is a school as well as a place for religious services.

YOUNG ISRAEL OF LAWRENCE AND CEDARHURST, 8 Spruce Street, Cedarhurst, 11516 *O*

See listing under "Cedarhurst" section.

LEVITTOWN

ISRAEL COMMUNITY CENTER OF LEVITTOWN, 3235 Hempstead Turnpike, Levittown, 11756 *C* (Closed)

The Israel Community Center, better known as "ICC of Levittown," became a concept when William Levitt built the community of Levittown. He deeded three parcels of land for ninety-nine years for the use and construction of religious institutions. At the time, several Jewish families gathered to discuss

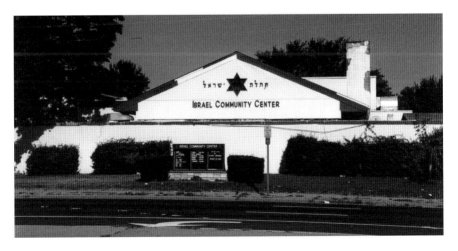

Former Israel Community Center, Levittown, demolished and replaced with medical offices. *Courtesy of Special Collections Department, Hofstra University Library.*

finding a place to hold religious services. From that meeting in 1948, the congregation was established.

Initially, the synagogue consisted of only two rooms, a sanctuary and a small social hall. The Holy Ark was donated by Temple Bnai Sholom of Rockville Centre from its building on Windsor Avenue, which had just been demolished after the congregation moved to a new larger building. The final part of the building was the school wing, which included a large wooden Star of David on the ceiling. Almost all the work on the building was done by congregants; tradesmen were only used for special services.

Over time, the demographics of Levittown changed dramatically. In January 2000, the remaining congregants merged with the Farmingdale-Wantagh Jewish Center in Wantagh to form Congregation Beth Tikvah. The former ICC was a constituent of the United Synagogue of Conservative Judaism, as is Beth Tikvah.

Temple Beth Avodah, 890 Carman Avenue, Levittown, 11756 *R* (Closed)

Originally known as Levittown Reform Temple, this group was organized at a meeting held on October 26, 1950. It was chartered by the Union for Reform Judaism on February 2, 1951, as the 426th URJ congregation. Meetings were held at Gardiners Avenue School until the end of 1951, when the local school board forbade religious groups from using the public schools. The congregation then met at Levittown Community Church on Periwinkle Road. The synagogue was built at 890 Carman Avenue in 1954.

In 1974, changing demographics forced the small membership to merge with Community Reform Temple in Westbury. The building was later used by the Nassau County Probation Department and is now vacant.

Lindenhurst

Congregation Neta Tzarchea, address unknown, *O* (Closed)

This is believed to be the first functioning synagogue group on Long Island, founded in 1876. It probably was originally a "Chevra Kadisha," or burial society. Unfortunately, a search has found no other information.

LINDENHURST HEBREW CONGREGATION, 235 North 4th Street, Lindenhurst, New York, 11757 *C* (Closed)

The Lindenhurst Hebrew Congregation was organized in 1903. The first meeting of interested men took place in the Barasch Building at the southwest corner of Hoffman Avenue and South 1st Street to organize a society to be known as the Lindenhurst Congregation.

Informal preliminary discussions were begun on October 26, 1913, and on the same day, pledges totaling $200 inaugurated a building fund drive. George Barasch was elected temporary president.

A legal certificate of incorporation was executed under the date of December 17, 1913, and the fifteen trustees whose names appear on the paper included their desire to associate themselves "for divine worship and instruction in the Jewish Religion and Hebrew Language."

The zealous interest and cooperative effort of this group ensured the success of its religious organization. An earlier attempt by another generation had failed to develop, although incorporation papers were filed. That was many years earlier. It was a congregation that was named Congregation Neta Tzarchea.

Through the years, the local Jewish people, although without a house of worship, met frequently for services in private homes. The religious fervor of the generation brought the early dream of a synagogue to realization.

Land was acquired on North 4th Street, and on June 20, 1915, formal exercises accompanied the laying of the cornerstone. More than three hundred people were in attendance. On August 29, 1915, contractor George Weirder completed the building, and it was ready for formal dedication. The first rabbi, B. Diamond, presided.

The concrete synagogue dedicated that day was to stand for thirty-three years. In 1948, it was razed to build a modern home for the rabbi. The congregation erected a more modern building in stages from 1931 to 1934 south of the old building.

In 1993, the rabbi was Howard Levine. In 2005, the congregation, an affiliate of the United Synagogue of Conservative Judaism, closed and merged with Temple Beth El of nearby Massapequa Park due to declining numbers.

TEMPLE BETH AM, 12 West John Street, Lindenhurst, 11757 *R* (Closed)

This congregation was formed in mid-1960s. Very little documentation of its history remains. A newspaper article from April 10, 1969, mentioned that it was a part of the South Shore Association of Temples. The building later housed the Evangel Church of God. At the time this book went to press, the building was for sale.

Former Temple Beth Am, Lindenhurst, later a church and now vacant. *Author's collection.*

LONG BEACH (ATLANTIC BEACH AND LIDO BEACH)

Long Beach is a changing city. Originally founded as a summer resort on the Atlantic Ocean, Long Beach has always been a refuge for city dwellers during the summer. The city has a long boardwalk, hotels and a long beachfront of white sand. In 1960, Long Beach had several kosher hotels, many of which hosted important conventions of organizations that required kosher food, as well as many Orthodox weddings where people were required to stay for the Sheva Brachas.

Long Beach also had many thriving synagogues—Reform, Conservative and Orthodox. There was a significant year-round Jewish population, mostly

merchants and professionals. The population swelled during the summer months as Jewish residents of the five boroughs of New York flocked to this resort. In the early 1960s, demographic changes were happening. Many of the homes previously rented only during the summer were now being rented out all year at a lower price. The city became more transient, with a significant year-round lower-middle class and working-class rental base. These changes have caused several synagogues, including Long Beach's only Conservative synagogue, to close.

At the same time, the Orthodox population of Long Beach has slowly grown. The arrival of a Chabad rabbi and rebbetzin, along with several other charismatic modern Orthodox rabbis and rebbetzin, has attracted many new, younger Orthodox families. Long Beach now has plenty of Orthodox synagogues and a proper eruv.

Is Long Beach to become another Cedarhurst? Probably not, but it is again becoming a center of Orthodox Judaism in Nassau County.

BACH JEWISH CENTER, 210 Edwards Boulevard, Long Beach, 11561 *O*

Bachurei Chemed (BACH) Jewish Center is an independent congregation serving residents of Long Beach and Island Park. Founded in 1946 by Simon Solomon, the BACH is motivated by a profound love for every Jew, with an innovative array of educational and outreach programs, as well as spiritual, religious and social services, to serve Jews from all walks of life.

Bachurei Chemed, which means "Selected Youth," epitomizes what the organization represents. Its mandate is to serve all Jews with a personalized Jewish experience, regardless of background, belief or level of commitment. BACH has always been unique, as young people often design and lead the services. Cantor Michael Sherman of Florida grew up in Long Beach and remembers his family "being active members of the Conservative congregation," but he also remembers the "thrill of the youth leading the services at BACH."

CHABAD OF THE BEACHES, 10 Franklin Boulevard, Suite 100, Long Beach, 11561 *O*

Chabad of the Beaches is affiliated with Chabad of Long Island.

JEWISH CENTER OF ATLANTIC BEACH, 100 Nassau Avenue, Atlantic Beach, 11509 *O*

The Jewish Center of Atlantic Beach is an active modern Orthodox congregation serving residents of Long Beach, Atlantic Beach and the nearby Five Towns. It was founded in 1949 by a group of five summer residents who met at the home of Henry Etra. In August 1953, they moved into their own building on Nassau Avenue and adopted the name Temple Israel.

The building, a converted private house, was enlarged in September 1968, with the addition of a social hall, a vestibule, a rabbi's study, a library, a dairy kitchen and a series of stained-glass windows. Two of the windows were installed in the lobby and depict the religious and material dimensions of Judaism. Another fourteen windows, erected in the sanctuary, illustrated fourteen significant events in the life of the Jewish people.

By 1986, the synagogue had changed its name to the Jewish Center of Atlantic Beach and moved to Park Street and Nassau Avenue. Its 1988 membership was 250 families. Rabbi Sol Roth, the congregation's first rabbi, retired after twenty years of service, and the congregation called Dr. Basil Herring to the pulpit. The synagogue is the only house of worship in the village of Atlantic Beach and hosts twice daily services and many social events.

LIDO BEACH SYNAGOGUE, 1 Fairway Road, Long Beach, 11561 *O*

Lido Beach Synagogue is a modern Orthodox synagogue, both traditional and halachic, situated just east of Long Beach. The synagogue has both summer and year-round members. It was founded in 1967. Rabbi and Rebbetzin Rappaport lead the synagogue.

MESIVTA OF LONG BEACH, 205 West Beach Street, Long Beach, 11561 *O*

Mesivta of Long Beach is a traditional Orthodox school under Rabbi Fagelstock. Daily services are held on the premises.

SEPHARDIC CONGREGATION OF LONG BEACH, 161 Lafayette Boulevard, Long Beach, 11561 *O*

The Sephardic Congregation of Long Beach was founded in 1943, making it the oldest Sephardic congregation on Long Island. The building was completed in 1953. Rabbi Asher Abittan guided the congregation for more than half a century. Since his passing in 2006, Rebbetzin Ida, as well as his children and grandchildren and students, continue his legacy. The synagogue is also known as Congregation Bnai Asher.

The congregation is currently being led by Rabbi Abittan's students, Rabbi David Bibi and Rabbi Michael Wagner, in association with Rabbis Meyer and Chaim Abittan. Outreach programming and children's services are organized under the leadership of Rabbi Yosef Kolish and resident scholars Rabbi Aharon Siegel and Rabbi Baruch Abittan.

TEMPLE BETH EL, 570 West Walnut Street, Long Beach, 11561 *O* (Closed)

Temple Beth El was founded in 1928. The first building was constructed that same year at 270 Lindell Boulevard. The current building was opened in 1964. These Orthodox citizens also helped found the Hebrew Academy of Long Beach and an eruv for the community. The congregation reached 350 families in 1968, but membership started to fall soon thereafter. The building was last used for religious purposes in the late 1970s, but the congregation remained as owner of the building, then used as a bingo hall and senior citizens' center. In 2013, the remaining congregants sold the building to be used as a private residence.

TEMPLE BETH SHOLOM, 325 Roosevelt Boulevard, Long Beach, 11561 *C* (Closed)

Temple Beth Sholom, also known as the East End Synagogue, was Long Beach's only Conservative synagogue. With only about seventy families remaining, Beth Sholom merged with the Island Park Jewish Center to form South Shore Jewish Center in 2013. Cantor Howard Mendelsohn served here for many years, and the street next to the former building is now known as Mendelsohn Way.

Beth Sholom was founded in 1951. The building was completed in 1953. Rabbi Amos Miller became the congregation's spiritual leader later that same year. The congregational membership rose to a high of more than five hundred families from 1976 to 1986. Beth Sholom sponsored a religious school, Sisterhood, Men's Club and an active youth program, and it had a full social calendar. It was a constituent of the United Synagogue of Conservative Judaism.

TEMPLE EMANU EL, 455 Neptune Boulevard, Long Beach, 11561 *R*

On Shavuot, in May 1945, the first service was held at the Hotel Ilya on West Broadway under the direction of Sylvia and Sam Schoenfeld, who were the original organizers of the only Reform temple in Long Beach.

The last temporary home was the Masonic Temple on West Walnut Street. Rabbi Gabriel Shulman was the first spiritual leader, volunteering his services part time. The religious school started with eighty students under a volunteer staff including the principal, Herbert Jacobs.

Rabbi Bernard Kligfeld became the rabbi in August 1950 and remained so for thirty-two years. In September 1951, ground was broken for the building on Neptune Avenue. In 1955, Cantor Richard Button began a twenty-year tenure with the congregation.

Cantor Bruce Malin followed Cantor Button for three years. Bette Cohen followed. In 1993, Rabbi Haskell Bennett assumed the pulpit. On July 1, 2013, Lisa Kinger-Kantor became the cantor. The current rabbi, Ellie Shemtov, assumed the pulpit on July 1, 2014.

TEMPLE ISRAEL, 305 Riverside Boulevard, Long Beach, 11561 *O*

In June 1920, a group of men began to dream of a suitable house of worship to take care of the religious needs of the Jewish people of Long Beach. Two homes were used for services that summer, while the Nassau Hotel served as a synagogue for the High Holy Days.

Soon after, Congregation Temple Israel of Long Beach was chartered by the State of New York, and a building fund was started. In 1922, the congregation purchased five lots at the corner of Walnut Street and Riverside Boulevard. Construction was soon underway. In 1923, services were held in the sanctuary for the first time.

Temple Israel, the first synagogue in Long Beach, was dedicated on August 31, 1924. That winter, Rabbi Morris M. Goldberg was called to officiate at a Bar Mitzvah at Temple Israel and said, "History has proven that Judaism can grow and still live. It is not a closed and finished product. It is the principle that has inspired us to build the beautiful edifice. It is here we shall learn that Judaism is not only a religion of the past. It is a living, cultural and spiritual combination of language, literature, history, customs and social institutions which must be brought to the hearts of our men, women and children…particularly the children."

The congregation asked Rabbi Goldberg to continue as its spiritual leader and teacher. He reorganized the Hebrew and religious schools, which consisted of daily and Sunday sessions. Within three years, there was a need for a separate building to house the school. The foundation was laid in the summer of 1929. The Talmud Torah Building was dedicated on August 24, 1930. Cantor Aaron Caplow chanted the dedicatory prayers.

As the community and congregation grew, there was need for a facility to accommodate the growing congregation. Thus, the third building, the Rose and Irving H. Engel Center, was dedicated in 1966.

TEMPLE ZION, 62 Maryland Avenue, Long Beach, 11561 *O*

Temple Zion, also known as the Jewish Center of Long Beach and Atlantic Beach, was founded in the summer of 1946 to provide an Orthodox synagogue for the residents of the West End of Long Beach and Atlantic Beach. They immediately raised a $25,000 building fund.

The temple was dedicated on August 22, 1948. Judge Saul Price, a summer resident at that time, made the principal address at the dedication service. The cornerstone was laid, and brief remarks were also given by Rabbi Solomon Goldfarb of neighboring Temple Israel and Rabbi Kimmel of Temple Beth El. The traditional Orthodox congregation remains on Maryland Avenue to this day.

YOUNG ISRAEL OF LONG BEACH, 120 Long Beach Road, Long Beach, 11561 *O*

This is a traditional Young Israel orthodox congregation led by Rabbi Waslack. The congregation moved from 158 Long Beach Boulevard.

LYNBROOK

CONGREGATION BETH DAVID, 188 Vincent Avenue, Lynbrook, 11563 *C* (Closed)

Congregation Beth David was a Conservative congregation affiliated with the United Synagogue of Conservative Judaism. On March 4, 2011, the group merged with Temple Bnai Sholom of Rockville Centre to form Congregation Bnai Sholom–Beth David in the Rockville Centre Building. The Lynbrook Building was sold to the Kingdom Ambassadors Global Ministries Church. Beth David's Rabbi Howard Diamond was elected to lead the combined group.

On March 21, 1924, the House of David of Lynbrook was incorporated as Lynbrook's second Jewish community group. For the next four years, it operated from a one-room building on Vincent Avenue. By August 1928, the congregation had built a two-story synagogue facility in front of the former building.

Within the next decade, the Jewish population of Lynbrook increased, and many new families joined. In 1938, the synagogue bought an additional piece of land and built an addition to house its school.

In 1950, increased membership prompted yet another expansion of the facilities. This time, the congregation used the property to its south and built the first floor of a new school building. One of the rooms was used for a daily chapel. A kitchen was included, as well as a vestry and foyer.

The next expansion took place in 1957, when a second floor was added to the new building to house a rabbi's study, a library and a permanent daily chapel. Air conditioning was also installed in 1957. The last expansion in 1966 included a new, larger sanctuary and ballroom along Denton Avenue. The old sanctuary was redesigned into a large youth room.

The peak membership was 505 families in 1972. The membership had fallen to 250 by 1986. At the time of the merger with Rockville Centre, the membership was below 175.

TEMPLE AM ECHAD, 5 Saperstein Plaza, Lynbrook, 11563 *R*

Temple Am Echad represents the 2008 merger of Temple Emanu El of Lynbrook and Temple Sinai of Lawrence. The congregation is in the building that formerly housed Emanu El. The congregation was formed on

October 20, 1920, as the Hebrew Educational Alliance. The synagogue was built on its current site in 1924 and in 1927 changed its name to Emanu El of Lynbrook.

Although some Jews settled in Lynbrook around the turn of the century, it wasn't until after World War I that any sizable number began to move in. When that happened, twenty families met on October 20, 1920, and formed the Hebrew Educational Alliance to provide a Jewish education for their children.

Classes were held in storefronts, lofts, private homes and firehouses before enough money was raised to buy the land on Lyon Place that houses Temple Am Echad's present building. In 1924, a modest building was erected on the site. Initially, the building was used as a Jewish community center, and a rabbi was hired to conduct services on holidays and special occasions.

Three years later, members decided to reorganize as a religious institution following the philosophy of Reform Judaism. The name Emanu El was adopted, and the building was redesigned to allow pews to be installed. The pews were purchased from Temple Emanu El in Manhattan, which was starting on a new building.

The social and educational functions were conducted in small rooms off the balcony. The Depression struck at the financial viability of the congregation hard, even though the group had slowly been increasing in size. When the congregation's rabbi died in 1933, synagogue historians reported that the synagogue was "at the lowest ebb of its fortunes."

Later that year, Rabbi Harold I. Saperstein was hired to serve as spiritual leader, a post he held for forty-seven years until his retirement in 1980. Gradually, membership grew. By 1940, there was an expanded religious school and a wide variety of youth activities, and it was clear that more space was needed. As a result, a community center, auditorium and classrooms were built adjacent to the synagogue.

During World War II, Rabbi Saperstein took a leave of absence to serve as a military chaplain. More than one hundred members of the congregation served during the war.

After the war, Rabbi Saperstein returned, and membership boomed as returning servicemen moved to the suburbs. Again the congregation increased its facilities to accommodate more members. Even with this expansion, the larger membership proved the facilities inadequate. Even at a normal Friday night service, the sanctuary was filled.

To make room for the even larger congregation, the original building and a private house next door were demolished. A new sanctuary and auditorium

were dedicated in 1958, A second floor was also added to the school wing to provide more classroom space, and the old auditorium was redesigned for use as a youth and activity center. At its peak in 1960, the congregation had a membership of over 800 families and over 1,000 students in its religious school. By 1980, the membership had dropped back to 735 families, with 253 students. At the time of Rabbi Saperstein's retirement in 1980, the Village of Lynbrook renamed the street where the building is located in his honor. Rabbi Stuart M. Geller was hired in 1980. This congregation is extremely active in the Union for Reform Judaism and is one of the most vibrant Reform groups on Long Island. The congregation has always provided leadership for the Long Island Jewish community. The current rabbi is Sandra M. Bellush, and the cantor is Jeffrey Korobow.

MALVERNE

MALVERNE JEWISH CENTER, 1 Norwood Avenue, Malverne, 11565 *C*

Malverne Jewish Center is an independent Conservative congregation that was at one time an affiliate of the United Synagogue of Conservative Judaism. Rabbi Susan Elkodsi is the spiritual leader.

Until its founding 1950, Jewish families in Malverne prayed in Lynbrook or Rockville Centre. Those who wanted to walk to synagogue found it a long haul, and a group met to form Malverne Jewish Center. Services were first held at the American Legion Hall in Valley Stream. High Holy Days were observed at the St. Thomas Episcopal Church in Malverne.

After the congregation affirmed its desire to affiliate with the Conservative movement in 1955, construction began on a new building on Norwood Avenue

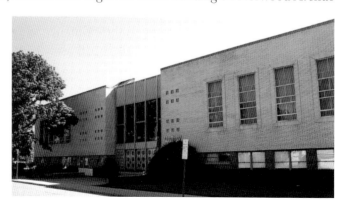

Malverne Jewish Center, Malverne. *Courtesy of Special Collections Department, Hofstra University Library.*

that was completed in 1960. Rabbi Samuel Chiel was elected rabbi in 1955. Membership peaked at 450 families in 1964. Rabbi Theodore Steinberg was appointed in 1968. In 1973, the congregation closed its Hebrew school and started sending its children to the JCC of West Hempstead.

Faced with a building too big for a congregation of its size, Malverne Jewish Center sold its building to Bridge Church of the Nazarene in 2010 and has a ten-year lease to operate out of a small portion of the building.

MANHASSET

TEMPLE JUDEA, 333 Searingtown Road, Manhasset, 11030 *R*

Temple Judea of Manhasset has a rich and vibrant history as a large Reform congregation on the North Shore of Nassau County. Temple Judea began in 1955 with seventy-five charter families. The first meetings were held in a local hall in Manhasset, and the first High Holy Day services were held in a local church. On May 22, 1960, Temple Judea dedicated a modest building at 333 Searingtown Road to be the permanent site of the synagogue. Yet, as the membership grew quickly, so did the need for the facility to expand. In April 1968, the Louis A. Perez Library and Youth Lounge were dedicated. Then, in May 1970, the Sisterhood School Wing was dedicated. In May 1978, the Sisterhood Office/Sophia Hammer Study was also dedicated. The exquisite Holy Ark Tapestry was added to Temple Judea in May 1980. In 1994, the Holocaust Resource Center was dedicated as a unique memorial to those who perished as well as those who survived the darkest period of Jewish history.

In 2016, Temple Judea had a membership of more than four hundred families. In July 2006, Temple Judea welcomed Rabbi Todd Chizner as its third rabbi in fifty years. Rabbi Chizner, a Long Island native, graduated from SUNY–Stony Brook in 1992 with a bachelor's degree in psychology. In 1999, he was ordained as a rabbi by the Hebrew Union College–JIR in New York. Following ordination, Rabbi Chizner served as associate rabbi of Temple Beth Torah in Melville, Long Island, for seven years. He then accepted Temple Judea's invitation to assume the pulpit in Manhasset. Previous rabbis were the late Rabbi Abner L. Bergman and the late Rabbi Eugene Lipsey.

Cantor Abbe Shor arrived in 2005. She followed Cantor Richard Berman, who served the congregation for more than forty-four years.

MASSAPEQUA AND MASSAPEQUA PARK

CHABAD OF SOUTH BAY, LONG ISLAND, 4725 Merrick Road, Massapequa Park, New York, 11762 *O*

Chabad of South Bay is an affiliate of Chabad of Long Island and is led by Rabbi Yona Edelkopf. The center offers all traditional Chabad services, including education and outreach. A former location was 25 Park Boulevard.

HILLEL HEBREW ACADEMY AND SYNAGOGUE, 1066 Hicksville Road, Massapequa, 11762 *O* (Closed)

Construction began circa 1962, and this synagogue was granted tax-exempt status by the Internal Revenue Service in August 1966. U.S. Congressman Steve Israel was a congregant and observed his Bar Mitzvah here in 1971. It was closed circa 1991.

TEMPLE BETH EL, 99 Jerusalem Avenue, Massapequa, 11758 *C* (Closed)

As demographics were changing, and the quest for spiritual fulfillment was rising, one United Synagogue of Conservative Judaism–affiliated synagogue was in the midst of its own search for enlightenment. Congregation Beth El of Massapequa took a good hard look at itself in an effort to become a "regional synagogue that will attract Jews looking for something different," according to its president.

The fifty-five-year-old congregation, once home to almost 500 families, had been grappling with a diminishing observant local Jewish community for many years. Now with only a 160-family membership, even after absorbing the former Lindenhurst Hebrew Congregation several years ago, the congregation vetoed a merger with Wantagh Jewish Center, itself the result of the mergers of Wantagh Jewish Center, Farmingdale Jewish Center and the Israel Community Center of Levittown.

"Beth El has always been a trend-setter among Conservative congregations on Long Island," said the synagogue president. "We were the first traditional Conservative synagogue to become fully egalitarian; we have the only kosher food pantry on Long Island; and our members just did not want to lose our uniqueness and innovative spirit to an unknown larger quantity."

Next, the congregation tried to reinvent itself, becoming a one-clergy synagogue, regrettably letting its cantor of eighteen years go. In June 2016, the congregation finally decided that it was facing a losing battle with demographics and decided to merge with Bellmore Jewish Center to form Congregation Beth Ohr at the home of the former Bellmore Jewish Center.

TEMPLE JUDEA OF MASSAPEQUA, 98 Jerusalem Avenue, Massapequa, 11758 *R* (Closed)

Temple Judea was founded in 1952 as Massapequa Jewish Center. Services were held in the Massapequa Community Methodist Church. In June 2007, the members of Temple Judea of Massapequa voted to merge with Suburban Temple of Wantagh to form Temple Bnai Torah, located at 2900 Jerusalem Avenue in Wantagh. The building is now occupied by the Center Point Church.

TEMPLE SINAI, 270 Clocks Boulevard, Massapequa, 11758 *R*

Temple Sinai is a small Reform congregation founded in 1958 by twenty families. It is the only remaining old synagogue in Massapequa. The Chabad center has only been in Massapequa since 2010. The temple originally held services in the Massapequa firehouse, a Presbyterian church and, later, in a small rented building that was the former home of Congregation Beth Sholom of Amityville and the Massapequas, a Conservative congregation that had closed. On December 15, 1963, the current building was dedicated. The current membership of slightly more than one hundred families is led by Rabbi Janise Poticha, Cantor Jeff Warschaver and school principal Lynn Rudin.

YOUNG ISRAEL OF MASSAPEQUA, 1100 Hicksville Road, Massapequa, 11762 *O*

A small Young Israel congregation. No other information is available.

Mastic Beach

Mastic Beach Hebrew Center, 218 Neighborhood Road, Mastic Beach, 11951 *R*

Mastic Beach Hebrew Center is also known as Congregation Bnai Sholom. The congregation was founded in 1937 in a private home. The first building was constructed on land donated by the *New York Evening Post*. It was a thirty-four- by twenty-foot frame and shingle structure dedicated on August 25, 1940. The building was torn down and replaced with the current larger structure. Dr. Harris Cohen, a cantor, is the spiritual leader.

Melville

Chabad of Huntington and Melville, 498 Sweet Hollow Road, Melville, 11747 *O*

Chabad of Huntington and Melville is one of New York's most unorthodox Orthodox synagogues—a popular center for Jews of all backgrounds who want to learn more about their Jewish roots. The group is an affiliate of Chabad of Long Island. Chabad offers a wide variety of educational and spiritual opportunities, including Torah classes and lectures, Shabbaton dinners and an array of family and social activities. Traditional Jewish values are brought to life in a joyous, non-judgmental atmosphere.

The congregation is under the direction of Rabbi Asher Vaisfiche, a warm, caring and energetic individual who formed the congregation in 1991. The rabbi's approach is that Torah must be presented and experienced in a modern, relevant context made available to every individual on their own level. Rabbi Vaisfiche and his wife, Miriam, are emissaries of the Lubavitcher Rebbe, Rabbi Menachem M. Schneerson. The group is an affiliate of Chabad of Long Island.

The services are traditional and are conducted in a joyous, casual atmosphere typical of Chabad centers. An important part of this community is the weekly Kiddush luncheons that follow Shabbat morning services. There friendships are created and nurtured, and the group celebrates happy occasions such as Bar Mitzvahs and anniversaries. Chabad of Huntington and Melville welcomed all during 2016, its twenty-fifth-anniversary year.

SOUTH HUNTINGTON JEWISH CENTER, 2600 New York Avenue, Melville, 11747 *C*

The genesis of the South Huntington Jewish Center occurred in 1960 at a meeting in the home of a founder. A storefront on Route 110 across from what is now the Waldbaum's Shopping Center served as the first shul. The first services were held there for an original group of fifty families, as well as classes for their children. The first High Holy Day services took place at the Sweet Hollow Presbyterian Church on Old Country Road. In 1962, the land on which today's synagogue stands was obtained with the help of Ruby Wagner and Leon Lazer. A groundbreaking was held, and many local dignitaries helped to dedicate the synagogue. After several interim rabbis, the synagogue hired the late Rabbi Morris Shapiro, a respected Talmudic scholar who stayed with the synagogue for twenty-three years.

After three expansions, the synagogue, an affiliate of the United Synagogue of Conservative Judaism, has expanded to almost five hundred members. The current leadership includes Rabbi Ian Jacknis, Hazaan Brian Shamash, Principal Ellen Marcus and Executive Director Joyce Ashkenazy.

TEMPLE BETH TORAH, 35 Bagatelle Road, Melville, 11747 *R*

In early 1969, Jay and Barbara Morris, a young couple residing in South Huntington, recognized the need for a Reform temple to service the growing Jewish community in the southern portion of Huntington. They brought together like-minded residents, approached the Union of American Hebrew Congregations (now the URJ) for advice in forming a new congregation, secured the King of Kings Church for an initial community meeting and set the ball rolling. The first public meeting was held in April 1969. At the end of the meeting, forty families signed on as "charter members." Immediately, committees of volunteers were formed to pick a name, write a constitution, plan for religious services, organize a school program and work on membership development. These efforts led to a congregation that reached one hundred families on the eve of its first worship service. The service was on Erev Rosh Hashanah and was held in the auditorium of the Suffolk Development Center (later known as the Greens).

The fledgling congregation was led by a student rabbi during the first year, Rabbi Earl Vinokur. He was invited to stay on as a full-time rabbi after

his graduation, but he elected to accept a pulpit in South Africa. Rabbi Jerrold Levy was the first full-time rabbi at Temple Beth Torah. He served for two years and was followed by Rabbis S. Howard Schwartz.

During the first two years, weekly religious services were held only on Friday evenings in the King of Kings Lutheran Church on Old South Path. The religious school also met there, usually on Shabbat mornings so as not to conflict with King of Kings' need for the building on Sundays. Reverend James Sorenson was a true friend to Temple Beth Torah, and its existence today can be traced, in large part, to his cooperative efforts. The use of King of Kings continued, on a gradually diminishing basis, until the first phase of Beth Torah's building was completed.

In the third year of the congregation's existence, it purchased a one-family house on Carman Road and converted it to classroom space and a small sanctuary. When larger assemblies of worshipers were expected, like holidays and Bnai Mitvot, services were held at King of Kings. Shabbat morning services were only held on Bnai Mitzvoth occasions.

The congregation soon outgrew its "little house" and in 1974 purchased land on Bagatelle Road, beginning construction on phase one of the current building. Since the original building was completed in 1976, the temple has grown to 750 families. The building has since been expanded several times. The senior rabbi is Rabbi Susie Moskowitz. Rabbi Rachel Weissenberg is rabbi-educator. Cantor Serene Applaud and Rabbi Emeritus Marc Gellman round out the clergy.

MERRICK AND SOUTH MERRICK

CHABAD OF MERRICK, 2174 Hewlett Avenue, Suite 101, Merrick, 11566 *O*

Chabad of Merrick is under the leadership of Rabbi Shimon Kramer and is affiliated with Chabad of Long Island. This center emphasizes education and children's activities.

CONGREGATION OHEV SHALOM, 145 South Merrick Avenue, Merrick, 11566 *O*

Ohev Shalom is a modern Orthodox congregation that was formed in April 1962 by six local families in a rented storefront on Merrick Avenue.

They were former members of the Merrick Jewish Center, a Conservative congregation, who desired a more Orthodox ritual approach. Initially, Yeshiva University sent a student rabbi each Shabbat. Six months after its founding, the now twelve families engaged Rabbi Jeremiah Wohlberg to be their spiritual leader. In 1964, the group purchased a private home and converted it to a synagogue.

The bedrooms were used for classrooms and meetings, and the dining room was redesigned into a one-hundred-seat sanctuary. To accommodate larger crowds on the High Holy Days, a tent was erected in the backyard.

Soon it was apparent that a larger building was needed, and by 1966, when the congregation had grown to more than one hundred families, the first wing of a new building was completed. The entire building was completed and dedicated in 1971.

By 1984, the group, now more than four hundred families strong, had begun an effort to erect an eruv in the hope of attracting more members. It was not easy because of all the canals in this community. The congregation was successful and has continued to thrive. The current rabbi is Ira Ebbin.

MERRICK JEWISH CENTER, 225 Fox Boulevard, Merrick, 11566 *C*

Merrick Jewish Center, sometimes called Congregation Ohr Torah, is a Conservative synagogue affiliated with the United Synagogue of Conservative Judaism. The congregation was founded in 1925 and met in members' homes. Early High Holy Day services were held in the Merrick Hook and Ladder Fire Company Hall. In April 1936, it built its first building on Fox Boulevard.

Seventeen years later, in 1953, new construction began under architects Scheiner & Swit, the designers of several Long Island synagogues. The congregation absorbed by merger Rochdale Village Jewish Center, which was in Queens County at 167–10 137th Avenue, Jamaica.

Today, Merrick Jewish Center is one of the largest Conservative congregations in Nassau County and has an active Men's Club, Sisterhood, Hebrew school and youth and adult activities, as well as inspiring services under the leadership of Rabbis Charles Klein and David Tilles and Cantor Javier Smolarz.

TEMPLE BETH AM, REFORM JEWISH CONGREGATION OF MERRICK AND BELLMORE, 2377 Merrick Avenue, Merrick, 11566 *R*

This group's first service was December 1, 1950, at the Empire Fire Hall on Merrick Avenue. The next move was to Oakwood Avenue Fire Hall in 1952. On December 17, 1954, the first services were held in the current building, which has been enlarged and modernized several times.

In 2011, the group merged with Congregation Shaarei Shalom of Bellmore. The Bellmore building was sold, and all activities were moved to the Merrick Avenue location. Both Ben Cohen and Jerry Greenfield, founders of the Ben & Jerry's ice cream company, attended Hebrew school here and were Bnai Mitvah in the '60s. Rabbi Ronald Brown is the spiritual leader. Rabbi Mickey Baum is the associate rabbi. Daniel Rosenfeld is the cantor.

TEMPLE ISRAEL OF MERRICK, 107 South Hewlett Avenue, Merrick, 11566 *O*

This small Orthodox congregation was formed in 1987. One year later, it purchased a private home and converted it for use as its present synagogue under Rabbi and Rebbetzin Volk.

TEMPLE ISRAEL OF SOUTH MERRICK, 2655 Clubhouse Road, Merrick, 11566 *C*

Temple Israel of South Merrick was founded by seven families in 1963. Six months later, they were thirty and held services in a rented storefront in the Holiday Park Shopping Center. In 1965, the present building was constructed on Clubhouse Road. The congregation is an affiliate of the United Synagogue of Conservative Judaism.

MINEOLA

CONGREGATION BETH SHOLOM, 261 Willis Avenue, Mineola, 11501 *C*

Beth Sholom was founded by ten families in 1910 as Mineola Jewish Center. The synagogue was built in 1931 at a cost of $60,000. It reached its peak membership of close to four hundred families in 1955. The spiritual leader

was Rabbi Simon Feld, and the congregation was an affiliate of the United Synagogue of Conservative Judaism. In 1990, the congregation decided to disband due to changing demographics, and Rabbi Anchelle Perl and Chabad of Long Island agreed to take over maintenance and operation of the building as a synagogue and Jewish learning center.

CONGREGATION BETH SHOLOM CHABAD, 261 Willis Avenue, Mineola, 11501 *O*

In 1990, Congregation Beth Sholom, a conservative synagogue, was in a dire situation. From a high of almost four hundred families, changing demographics had dropped its membership to under thirty.

Rabbi Anchelle Perl and Chabad of Long Island offered to take over maintenance and operation of the synagogue under the name Congregation Beth Sholom Chabad. It has slowly become an important Chabad center offering services and children's and adult education programs, and it is truly the center of Jewish life in Mineola. The rabbi and the congregation are also extremely active in civic and charitable affairs.

MOUNT SINAI

Signpost welcoming worshipers to Temple Beth Emeth, Mount Sinai. *Courtesy of Beth Emeth.*

TEMPLE BETH EMETH, 52 Mount Sinai Avenue, Mount Sinai, 11766 *R*

Temple Beth Emeth is a Reform congregation under the leadership of Rabbi Helayne Shalhevit and Cantor Lisa Ann Green. The group was founded in 1986 and built its current building a few years later.

NESCONSET

JEWISH WITHOUT WALLS (JWOW) (Beth Finger, founder, beth@ jewishwithoutwalls.org) *Unaffiliated*

This group meets at private homes and various public spaces for all types of activities. It is more social and educational rather than a place for worship.

Young Israel of Smithtown, 132 Midwood Avenue, Nesconset, 11767 *O* (Closed)

This congregation was founded in 1997 and has since closed. No other information is available.

New Hyde Park

New Hyde Park Jewish Community Center, 100 Lakeville Road, New Hyde Park, 11040 *C* (Closed)

New Hyde Park Jewish Community Center was founded in 1925. The Conservative Jews in New Hyde Park met in private homes prior to this. Rounding up a minyan was no easy feat, as there were few housing developments yet in New Hyde Park. Many times, those called for a minyan walked three miles.

New Hyde Park was still a farming community in 1925 with a stop on the trolley that ran from Mineola to Jamaica. Soon, a steady, organized minyan of fifteen Jewish families developed. They met each Shabbat at the home of Aaron Holman at the corner of South 3rd Street and Jericho Turnpike. High Holy Day services were held at the firehouse on Millers Lane.

The first official meeting of what was then known as the Hebrew Center in New Hyde Park was held on June 11, 1925. Max Rendel was elected chairman, and Aaron Holman became vice-chairman. That night, a motion was passed for each to contribute $1.00 toward a treasury. A treasurer's report noted income at $21.00, expenditures for letters and stamps at $5.86 and the balance at $15.14. With that tidy sum in the bank, the group got started.

When the members met on September 26, 1927, at the Brit Milah for the son of congregant Samuel Plessers, they decided to embark on constructing their own building. The next year, they bought a plot of land at 100 Lakeville Road.

In 1931, construction was started and finished two years later. By the end of World War II, many returning servicemen had left the five boroughs of New York for the inner-ring suburbs, including New Hyde Park. The membership increased dramatically, and in May 1964, a new building was constructed to accommodate the larger membership.

Demographics changed, and by 1977, the corridors of the religious school building were empty, and the school was closed. By 1992, even with the

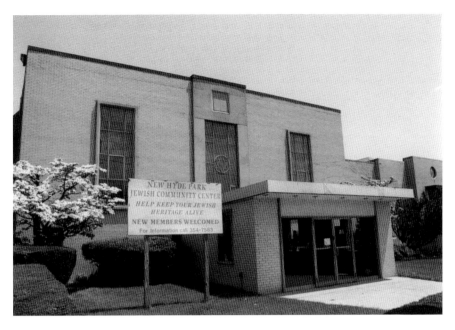

Former New Hyde Park Jewish Center, New Hyde Park, now a church. *Courtesy of Special Collections Department, Hofstra University Library.*

merging of Floral Park Jewish Center into the synagogue, membership was down to 120 families. In 2004, the building was sold to a Hindu temple, and the congregation merged with Shelter Rock Jewish Center, which renamed its daily chapel the New Hyde Park JCC Chapel.

Temple Tikvah Center for Reform Judaism, 3315 Hillside Avenue, New Hyde Park, 11040 *R*

Temple Tikvah is the product of the merger of Temple Emanu El of New Hyde Park and Temple Israel of Jamaica, Queens County, in January 2008.

The first meeting of the Reform congregation took place in the home of a founder on January 10, 1950. The name initially was New Hyde Park Reform Temple. Twenty-two families were represented at that time. Four months later, the group hired a rabbinical student, Joseph Reich, to serve as its acting rabbi.

Cantor Herman Russ led the congregants in the liturgy and later became the first principal of the religious school. Services during those

first years were held in the Community Congregational Church, the Lakeville Firehouse, the Lutheran church and the Hillside Methodist Church. In 1953, the group broke ground for its own synagogue, which was dedicated on February 5, 1954. By 1961, the congregation had outgrown the building and constructed an addition that housed a new sanctuary, additional classrooms and office space. It was dedicated on September 8, 1961.

The congregation is a member of the Union for Reform Judaism. The current rabbi is Randy Sheinberg, and the cantor is Guy Bonne.

YOUNG ISRAEL OF NEW HYDE PARK, 264–15 77th Avenue, New Hyde Park, 11040 *O*

Young Israel of New Hyde Park is right on the Queens side of the border. New Hyde Park straddles Nassau and Queens Counties. The group was founded by ten families and received a charter from the National Council of Young Israel in 1953. It was the first and only Orthodox synagogue in New Hyde Park and, since its founding, has undergone many major renovations.

Membership in the congregation increased steadily over the years, right on up to the late '60s, when numbers started to level off. In 1963, so many of the young families were sending their children to yeshivot that the synagogue closed its supplementary religious school.

Shortly after its founding, Young Israel of New Hyde Park instituted a rite of passage for its young men and women who reach the age of twenty. A board reviews each young person based on his or her character, loyalty to the synagogue and Judaism. The board's selection for entry into the Ben and Bas Club is considered a great honor. Like most Young Israel congregations, a great emphasis is not placed on Bar Mitzvah.

By 1986, membership was 175. By 2005, a resurgence in the Jewish population of the area had brought membership back up to 220. Rabbi Lawrence Teitelman leads the synagogue, which was founded by Rabbi Meir Belitzky.

NORTH BELLMORE

TEMPLE BETH EL OF NORTH BELLMORE, 1373 Bellmore Road, Bellmore, 11710 *C*

A group of twenty families started this United Synagogue of Conservative Judaism–affiliated congregation on October 29, 1952. In January 1953, members started regular Shabbat services in the social hall of the Smithville South Firehouse.

The congregation's leaders wasted no time adding the different elements of synagogue life. In March 1953, Sunday school began for ninety-one children, with six volunteer teachers under the supervision of Rabbi Benjamin Sincoff. In April of the same year, a fundraising drive was held to purchase land on which to build a synagogue. As part of the fundraiser, a new Dodge was raffled off.

By September 1953, enough money had been raised to buy a bar and grill known as Eddie's Tavern and Picnic Grove at 1373 Bellmore Road, as well as the picnic grounds that surrounded it. The tavern was quickly converted into a synagogue, and a year later, the congregation engaged its first rabbi, Nathan Rosenbaum.

The converted tavern was replaced in 1957 by a new synagogue building with a sanctuary, offices, classrooms and activity rooms. It became fully ready by early 1959. By that time, the membership was at 525 families. The religious school had more than 500 students, and in 1960, a full-time educational director was hired. Cantor David Hiesiger started that same year. In 1962, the congregation hit its all-time high in membership with 750 families.

A nursery school was added in 1971. In 1973, the synagogue was expanded, permanent pews were installed in the sanctuary and new catering facilities were built.

In September 1978, Rabbi Rosenbaum suddenly passed away. In April 1979, Rabbi Harvey Goldscheider was selected as the new rabbi. The current rabbi is Royi Sheffin, and the cantor is Eitan Binet.

Temple Beth El was one of the last Conservative congregations in Nassau County to become egalitarian. By 1986, membership had dropped to 450 families. By 2002, membership was around 250 families, a number that holds to this day.

Young Israel of North Bellmore, 2428 Hamilton Avenue, North Bellmore, 11710 *O*

This congregation was established in 1966 and worked from the former Pillar of Fire Church. There were originally about seventy families involved, mostly couples in their twenties, thirties and forties. Soon after getting together, they hired Rabbi Morris Gorelik as spiritual leader and decided to affiliate with the National Young Israel movement.

Most of the congregants walk up to two miles to synagogue. There is no religious school because most members' children attend the Orthodox Hebrew Academy of Nassau County. The congregation has a Sisterhood, a youth group, a library and an adult education program.

North Woodmere

Bais Ha'Knesses of North Woodmere, 649 Hungry Harbor Road, North Woodmere, 11581 *O*

Bais Ha'Kenesses of North Woodmere was founded in 2004 in its rabbi's basement on Longacre Avenue. Shortly thereafter, it moved to the current address, where it has a modern building. It is in the middle of a fundraising drive for a $1 million expansion. Rabbi Aryeh Liebowitz leads the congregation.

Congregation Ohr Torah (North Woodmere Jewish Center), 410 Hungry Harbor Road, North Woodmere, 11581 *O*

Rabbi Theodore Jungreis and his wife, Esther, formed this Orthodox congregation with three other families in 1963. Of course, both the rabbi and Esther would go on to become among the most well-known modern Orthodox leaders in the United States.

To build a congregation, the Jungreises went door to door, recruiting families who were devoted to Orthodoxy and wanted an Orthodox congregation in their community, as well as those who had a minimal association with Judaism. They could inspire countless numbers of Jews through their ability to teach.

The Jungreises and the three original families bought three plots of land, on which they established their congregation. Two of three adjacent plots contained houses. One was used by the Jungreises as their residence, and the other was converted for use as a synagogue. The vacant lot, which was bought from the Village of Valley Stream, was set aside for use when the congregation became so large that a new, larger building would be needed.

To generate interest in the new congregation and involve the larger Jewish community, the Jungreises created a series of novel programs. The rabbi organized the Talmudic Institute of Long Island, taught Bible classes and initiated the "Home Course," in which couples met in one another's homes to learn of their histories and biblical heritage. The rabbi also taught adult education courses at the local public high school. Congregants were invited to the Jungreis home for Sabbath lunch after services.

Because many Jewish families in the area had young children, the Jungreises organized a "Tiny Tots" program for children whose parents attended an adult education class in the next room. Rebbetzin Jungreis taught the children, while the rabbi led the adult class. The rebbetzin also

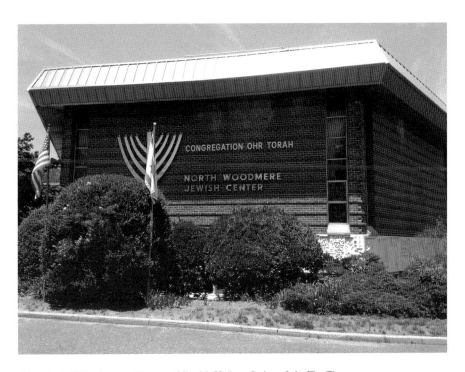

Ohr Torah, Woodmere. *Courtesy of Jewish Heritage Society of the Five Towns.*

conducted a class in her kitchen where young women were taught the art of a kosher Jewish kitchen. In addition, there were luncheon discussions, home study classes, weekend retreats and marriage encounter sessions. Through her teaching, Rebbetzin Jungreis became known as the voice of the modern Orthodox woman in America.

Twelve years after the synagogue was founded, the synagogue building was sold and a new building was erected on the vacant piece of land that had been kept in reserve all those years. By the mid-1980s, membership was at an all-time high, around three hundred families. Today, with a similar membership, Rabbi Mordecai Shapiro is the spiritual leader.

The congregation now includes a beautiful catering hall, as well as all the other amenities of a large, modern Orthodox congregation.

KEHILLAS BNAI HA YESHIVAS, 575 Hungry Harbor Road, North Woodmere, 11581 *O*

No information is available.

PICK WICK MINYAN, Branch and Peninsula Boulevards, North Woodmere, 11581 *O*

Located in a storefront next to Pick Wick Store.

YOUNG ISRAEL OF NORTH WOODMERE, 674 Hungry Harbor Road, North Woodmere, 11581 *O*

This Orthodox congregation was founded in 1978 by former members of the Laurelton Jewish Center of Queens and of Congregation Ohr Torah. One of synagogue's presidents, Robert Benedek, stated that those Jews who came from Congregation Ohr Torah were "unhappy" with the philosophy of the founding rabbi and rebbetzin—perhaps they were too liberal for their tastes. Benedek noted that when the demographic change occurred in Laurelton, a group of Jews from Young Israel of Laurelton moved to the Five Towns, and soon the entire synagogue moved too. For a time, this new synagogue was known as Young Israel of North Woodmere and Laurelton.

It started in the mid-1980s in a converted private home at 785 Gold Road. It also purchased a second home for the rabbi's residence and meeting and classrooms. It moved to its current address in 1998.

Oakdale

Bnai Israel Reform Temple, 67 Oakdale-Bohemia Road, Oakdale, 11769 *R*

On the morning of May 16, 1964, a letter was received by many of the Jewish residents of East Islip urging them to attend a meeting at the American Legion Hall to discuss the formation of a new temple that would meet the needs of the local Jewish community.

Shortly after, on August 11, 1964, Bnai Israel rented its first home, a storefront on West Main Street in East Islip. In 1965, the congregation moved into the Knights of Columbus Hall in East Islip. The building was graciously offered by the Knights of Columbus and served as the house of worship and religious school until June 5, 1970, when Bnai Israel's building on Idle Hour Boulevard in Oakdale was dedicated at the Shavuot Confirmation service.

Rabbi Steven Moss conducted his first service for Bnai Israel in September 1972 while a rabbinical student. He became the temple's first ordained rabbi in 1974. Over the next years, the congregation grew from twenty-three families to more than three hundred. The congregation was forced to hold double High Holy Day services, first in the Idle Hour Boulevard building and then at Dowling College in Oakdale. Dowling also helped Bnai Israel by furnishing badly needed classrooms for the Sunday morning religious school.

In 1979, four acres of land on Oakdale-Bohemia Road were donated to Bnai Israel by Morton Pickman, and groundbreaking for the present temple complex was held in August 1983. The building was dedicated in June 1984.

Recently, Temple Sinai of Bay Shore, with its membership falling, sold its building and merged with Temple Bnai Israel. This affiliate of the Union for Reform Judaism is considered by most as one of the strongest, most vibrant Reform congregations on Long Island. The rabbi, Dr. Steven Moss, has been in Oakdale for more than forty years. The cantor is Ilana Plutzer. There is a Sisterhood, a Brotherhood, a religious school, a youth activities program, adult education classes, a library and many social events.

OCEANSIDE

BNAI TORAH CONGREGATION, Oceanside Road, adjacent to Southside Fire House, Oceanside, 11572 *O*

This group had about forty-five families and was led by Mr. Manuel Fenner. Notations refer to the temple disbanding in the 1980s.

CHABAD OF OCEANSIDE, 3700 Oceanside Road, Oceanside, 11572 *O*

This is an affiliate of Chabad of Long Island founded in 2001. It offers all the usual things found in a Chabad center plus it houses a Chabad preschool with an arts-centric educational program.

CONGREGATION DARCHEI NOAM, 3310 Woodward Street, Oceanside, 11572 *O*

This group is an offshoot of Young Israel of Oceanside and was founded in June 1984 by Irwin Gelbart, who found Young Israel too far of a walk on Shabbat and Holy Days. For the first three months, the congregants met in a narrow room in nearby Congregation Shaar Hashamayim. Then, in September 1984, Erwin Kombert, the owner of Oceanside Country Club, offered the congregation a room in his club for services. The room had its own entrance, and services were held there each Friday evening, Saturday morning and Holy Days.

In the mid-1980s, the group was attracting seventy-five men, women and children to its Sabbath services, and the room they were using could barely accommodate them. Among those attending their services were members from the recently disbanded Bnai Torah Congregation that was formed by other unhappy Young Israel members but could not stay afloat.

Now located on Woodward Street, the group continues with about one hundred families.

CONGREGATION SHAAR HASHAMAYIM, 3309 Skillman Avenue, Oceanside, 11572 *O*

This Orthodox congregation was started by Rabbi Elihui Kasten as nothing more than a minyan that met in the basement of his home in 1963. Rabbi Kasten had just completed his duties as rabbi of Oceanside Jewish Center. He had been asked to resign in a policy dispute.

After Kasten left Oceanside Jewish Center, he held services in the basement of his home with some of his Orthodox followers. He disbanded the minyan for a short time but revived it in a rented house on Long Beach Road. In 1964, he bought a two-story house on Skillman Avenue and converted it for use as a synagogue. The sanctuary is located on the first floor and is still in use to this day.

The congregation totaled seventy-five families by 1965, and most of them were lower-income families. There were eighteen students in the religious school that Kasten ran, and most of the students did not come from Orthodox homes.

Initially, Kasten paid the expenses of the congregation with money he earned from his law practice. But in 1965, he began to charge families $165 per year in dues to cover costs. "I just want to make religion easy from an economic point of view," he said in an interview. "We could expand, but we run a nice, tight little shul and I like the one-on-one situation here." The synagogue continues today in the image created by Rabbi Kasten under the guidance of his son, Rabbi Ari Kasten.

OCEAN HARBOR JEWISH CENTER, 3159 Royal Avenue, Oceanside, 11572 *C* (Closed)

Although this group was founded in early 1963, it did not get off the ground until 1967. In 1968, a building was constructed at 3159 Royal Avenue, adjacent to the Oceanside Long Island Railroad station. The first rabbi was Dr. Greenberg. This United Synagogue–affiliated congregation had about 300 member families in 1973. According to longtime member Carol Rubenstein, "Rabbi Noah Valley used to lead minyanim on the Long Island Railroad most mornings." By 1985, the median age of congregants was fifty-five, and no new members had joined for a few years. Membership dropped to 102 families, and there were 12 students in the religious school.

Attempts to recruit new members was very difficult now because the Oceanside Jewish Center, which was also Conservative, was only ten minutes

Former Ocean Harbor Jewish Center, now a church. *Courtesy of Special Collections Department, Hofstra University Library.*

away and offered programs only a much larger congregation could. Walking distance was no longer a big issue, as most Conservative Jews now drove on the Shabbat.

In 2002, the congregation merged with the Oceanside Jewish Center. The Torahs, religious articles and memorial plaques went there. A few members also joined the Hewlett–East Rockaway Jewish Center.

OCEANSIDE JEWISH CENTER, 2860 Brower Avenue, Oceanside, 11572 *C*

During World War II, Oceanside was the South Shore headquarters for the Ku Klux Klan and for the German American Bund. It was not until after the war, in 1949, that the community had its first synagogue.

When that first synagogue, Oceanside Jewish Center, began, there were only about 150 Jewish families, and it was difficult to put together a minyan. Elihu Kasten, who became rabbi in 1950, recalled that "without the Bar Mitzvah boys in the minyan, we never would have made it." Some locals did not want to "tough it out" with a new congregation and joined congregations in Rockville Centre, Island Park or even Long Beach.

The congregation received a real shot in the arm in 1951 when two large housing developments were completed and most of the new residents turned out to be Jewish. Membership soared almost overnight, and by 1953, there were 450 families.

Kasten remained with the congregation for thirteen years, and an irreparable break developed because of his Orthodox leanings. Eventually, Kasten founded Shaar Hashamayim, an Orthodox congregation, nearby.

By 1985, Oceanside Jewish Center had a membership of more than 800 families and a religious school of 340 students. It was always a liberal Conservative congregation and was among the first to count women in a minyan and to call women to the Torah. The median age of its members in 1985 was forty, and more couples were still joining.

By 2000, membership had leveled off at about 375 families. Today, it is close to that number. The rabbi now is Mark Greenspan, and he is assisted by Student Rabbi Adam Zagoria-Moffet. The group has always been affiliated with the United Synagogue of Conservative Judaism.

TEMPLE AVODAH, 3050 Oceanside Road, Oceanside, 11572 *R*

A group of Reform Jews founded Temple Avodah on September 2, 1952, meeting at the Salamander Hall Firehouse. In all, 56 families packed the meeting hall and signed up that night as charter members. Within ten months, 125 families had signed on.

Temple Avodah, Oceanside. *Photograph by Sandy Feit.*

The group bought a 4.5-acre plot of land on Oceanside Road on August 19, 1953. The congregation took the name Temple Avodah because much of the synagogue was built with their own hands, and *avodah* means work. In 1959, a complete renovation was done, and a new façade was added.

By 1963, the congregation had grown to 525 families, and by 1984, it had hit its all-time high membership of 605, with 300 children in the religious school. In 2000, Union Reform Temple of Freeport sold its building and merged with Temple Avodah. In 2010, membership leveled off at today's 400-family level. The rabbi is Uri Goren. Jessica Gubenko is the cantorial soloist. The educational director is Marilyn Greenspan.

YOUNG ISRAEL OF OCEANSIDE, 150 Waukene Avenue, Oceanside, 11572 *O*

This Orthodox synagogue was founded in 1955 by a group of Oceanside Jewish Center members who were upset at being rebuffed on suggested ritual changes to make the services more traditional. Oceanside Jewish Center was founded as a Conservative synagogue.

A founding member of Young Israel of Oceanside, Al Kustig, stated that many members of Oceanside Jewish Center were raised in traditional Orthodox homes and found it shocking to see congregants driving to synagogue on Shabbat. And although the rabbi acceded to some of their requests—such as having the cantor face the Aron Kodesh on Friday nights and weekdays—their requests generated resentment among the majority Conservative members of the synagogue.

Finally, on October 9, 1955, a group of traditional Jews gathered at the home of Al and Lilyan Wien to organize an Orthodox shul. The fight had been raging at Oceanside Jewish Center. Two years earlier, the rabbi was let go over a disagreement in how traditional services should be. A small group followed him to form another Orthodox synagogue. This group held on until this fateful meeting. On November 10, 1955, at a subsequent meeting, the group agreed to affiliate with the National Young Israel movement. On November 16, it conducted its first Sabbath service in a loft over a Chinese laundry at 23 Davison Avenue. It was donated rent-free by the Chwatsky family, well-known local retailers. A desire for "more dignified surroundings" compelled the congregants to buy a private home at 170 Waukena Avenue and convert it to a synagogue. The first services were held there in January 1958. One year later, the congregation broke ground for a new home on Oceanside Road, and it was dedicated in 1962. It was built for $34,000, and

the land on which it was built, a twenty-five- by four-hundred-foot plot, cost $1,000. After its construction, the former synagogue became the residence of the group's rabbi, Benjamin Blech, who became spiritual leader in 1958 and was granted life tenure ten years later.

By 1966, the congregation had a membership of three hundred families, and plans were made in 1968 to expand the building. But after more debate, these plans were thrown out, and plans were made to construct a complete new building. The new building cost $350,000, the same renovation and expansion of the old building would have cost.

In April 1971, the new building was dedicated. It contained a sanctuary designed to accommodate 250 persons on a permanent basis and a social hall that could be used for additional seating on the High Holy Days, as well as a chapel for daily minyanim, an office and several classrooms.

The congregation ran into a financial squeeze the following January and was forced to close its youth lounge to limit fuel costs. To help meet its obligation to its contractors, each family was assessed an additional $100, and the congregation survived. By 1986, membership was at 275 families.

Since 1963, there has been an eruv in the community, and a mikveh was opened in 1984. Members' children attend yeshivot in the area, so the congregation does not need to run a religious school. Rabbi Jonathan Muskrat leads the congregation, whose membership has leveled off at two hundred.

Old Bethpage

Society of Jewish Science, 825 Round Swamp Road, Old Bethpage, 11804
Unaffiliated (Closed)

The Society of Jewish Science was founded by Rabbi Morris Lichtenstein and his wife, Tehilla, in 1922 as the Jewish alternative to the popularity of Christian Science. The organization operated in Manhattan and built a synagogue in Old Bethpage that was dedicated on May 30, 1956. The synagogue closed in 1977, but the Society of Jewish Science still operates out of offices at 109 East 39 Street in Manhattan. The current sanctuary at that site used the Holy Ark taken from the Old Bethpage synagogue before it was demolished.

Temple Beth Elohim, 926 Round Swamp Road, Old Bethpage, 11804 *R* (Closed)

A group of seventeen families met on the patio of a new home in Old Bethpage in the spring of 1955 and spoke seriously of starting a Reform synagogue in Old Bethpage.

Most of them had in recent years used the GI Bill to buy their split-level and ranch homes, with large windows that looked out on what was, until recently, farm country. Most of the Jews who lived in this new area returned to their parents' home synagogues for High Holy Day services, and some did not worship at all. But this group of seventeen believed that a synagogue was needed here not only to provide a house of worship but also to develop a social cohesion for the Jewish community of Old Bethpage.

Initially, services for this Reform congregation were conducted in basements of members' homes, the local American Legion Hall and the Methodist church. A young rabbinical student, entering his second year of postgraduate studies at the Jewish Institute of Religion, provided the spiritual leadership. A Torah was loaned to the group by Temple Beth Elohim of Brooklyn.

The first High Holy Days season found the congregation attending services in the rented American Legion Hall. Rabbi Louis Stein, who served Beth Elohim for many years, led the services. Seating was open to all Jews, many of whom were attending their first service conducted under Reform ritual.

By the end of the Days of Awe, the group had grown to sixty-five families, and one hundred children were enrolled in the religious school. During these first years, religious school classes were held wherever room could be found. Meanwhile, the congregation bought 1.85 acres of land on Round Swamp Road and moved a small real estate office, which it bought for $900, onto the property. It was officially dedicated as a synagogue on Chanukah in 1956.

Throughout the late 1950s and early 1960s, the congregation erected several buildings next to the synagogue. In 1969, a major building was constructed, including classrooms, a library, kitchen facilities, a social hall and an added organ. The original converted real estate office stood until the congregation merged many years later.

The peak membership was 500 families and 740 religious school students in 1985. From 1987 to 2015, membership dropped dramatically to 100 families. During the summer of 2015, the congregation sold its building to St. Mary's Syro-Malabar Catholic Church and merged with North Shore Synagogue in Syosset.

OLD WESTBURY

CHABAD OF OLD WESTBURY, 267 Glen Cove Road, Old Westbury, 11568 *O*

Chabad of Old Westbury is an affiliate of Chabad of Long Island. The center offers services, adult and children's education and social activities. The leaders are Rabbi and Mrs. Aaron Konikov.

OLD WESTBURY HEBREW CONGREGATION, 21 Old Westbury Road, Old Westbury, 11568 *C*

Until 1946, when William Levitt began to build houses between Westbury and Carle Place, there were only about twenty-five Jewish families living in Westbury out of a total population of four thousand.

The Jews, who were merchants and tradesmen, had settled into the community during the previous twenty-five years. During much of that time, they gathered annually to hold High Holy Day services. The service was conducted by learned Jews from Manhattan who were hired each year. A different man was hired each year, and he served as rabbi, cantor and Torah reader.

Services for the High Holy Days were conducted in a variety of places over the years, including the Westbury Masonic Temple, Del'Assunta Hall, the firehouse, the Westbury Village Hall, the Methodist church and the Friends Meetinghouse. One unforgettable year, Yom Kippur services were held in the courthouse, and court business was suspended for the day to permit the special use.

Despite a realization by many families that they should organize more formally and even build a temple for themselves for services, classes and meetings, the matter was always deferred. But with the construction of new homes and the influx of Jewish families to fill them, a new impetus was present to get the synagogue built. The "natives" like Barnett Mackler, Dr. Harry Mackler and Dr. Morris Tear greeted the newcomers with open arms.

The congregation was formally organized by about twenty people during a January 1947 meeting in the home of Lou Smiles. During that meeting, the name Westbury Hebrew Congregation was chosen, and it was agreed to meet the following month in the Masonic Hall. Word spread of the meeting, and thirty new families were on hand when it was held.

The group held services regularly and met every two weeks thereafter to discuss further plans for the synagogue. Dr. Tear chaired the meetings, and by June of that year, trustees and officers were elected and Dr. Tear was elected chairman of the board.

The Sisterhood was also organized in 1947, and as one of its major fundraising events, it held a cake sale at Staab's Hardware Store.

During the next few years, it became increasingly difficult to find meeting places, and the congregation decided to construct its own building. A site was found on Ellison Avenue, and in August 1950, groundbreaking ceremonies were held. The building was ready for occupancy in March 1951; by then, the group had grown to ninety-two families.

In reporting on that first service, which was held on Friday evening, March 10, the *Westbury Times* ran a story with the headline "Jewish Church Comes to Westbury." When the building was dedicated on March 18, the commandant of the nearby Mitchell Air Force Base (now part of Hofstra University) sent three planes into the air to dip their wings over the synagogue in salute.

By 1957, the membership had grown to three hundred families, so expansion was necessary. A house near the synagogue had to be purchased just to provide extra classroom space for the religious school.

Limited parking and other logistical problems made expansion of the Ellison Avenue site impossible, and it was decided to move to the present location on Old Westbury Road. Groundbreaking ceremonies for a new $500,000 building were held on September 21, 1958. In attendance were Governor Averill Harriman and the congregation's new rabbi, Melvin Kieffer, who had been appointed the year before. Rabbi Kieffer fathered three sons, all of whom became Conservative rabbis. Two years later, the building was dedicated as a cortege of cars carrying the Torahs and other religious objects drove from the old building to the new building. There were also many who walked.

In 1967, the Solomon Schechter Day School of Nassau County was born at the synagogue. The Conservative day school was housed at the synagogue for its first three formative years.

In 1960, with membership continuing to increase to an all-time high of almost six hundred families, new classrooms and a few other needed spaces were added. Since then, there have been two other small expansions and modernizations. The congregation is a longtime affiliate of the United Synagogue of Conservative Judaism and is led by Rabbi Stranger and Cantor Karavani.

Oyster Bay

Congregation L'dor V'dor, 11 Temple Lane, Oyster Bay, 11771 *R*

Congregation L'Dor V'Dor represents the merger of Oyster Bay Jewish Center and the Jewish Congregation of Brookville in 2015.

Oyster Bay Jewish Center was founded in 1964 by thirty-four families and to this date is the only synagogue in Oyster Bay. Thus, it draws members from East Norwich, Mill Neck, Bayville, Muttontown, Oyster Bay and Syosset.

The congregation originally held services in the Oyster Bay Community Center on Church Street. The present building was constructed after an extended capital campaign, with the first service held on September 20, 1968. The group founded the synagogue with Conservative ritual but drifted further toward Reform ritual as time went on. After the merger, it was agreed to follow Reform ritual exclusively, under the leadership of Rabbi Steven Moscowitz.

Patchogue

Chabad of Patchogue, 28 Mowbray Street, Patchogue, 11772 *O*

Rabbi Berel Sasonkin leads this Chabad of Long Island affiliate. It is also known as Young Israel of Patchogue. There are Friday night and Saturday morning services, adult education classes for both men and women and a Hebrew school.

Temple Beth El, 45 Oak Street, Patchogue, 11772 *C*

More than one hundred years ago, a group of people met to establish a synagogue to meet the needs of the fledgling Patchogue Jewish community. A synagogue was built at the corner of Oak Street and Jayne Avenue that to this day remains the center of Jewish life in Patchogue and its environs. Beth El is one of the few congregations that has had a father and son, the Robinsons, both serve as president.

When originally built, the synagogue had a small balcony for women, and it was heated by a large potbellied stove. In 1931, the congregation realized that it had outgrown its quarters and made plans for a larger structure. The new building was completed in 1933 and dedicated by the

Left: Dedication of Temple Beth El, Patchogue, circa 1932. *Courtesy of Alan Robinson.*

Right: Centennial of Beth El, Patchogue, 2002. *Courtesy of Alan Robinson.*

Beth El, Patchogue, circa 1932. *Courtesy of Alan Robinson.*

lieutenant governor of New York State (he went on to be governor), Herbert H. Lehman.

The mortgage was satisfied in 1944. A new addition was built in 1968 that includes a modern sanctuary and a social hall with facilities for a caterer. Today, Rabbi Joel Levinson leads the congregation, a longtime affiliate of the United Synagogue of Conservative Judaism. In addition to offering Friday evening and Shabbat morning services, weekday services are scheduled on certain days and can requested by any member observing Shiva or having a yahrzeit. There is a Hebrew school, youth group and an adult education program. The congregation also sponsors social events, including an annual golf outing.

Plainview

Congregation Rinat Yisrael, 2 John Street, Plainview, 11803 *O* (Closed)

No information is available.

Manetto Hill Jewish Center, 255 Manetto Hill Road, Plainview, 11803 *C*

Manetto Hill Jewish Center, an affiliate of the United Synagogue of Conservative Judaism, was founded in 1971 by a small group that loaned money to the congregation to enable it to buy the land on which the synagogue sits today. As membership expanded, seventy-four families signed a personal guarantee to a mortgage company that allowed the congregation to build its synagogue. The building was expanded eight years later with the addition of an education wing.

The congregation has long had a liberal leaning and was one of the first Conservative synagogues on Long Island to count women in a minyan and call them to the Torah. The congregation hit its peak membership in 1984 with 310 families. The congregation is led by Rabbi Neil Schuman and Ruth Kravit, the educational director.

Plainview Jewish Center, 35 Floral Drive, Plainview, 11803 *C*

Plainview Jewish Center was incorporated on March 12, 1953. The original eight families grew to seventy-five in 1955 when they erected their first building. The current building was started in March 1959 and officially dedicated on March 6, 1960.

In 1990, the congregation reported its all-time high of more than eight hundred members. Rabbi Joshua Goldberg served the congregation during its formative years and stayed until his retirement, thirty-five years later. Rabbi Steven Conn and Cantor Morris Wolk are the current spiritual leaders. Today, the membership has leveled off at more than four hundred families.

Plainview Synagogue, 255 Manetto Hill Road, Plainview, 11803 *O*

Plainview Synagogue, an Orthodox congregation, was the first synagogue established in Plainview, having started in 1964. Most of its members joined at the time of its founding by Rabbi Gutman Bara. Because of an influx of Orthodox Jews into Plainview at that time, membership grew to 150 families.

Although Orthodox, with many members' children attending yeshivot, Plainview Synagogue maintains an education program for non-yeshiva students.

Sephardic Synagogue of Plainview, 51 Country Drive, Plainview, 11803 *O*

Sephardic Synagogue of Plainview started in a private home bought by a group of twenty-eight families for a synagogue. In 2014, the house was demolished, and ground was broken for a new synagogue building. This building, the newest synagogue on Long Island, was recently consecrated.

Temple Chaverin, 1050 Washington Avenue, Plainview, 11803 *R*

Temple Chaverim, an affiliate of the Union for Reform Judaism, is led by Rabbi Jonathan L. Hecht, Rabbi Debra Bennet and Cantor Bradley Hyman. The group started in 1981, holding services at the United Methodist Church in Woodbury until 1993, when it moved to the Mid-Island Y-JCC.

In September 1999, the new synagogue, designed by the architectural firm of Levin & Brown, opened. The Holy Ark comes from Congregation Ahavas Yisroel of Jamaica, Queens, which opened in 1900 and closed in 1980. The synagogue is in Plainview, Nassau County, but a small part of the lot enters Suffolk County, making it Long Island's only congregation located in both counties.

TEMPLE SHOLOM, 479 South Oyster Bay Road, Plainview, 11803 *R* (Moved)

See the "Woodbury" section.

YOUNG ISRAEL OF PLAINVIEW, 132 Southern Parkway, Plainview, 11803 *O*

Logo of Young Israel.

This Orthodox congregation was founded in 1970 by ten families who met in a private home. They later formally organized an Orthodox synagogue to be affiliated with the National Young Israel movement. In 1978, they moved to the present site and built a synagogue with a sanctuary that could accommodate two hundred persons.

By 1986, membership had reached one hundred families, and the congregation's growth was increasing at such a pace that expansion was being planned. All the members walk to synagogue, as most live within a mile and half of the site. On an average Shabbat, attendance exceeds one hundred persons.

When Rabbi Moshe Portnoy became the group's spiritual leader in 1980, he reorganized the eruv so that it now covers an eight-mile radius. It extends from Woodbury Avenue on the north to Old Country Road on the south and from Manetto Hill Road on the east to South Oyster Bay Road on the west.

The congregation continues to attract Orthodox families through its real estate committee, which helps young Orthodox families settle into Plainview. Rabbi Elie Weisman is the spiritual leader, and each year, he invites a rabbinic intern to assist him. Mrs. Avital Weisman serves as yoetzet halacha.

PLANDOME

RECONSTRUCTIONIST SYNAGOGUE OF THE NORTH SHORE, 1001 Plandome Road, Plandome, 11030 *REC*

A group of about eight families from the Roslyn area met in one another's homes starting in 1958 to discuss the Reconstructionist movement, founded in 1926 by Rabbi Mordecai Kaplan. They formed the basis of this congregation.

During the following years, they continued meeting in one another's homes to discuss the philosophy of the movement and conduct services using the Reconstructionist prayer book. On occasion, space was rented to accommodate more people. For a ten-year period, they engaged the services of a part-time rabbi. The group moved to its first permanent home in 1976 at 1 Willow Street in Roslyn Heights. Membership expanded over the next years, and the congregation attracted members from Great Neck to Roslyn Harbor. By 1985, membership was 175 families, and the members instituted a maximum number of 200 families. They vowed if that figure were reached they would help other Reconstructionist Jews build a satellite synagogue.

The group operates a religious school. There is also a preschool and a post–Bar Mitzvah and Bat Mitzvah class for those in middle school and high school. Rabbi Lee Friedlander, Rabbi Jodie Siff and Cantor Eric Schulmiller lead the congregation today. The late Rabbi Ira Eisenstein, one of the most important rabbis of his era, was Rabbi Emeritus.

The current building on Plandome Road in Plandome was built without limiting the size of membership in mind. That was a good thing, as it is one of the few synagogues on Long Island that has continued to grow, albeit slowly, over the years.

Logo of the Reconstructionist movement.

PORT JEFFERSON STATION

AGUDAT ACHIM (MAIN STREET SYNAGOGUE), Main Street, East Setauket *O/C*

This congregation preceded the following entry, for North Shore Jewish Center.

NORTH SHORE JEWISH CENTER, 385 Old Town Road, Port Jefferson Station, 11776 *C*

The North Shore Jewish Center sprang from an Orthodox synagogue named Agudat Israel in East Setauket. It was founded in 1887 and in 1893 erected a small building on Main Street in East Setauket to serve the influx of almost two hundred families who arrived in the area directly from Ellis Island to work in the local rubber factory.

The Golden family came to the area in 1885 and were instrumental in the organization of the congregation and in the building of the synagogue. David Pines was also instrumental in the building of the synagogue.

Samuel Golden was born in Setauket. Mr. Golden became a Bar Mitzvah in 1911 in the sanctuary of the synagogue on Main Street. The reception that followed was held in a tent borrowed from a traveling show. The tent was pitched where the American Legion Hall now stands.

The synagogue flourished until a fire destroyed the rubber factory. Slowly, the families left Setauket, and by 1914, the synagogue had been closed. The synagogue was opened again in 1916 to provide religious services for servicemen who were housed at the site of the Port Jefferson High School during World War I. The end of the war saw the closing of the synagogue. The Torahs remained in the deserted building for two years after the closing. Rather than leave them to lack of use, the Torah were given to the synagogue in East Northport, which later gave them to a congregation in Springfield Gardens in Queens County.

In 1946, twenty-eight years after the building was closed, a group of families met at the home of Samuel Golden to discuss the future of the building. The group met every few weeks to get things moving and elected Mr. Golden as president. Ed Vogel was secretary, and Sy Hersh was vice-president. The members voted to fix up the building. Much work was done by volunteers. In 1947, there was an official opening, with an overflow crowd. The Torahs were located and brought back in 1947.

The congregation was renamed the North Shore Jewish center and became a Conservative synagogue affiliated with the United Synagogue of Conservative Judaism. It started with a part-time rabbi and a small Hebrew school. It purchased ground at the current location in Port Jefferson Station in 1965. The architectural firm of Landow & Landow designed its new building, which had its cornerstone dedicated on December 20, 1970. The last services at the old building in East Setauket were on August 29, 1970, followed by a procession bringing the Torahs to their new home, two and a half miles away.

According to its website, the leadership of North Shore Jewish Center has one major goal: to preserve the bright future of its sacred community and fulfill its potential as a vibrant center of Judaism in Suffolk County—one filled with *ruach* (joyous spirit) and a welcoming, inclusive atmosphere.

The following words were written in 1967 and served as the introduction to the Design Plan of the synagogue: "We are looking for an American Synagogue for Today and Tomorrow. In these times of radical and rapid changes, the synagogue must be both of our time and, in a sense, timeless: both a functioning community center and a focal point of the community's aspirations." These were similar to the words spoken by Dr. Solomon Schechter in 1913 upon organizing the United Synagogue (governing body of the Conservative movement in America).

The congregation described North Shore Jewish Center as, first and foremost, a place of worship. It is committed to remaining a traditional egalitarian Conservative synagogue. It does, however, recognize the diverse spiritual needs of Jews in Suffolk County who identify with the Conservative movement. Without diluting the integrity of its religious foundation, it remains committed to address the diverse needs and viewpoints of Conservative Judaism.

It is obvious that the founders of North Shore Jewish Center had it right the first time—they continue to be concerned with the fundamentals of their faith but hope to broaden this to attract and welcome those with more wide-ranging needs and observances within Conservative Judaism.

The congregation is vibrant and strong, with more than two hundred member families today. It is considered one of the cornerstone congregations of the United Synagogue in Suffolk County. Rabbi Aaron Benson, Cantor Daniel Kramer, Executive Director Marcie Platkin and Principal Heather Welkes lead the congregation.

PORT WASHINGTON

CHABAD OF PORT WASHINGTON, 90 Shore Road, Port Washington, 11050 *O*

Chabad of Port Washington was founded by Rabbi Shalom Paltiel and Mrs. Sara Paltiel in 1995. The present building, including the Samuel Brownstein Memorial Shul, was dedicated in 1998. It is also known as the Pinchus Iseson Chabad House. It offers all normal Chabad activities and is an affiliate of Chabad of Long Island.

CHEVRAH TEFILAH CONGREGATION, 1 Sincsink Drive, Port Washington, 11050 *C* (Closed)

This congregation was founded as a breakaway from the larger Temple Beth Israel in 1993. It was an affiliate of the United Synagogue of Conservative Judaism. It ceased operations in 2017.

COMMUNITY SYNAGOGUE, 160 Middle Neck Road, Port Washington, 11050 *R*

Founded in 1950, this Reform synagogue's first years were of constant moving, from private homes to the American Legion Hall and the old Temple Beth Israel building on Bayview Avenue (referred to in above description of Temple Beth Israel). At one point, this group merged with Temple Beth Israel. The ideological conflict between its Reform members and the Conservative members of Beth Israel was too great, and the merger was short-lived.

The first service was held on February 9, 1972, at the American Legion Hall on Main Street. A Torah was borrowed for this occasion, along with a Holy Ark. A rabbi was engaged on a very part-time basis, and later a religious school was run in the Odd Fellows Hall and High Holy Day services were held in the local firehouse.

The congregation thought that its wandering had ceased when on September 9, 1952, it bought a four-acre parcel on the Vincent Astor estate at the entrance to Harbor Acres. Two neighbors fought the sale in court, contending that restrictive covenants in the Astor deed prohibited anything but a sale for residential use. While the suit was pending, the congregation employed an architect to renovate the building and held a

groundbreaking ceremony on April 26, 1953. Eight months later, Supreme Court justice Ormond Ritchie threw out the neighbors' suit, but it was clear to the congregants that they were not welcome as neighbors.

When the Chimneys, the magnificent twenty-four-acre estate of Mrs. Christian Holmes, came on the market, the Community Synagogue gave a $10,000 down payment on August 5, 1954, for an option to buy the property for $215,000. It had cost more than $1 million to build in 1929 and 1930.

Mrs. Holmes, the daughter of the founder of the Fleischmann yeast and liquor empire, had a working fireplace installed in every room of the house, hence the name of the estate. The house itself was a work of art, with imported floors, wood carvings and antiques, such as the 1770 main beam supporting the main entrance. The grounds were filled with gardens, the centerpiece of which was a formal garden with a reflecting pool that was later converted into a swimming pool. The gardens were filled with exotic plants, and the entire grounds were well maintained.

It all seemed too good to be true, as just six days before the purchase option was signed, the Sands Point Village Board changed its zoning ordinance, making it a privilege, and not a right, to establish a religious institution in the village. The village's Board of Zoning Appeals was given the right to decide all such matters. When it reviewed the synagogue's application, it imposed a series of strangling regulations.

Among the regulations was that the synagogue could build on only 5 percent of the property, that building must be taller than 50 feet in height, that there must be 150 square feet of paved parking area for each seat in use and that all "accessory uses" (such as schooling and board meetings) were prohibited on the grounds.

After the synagogue hired a prominent Republican attorney, Henry Root Stern Jr., to fight the village in court, it received support from several other prominent political leaders in the area. Among them was Averill Harriman, who had a home across the street from the estate and was then the Democratic candidate for governor of New York. He sent off a telegram to the village board decrying its actions.

Finally, on January 22, 1955, the Sands Point Village Board of Trustees rescinded its eight-month-old ordinance. But that didn't help because the village still refused to issue a certificate of occupancy, claiming that the synagogue would pose a threat to the character of the community, as well as the public's health, safety and welfare. It was now becoming obvious that there was some anti-Semitism behind the actions of the village board and its zoning board of appeals actions.

The synagogue contested that action and lost in the Supreme Court. On July 11, 1956, New York's Court of Appeals overturned the Supreme Court decision and held in favor of the synagogue. Three weeks later, the Community Synagogue held religious services at the Chimneys, and the building was formally dedicated as a synagogue on June 1, 1957.

Soon after the group moved into its new home, architect Sidney Katz was hired to design a new master plan for the entire twenty-four-acre estate, including a new wing for a sanctuary and a social hall capable of seating four hundred families. To do that, he used a basic hexagonal form that blended perfectly with the angles of the original building. In addition, he selected materials to match or complement the colors and textures of those found in the Holmes mansion. The initial cost of the wing was $400,000.

In 1955, the congregation had two hundred families. That same years, sixty families left to become founding members of Temple Judea in Manhasset. In 1971, membership reached the practical limit of four hundred families, and another group broke off and founded the Port Jewish Center. Thus, this little synagogue has become the genesis for two other local synagogues.

In the years that followed, the congregation decided to abandon its membership limits and reported a membership of over 550 families in 1989. Membership has since leveled off at slightly over 400 families. Rabbis Irwin Zeptowatts and Danny Burkeman lead the congregation, along with Cantor Claire Franco. It is a longtime affiliate of the Union for Reform Judaism.

PORT JEWISH CENTER, 20 Manorhaven Road, Port Washington, 11050 *R*

The Port Jewish Center was founded in 1971 by ten families who broke away from the Community Synagogue, another Reform synagogue. They met in members' homes for services. As the number of congregants grew, members held services in space rented from the Community Synagogue and, later, the United Methodist Church.

In the summer of 1986, a member donated a building for the congregation. Membership at that time was 100 families. The religious school had 65 students. In 1981, Rabbi Donna Berman became its first full-time rabbi. In 1993, Rabbi Beth Davison arrived and served for twelve years. Rabbi Shelia Goloboy served from 2005 to 2013. Rabbi Alyssa Graf arrived in 2013 and continues to serve. The congregational membership has remained stable, reporting 104 members in 2016.

TEMPLE BETH ISRAEL, Temple Drive, Port Washington, 11050 *C*

Temple Beth Israel is a constituent of the United Synagogue of Conservative Judaism and the oldest synagogue in Port Washington, founded in 1933. The petition for incorporation was signed by its founding twenty-three families in 1933. Don Horowitz, the son of the group's first president, Benjamin Horowitz, recalled that in 1915, when he was five years old, his family moved to Port Washington. There were eight other Jewish families in the community, including the Alper family, whose fourth-generation descendants are still members. Although the synagogue would not be formed until 1933, there was Jewish activity long before that date.

Mr. Horowitz reported that "during the very early years we often imported relatives and friends to form a minyan for the High Holy Days. During the early years, the group rented a building at the corner of Shore Road and Main Street, known as the Bayles Building. During those years, they even had a visiting educated Hebrew scholar from Glen Cove to help the boys prepare for a Bar Mitzvah."

In 1938, the congregation purchased the building at 138 Bayview Avenue to serve as its first synagogue. The current building on Temple Drive was dedicated in 1962. Rabbi Michael Mishken and Cantor Baruch Blum lead this contemporary egalitarian synagogue.

RIVERHEAD

TEMPLE ISRAEL, 400 Northville Turnpike, Riverhead, 11901 *C*

Temple Israel was formed in 1911 as the Brotherhood of Jews of Riverhead. It used members' homes and halls, including the Odd Fellows Hall and the Lyceum Theater on Bridge Street (now 18 Peconic Avenue). Its first building opened on September 21, 1924, at 119 Northville Turnpike as Beth Harkness Anshe Riverhead. In September 1936, it purchased the Agudat Israel Cemetery in East Setauket, as the local congregation had disbanded. The congregation changed its name to Temple Israel of Riverhead in 1944.

On August 10, 1947, the current building was dedicated. It has since been expanded and refurbished several times. The old building is still in use today as a furniture warehouse.

According to Temple Israel historian Carol Levin, a near-capacity crowd of members, friends, neighbors and dignitaries helped Temple Israel mark

its 100th anniversary centennial celebration on Saturday, September 17, 2011. The morning went flawlessly, just as planned by Chairperson Jamie Siegel and his committee of hard workers. The rabbi presided over a lovely Shabbat service in the newly renovated sanctuary, specially completed just in time for this event. Services were followed by speeches of congratulations from dignitaries, including State Assemblyman Dan Losquadro, Suffolk County legislator Ed Romaine, Riverhead town supervisor Sean Walter and a representative from the office of Governor Cuomo. All had proclamations of congratulations declaring September 17, 2011, as "Temple Israel of Riverhead Day." The celebration culminated as all adjourned to the social hall to a meat luncheon, followed by a presentation on early life in Riverhead by Shep Scheinberg.

For many, it was the first opportunity to view the completion of the first stage of the temple's renovation planned and executed by Robert Brown, Richard Israel and Herbert Israel and their committee. The refinished and spruced-up sanctuary seemed more light, airy and spacious than ever before—restored to maintain the traditional décor while ensuring that everything looked new.

Michael Rasco is rabbi of Temple Israel, which is an affiliate of the United Synagogue of Conservative Judaism.

Rockaway Beach (Queens County)

Temple Israel, 188 Beach 84th Street, Far Rockaway, 11693 *O* (Closed)

This building is now the home of the Haven Ministries. It is listed in the National Register of Historic Places.

West End Temple, 47-02 Newport Avenue, Neponsit, 11694 *R*

West End Temple was founded in the summer of 1939. High Holy Day services were led by Rabbi Emanuel Schenk.

During the first years, services were held in the old Seville Hotel on Rockaway Beach Boulevard and, later, in the Park Theatre on Beach 108th Street. The current location was once a property known as the Mandel Mansion. The congregation purchased the property at an auction in 1947. As the congregation grew, it became too large for the

mansion. The current building was constructed in 1954 and has been expanded and refurbished since.

West End Temple is an affiliate of the Union for Reform Judaism. The rabbi is Marjorie Slome, a graduate of the Hebrew Union College–Jewish Institute of Religion in New York City. Stuart Rauch is the music director, and the current student cantor is Jennifer Ruben.

ROCKVILLE CENTRE

CENTRAL SYNAGOGUE—BETH EMETH, 430 DeMott Avenue, Rockville Centre, 11570 *R/REC*

This is the former Central Synagogue of Nassau County and is the result of the merger between the former and Beth Emeth Congregation in 2016. It is a constituent of the Union for Reform Judaism and the Reconstructionist movement as well.

In December 1935, fifty-eight families met at the Millburn Country Club to discuss the possibility of forming a liberal Jewish congregation. Four months later, Central Synagogue of Nassau County was incorporated, and Roland Gittlesohn of Boston was hired as its first full-time rabbi. Services were held at the Masonic Temple on Lincoln Avenue, and Saturday religious school classes were held in rented space at the Wilson School.

Property on DeMott Avenue was purchased in 1940, but the outbreak of World War II delayed completion of the building until 1947. The congregation held its first High Holy Day services here on September 9, 1947. A small chapel, named in the memory of David Hornstein, a congregant killed in the war, was also completed that year. The school building was begun in March 1952. When all the construction was finished in 1955, an address by Eleanor Roosevelt was part of a yearlong dedication celebration.

Renovations and improvements have continued over time. A stage that was part of the auditorium, and which was the scene of several outstanding musical productions, was renovated, and a reception area was created in its place. Fundraising over the years provided sufficient funds to correct a design oversight, and an elevator to all floors in the building was installed. A large basement space was converted into an indoor play area for the pre-kindergarten school, Jacob's Ladder.

The synagogue established the Long Island Extension Center for the Hebrew Union College–Jewish Institute of Religious Education in 1962.

Many famous speakers have appeared at Central Synagogue, including Elie Wiesel, Mark Van Doran, former New York City mayor John Lindsay, Bill Moyers and, of course, Eleanor Roosevelt. The synagogue has welcomed Rockville Centre clergy of all denominations to its sanctuary. The first Community Interdenominational Thanksgiving service, a Rockville Centre tradition, was held at Central in 1969. Rabbi George B. Lieberman, who succeeded Rabbi Gittlesohn in 1954, became the first rabbi to preach from the pulpit of St. Agnes Cathedral at the 1977 Rockville Centre Thanksgiving service.

When Rabbi Lieberman retired after twenty-five years of service in 1979, Rabbi Lewis Litman succeeded him and served until 1982. Rabbi Paul Joseph followed, and in 1988, Rabbi Jeffrey Salkin assumed the pulpit. Eight years later, in 1996, Rabbi Julian Cook followed. In 2002, Rabbi Marc A. Gruber became the spiritual leader and continues to this day. Rabbi Elliot Skiddell, former rabbi of Beth Emeth, serves as education rabbi, and Rachel Kohlbrenner is the cantor. In 1994, Amy Schumer celebrated her Bat Mitzvah at Central Synagogue.

During the spring of 2016, the memberships of both Central Synagogue and Congregation Beth Emeth voted to merge. The merger became official on November 18, 2016, following approval from the New York State Supreme Court. Central, a Reform affiliate, and Beth Emeth, a Reconstructionist affiliate, voted to follow both rituals in the merged congregation. They remain affiliated with both the Reconstructionist movement and the Union for Reform Judaism. This is one of the few interdenominational mergers among synagogues in recent times and only the second known in Long Island history.

CONGREGATION BETH EMETH, 430 DeMott Avenue, Rockville Centre, 11570
REC (Merged)

Congregation Beth Emeth was a Reconstructionist congregation in Hewlett. It was founded in June 1953 as the Hewlett Temple, a Conservative congregation. It opened a building at 36 Franklin Avenue, Hewlett, in 1960. In 1994, a close vote changed the affiliation from Conservative to Reconstructionist.

In 2012, declining membership made the congregation look for a merger partner. None could be found, but Central Synagogue of Rockville Centre was willing to rent it space and consider some joint programs. The only problem

was that Central was Reform and Beth Emeth was Reconstructionist. In June 2016, the congregations merged officially and will follow both Reform and Reconstructionist rituals. The last rabbi at Beth Emeth, Elliot Skiddell, stayed on at the newly merged Central Synagogue–Beth Emeth as education rabbi.

T<small>EMPLE</small> B<small>NAI</small> S<small>HOLOM</small>–B<small>ETH</small> D<small>AVID</small>, 100 Hempstead Avenue, Rockville Centre, 11570 *C*

This congregation represents the March 4, 2011 merger of Congregation Beth David of Lynbrook and Temple Bnai Sholom of Rockville Centre. The Lynbrook building was sold, and all activities are conducted in the former Bnai Sholom building in Rockville Centre. The congregation was the first United Synagogue of Conservative Judaism affiliate on Long Island and remains so today. Howard Diamond, formerly the rabbi of Beth David in Lynbrook, is rabbi. The cantor is David Mendelson. For the history of Beth David, please see the "Lynbrook" section.

Temple Bnai Sholom was organized on September 30, 1906, as the Nassau County Hebrew Association. It started with ten members, all of whom were residents of Rockville Centre. Services were originally held at the home of one of the founders, A. Mintz.

The death of the congregation's president, Ed Starenhagen, in October 1911 almost caused the demise of this institution. The last meeting under Starenhagen's administration was held in August 1911. A period of inactivity followed.

New blood was infused into the group, and on April 6, 1913, congregants again gathered. At that meeting, which an old document described as having "fair attendance" and having been an "enthusiastic, aggressive session," a board of trustees was elected. Philip Goldberg was elected president and A. Mintz secretary. One year later, Mintz retired after a "praiseworthy performance," and the rest of the board was reelected.

The same archival document, which was signed by Goldberg as president of the congregation, noted that "among the things the organization recognized was that the soul of a Jewish community is education."

The founders realized that the needs of the membership would have to include a school for the young. Without a Jewish education, children raised in the country surroundings of Rockville Centre would grow up ignorant of their religion, history and customs. Therefore, they formulated plans for the building of a school and a synagogue.

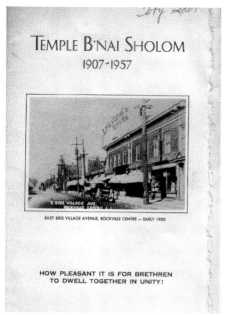

Above, left: Temple Bnai Sholom, Rockville Centre, fiftieth-anniversary program, 1957. *Courtesy of Rockville Centre Public Library.*

Above, right: Temple Bnai Sholom, Rockville Centre, fiftieth anniversary program, 1957. *Courtesy of Rockville Centre Public Library.*

Left: Reproduction of original document relating the early history of Temple Bnai Sholom, Rockville Centre, from the cornerstone of its original building on Windsor Avenue. *Author's collection.*

Original building of Nassau Hebrew Congregation, later known as Temple Bnai Sholom, 55 Windsor Avenue, Rockville Centre. This was the first synagogue built in Nassau County. The image is a photograph of a painting. *Courtesy of Temple Bnai Sholom, photograph by Sandy Feit.*

The congregation's first synagogue was erected on Windsor Avenue in 1915. It was the first synagogue building in Nassau County. It served the group until 1949, when due to the construction of the Sunrise Highway bypass at Merrick Road, parts of Windsor Avenue had to be demolished. The present structure at 100 Hempstead Avenue was dedicated in 1949. The congregation's peak membership was 770 families in 1967. In 1986, it reported 650. As Rockville Centre became the center of the new Catholic Diocese of Long Island, demographics changed, and many Jewish homeowners were replaced by Catholics. In 1998, the congregation reported only 370 members. The congregation has had two long-serving rabbis in its history: Max J. Routtenberg, who served a term as president of the Rabbinical Assembly of America, and Barry Dov Schwartz.

On March 4, 2011, with numbers being an issue for both synagogues, Bnai Sholom and Beth David of Lynbrook merged, with one congregation using Rockville Centre's building. It is led by Lynbrook's former rabbi. It should be reported that the author of this work lived in Rockville Centre and attended Hebrew school here in the early to mid-1950s.

ROOSEVELT

ROOSEVELT JEWISH CENTER, 55 Mansfield Place, Roosevelt, 11575 *C* (Closed)

Roosevelt Jewish Center was a United Synagogue of Conservative Judaism affiliate that was incorporated on July 14, 1932. It originally held meetings at the Roosevelt Square Club. Architect Reinhold Groeper designed its first building, a twenty- by forty-foot building dedicated on May 2, 1937. A new building was constructed in 1963 when the synagogue reached its peak membership of almost two hundred families. The synagogue always had an active United Synagogue USY youth group. Howard Stern, the famous radio and movie personality, was a Hebrew school student here. In 1987, the synagogue faced extreme demographic changes in Roosevelt and disbanded. Most religious articles and the Torah Scrolls went to Freeport and Baldwin. The remaining members joined neighboring synagogues in Freeport, Baldwin or Hempstead.

ROSEDALE AND LAURELTON (QUEENS COUNTY)

LAURELTON JEWISH CENTER, 228-20 137th Avenue, Laurelton, 11413 *C* (Closed)

Laurelton Jewish Center was founded in 1928. The building's first floor was completed in late 1928, and the second floor was added in 1934. Dr. A. Herbert Fedder was the first rabbi. The synagogue was very prosperous

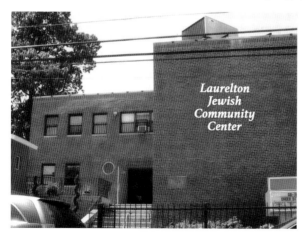

Left and next page: Former Laurelton Jewish Center, Rosedale-Laurelton. *Photograph by Marv Merein.*

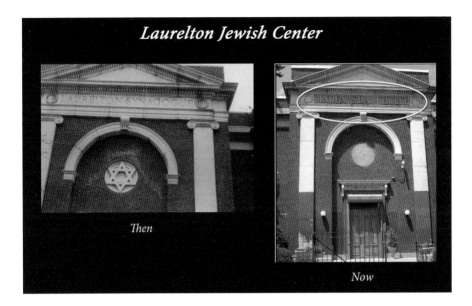

Laurelton Jewish Center

Then

Now

during the 1950s and '60s and had one of the largest Conservative USY youth groups in New York. The infamous Bernie Madoff married his wife at this synagogue in 1959. As the demographics changed, the building was sold to the New Liden Seventh-day Adventist Church.

ROSEDALE JEWISH CENTER, 247-11 Francis Lewis Boulevard, Rosedale, 11422 *C* (Closed)

Rosedale Jewish Center was a Conservative synagogue affiliated with the United Synagogue for Conservative Judaism. The synagogue was built in 1947 and closed in 2000. The closest synagogue to Rosedale, Laurelton Jewish Center, also closed in 2000. Some remaining Jews in Rosedale have affiliated with congregations in Valley Stream.

TEMPLE BETH EL OF LAURELTON, 133-21 232nd Street, Laurelton, 11413 *O* (Closed)

This congregation closed in the late 1990s. The building is now the St. Luke Cathedral.

Roslyn and Roslyn Heights

CHABAD OF ROSLYN, 75 Powerhouse Road, Roslyn Heights, 11577 *O*

Chabad of Roslyn is an affiliate of Chabad of Long Island. The center maintains daily minyanim, educational programs for men, women and children and social activities.

CONGREGATION ZICRON ELIEZER, 2 Shelter Rock Road, Roslyn, 11576 *O*

Zicron Eliezer was established in 1991 and is a Bukharian congregation. Rabbi Tzvi Kramer leads the group.

NORTH HILLS SYNAGOGUE, 2 Shelter Rock Road, Roslyn, 11576, *O* (Closed)

This congregation's rented quarters was sold from under it in June 2013, forcing it to vacate. The members joined the Shelter Rock Jewish Center and now use the downstairs auditorium for Orthodox services—now referred to as the North Hills Minyan.

ROSLYN SYNAGOGUE, 257 Garden Street, Roslyn, 11557 *O*

The Roslyn synagogue was founded by four families in 1978. Until June 1986, the small group attended services in a storefront at 270 Garden Street. During the early years, the only Orthodox synagogue in Roslyn grew to seventy-five families. The current building is a remodeled former firehouse across from its former home. It opened in June 1986.

Rabbi Robert Block has been the rabbi since the very early years and is ably assisted by his wife, Mrs. Beile Block. There is a tradition of rabbinical interns at the Roslyn Synagogue because both Rabbi Block and the congregation believe it is important to nurture and assist the next generation of rabbis. Rabbi Aron Rubin, a former resident of Australia, is the most recent intern. There is no religious school because the children attend nearby yeshivot.

SHELTER ROCK JEWISH CENTER, 272 Shelter Rock Road, Roslyn, 11557 *C*

Shelter Rock Jewish Center, an affiliate of the United Synagogue of Conservative Judaism, was founded in 1958. By 1965, membership was 650 families, and the religious school enrolled 225 students.

The congregation, under the leadership of Rabbi Myron Fenster, who joined in 1966, has an Orthodox wing, the North Hills Minyan (described earlier).

A large majority of the congregants attend the traditional Conservative services in the main sanctuary. Shelter Rock was one of the last Conservative synagogues in Nassau County to give equal religious rights to women. As late as 1995, there was a separate women's service on Rosh Chodesh, at which women read the Torah.

The synagogue was the first on Long Island to erect a Holocaust Memorial Park and participated in Soviet Jewry rallies outside the Soviet Embassy Estate Complex in Glen Cove. In August 2015, the congregation lost Mr. Morris Feldman, its first president.

In 2004, the New Hyde Park Jewish Center merged with Shelter Rock. The daily chapel is now called the New Hyde Park Jewish Center Chapel.

Shelter Rock Jewish Center, Roslyn. *Photograph by Mark Friedman.*

Membership has leveled off at about four hundred families, and it is still very active. Rabbi Fenster is now Rabbi Emeritus. Martin S. Cohen is rabbi, and Mitch Berkowitz, a student at the Jewish Theological Seminary, is the rabbinic intern.

TEMPLE BETH SHOLOM, 401 Roslyn Road, Roslyn Heights, 11557 *C*

On June 18, 1951, thirty-five families met at the Roslyn Country Club to establish Roslyn's first Conservative synagogue.

A few weeks later, they learned that fourteen acres of hillside land was available for $30,000, and they immediately put together a down payment. Shortly thereafter, two hundred families came forward at High Holy Day services at the Roslyn Theatre to pledge money. The land was bought and construction began.

During that first year, the congregation met at various locations, including the Roslyn American Legion Hall, the Masonic Temple, Rolling Hills Day Camp, the Roslyn Theatre, the Odd Fellows Hall and the Roslyn Methodist Church.

Fifteen months after the first meeting, in September 1952, enough of a shell of the synagogue's school building was complete to permit holding of services for a congregation that had grown to three hundred families. Rabbi Jacob Hochman led this first service in the building. Max Greenfield was the congregation's first president.

During the period from 1952 to 1962, the building was expanded to include an auditorium, a sanctuary, a library, more classrooms, meeting rooms and offices. Rabbi Joseph Sternstein became rabbi in August 1969. In 1971, membership was 710 families.

By 1985, membership peaked at nine hundred families. A large addition to the original building opened on September 8, 1991. Membership leveled off at about six hundred. Alan B. Lucas is senior rabbi. The associate rabbi is Paul Kerbel, and the cantor is Ofer Barnoy. Rabbi Sean Jensen is the director of learning, and Ms. Sharon Solomon is the religious school director. Ms. Suzy Freier directs the preschool. The synagogue is a longtime affiliate of the United Synagogue of Conservative Judaism.

TEMPLE SINAI, 425 Roslyn Road, Roslyn Heights, 11557 *R*

This Reform congregation was Roslyn's first synagogue. It was formed in 1947. Initially, it was known as the Roslyn Jewish Community Center. The members declined to affiliate with any specific Jewish denomination. In 1950, with other synagogues opening in the Roslyn area, the members decided to become the area's first Reform temple.

The decision to affiliate with the Union for Reform Judaism (then known as the UAHC) alienated some more traditional families, who broke away to form Temple Beth Sholom (described earlier).

During the first three years, the congregation rented space from the Roslyn Presbyterian Church for weekly and High Holy Day services. The rest of its activities were scattered all over. Sunday school was conducted at the Pierce Country Day School. Weekday classes were at the Roslyn Firehouse. Meetings were held at the War Memorial, Odd Fellows and American Legion buildings.

Temple Sinai, Roslyn. *Photograph by Mark Friedman.*

In 1948, the congregation bought its present seven-and-a-half-acre plot. The building was dedicated on August 27, 1950. An extension was built and dedicated in March 1955. In response to the members who preferred the name, Temple Sinai was chosen in 1960 as the new permanent name for the congregation.

The peak membership was 1976 at 1,225 families. On June 2, 1985, the congregation rededicated its facilities following a total refurbishment. In 1985, membership was still 1,100 families. Membership today has leveled off to about 700. Michael A. White is the senior rabbi. Rabbi Andrew Gordon and Cantor Sergei Schwartz complete the clergy.

Sag Harbor

Chabad North Haven in the Hamptons, Ferry Road, Sag Harbor, 11963 *O*

Chabad North Haven was started in 2013 by Rabbi Beryl Lerman, who is a respected teacher of Kabbalah and the spirituality of Judaism. The group is affiliated with Chabad of Long Island. High Holy Day services have been held at the Sag Harbor Inn on West Walter Street. Other events have been held in various locations.

Independent Hebrew Association, Engravers Hall, Main Street, Sag Harbor, 11963 *O* (Closed)

The Independent Hebrew Association was formed circa 1890 by local Jews of Hungarian descent. It merged with Mishcan Israel in 1918 to form what eventually became Temple Adas Israel.

Temple Adas Israel, Elizabeth Street and Atlantic Avenue, Sag Harbor, 11963 *R*

So much is made of the history of this, the oldest continuously operating synagogue on Long Island, that few realize that it is an active, operating congregation. A complete history of the congregation was written by Leda Goldsmith and the synagogue's administrator, Eileen J. Moskowitz. Much of it is reprinted here with their permission. Daniel N. Geffen is the rabbi, and

Jordan Shaner is the cantor. Rabbi Emeritus is Leon Shaner, who served the congregation for fifteen years before moving to Israel. The congregation is a longtime affiliate of the Union for Reform Judaism.

Legend has it that Sag Harbor's synagogue, Temple Mishcan Israel— the predecessor to today's Temple Adas Israel—was given its first Torah by President Theodore Roosevelt. According to the story, Roosevelt acquired the Torah in 1898 when he returned to the United States with the 1,200 Rough Riders whom he had led in the charge up San Juan Hill during the Spanish-American War. When three of the men contracted yellow fever, Roosevelt returned to American shores, via Montauk. The brigade was quarantined for a month to make sure that no one else caught the contagious disease. During their stay in Montauk, the men held worship services, including Shabbat services for the Jewish soldiers. A Torah was procured for this purpose.

When the brigade left after the quarantine period, Roosevelt donated the Torah to the nearest synagogue, Temple Mishcan Israel in Sag Harbor. He and his soldiers then went on to a hero's welcome in Manhattan. Like the clear majority of other Jewish immigrants, Sag Harbor's early Jews established a toehold in the community, formed mutual benefit societies, founded a cemetery and, as their numbers grew, built a synagogue. They also struggled to redefine Jewish family life in a new world. In some respects, Sag Harbor's Jewish history is unique. It is the story of Jewish immigrants, attracted by the opportunity and the availability of work, choosing life in a small village over the more common urban experience. In 1847, there were only fifty thousand Jews in the United States, 0.0025 percent of the total population.

Fifteen thousand of them lived in New York City. It took Sag Harbor another forty years and the relocation of a watchcase factory from New Jersey before a Jewish community appeared. Sag Harbor was once a thriving commercial center but reverted to a sleepy rural village in the mid-1800s. By 1850, with the demise of the whaling industry, the town was searching for an economic base that would return it to prosperity. In the early 1800s, Joseph Fahys, a watchcase manufacturer, moved his factory from Carlstadt, New Jersey, to Sag Harbor, bringing hundreds of needed jobs to the struggling community. From this new location, Fahys could easily ship his products to New York City via the newly opened Long Island Railroad. Fahys built the brick factory that currently stands empty on Washington Street.

At the same time, additional manufacturing and commercial structures, as well as workers' houses, were built on the nearby streets and alleyways. They

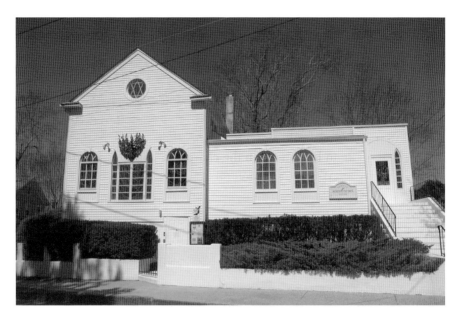

This page: Temple Adas Israel, Sag Harbor. *Photograph by Eileen J. Moskowitz.*

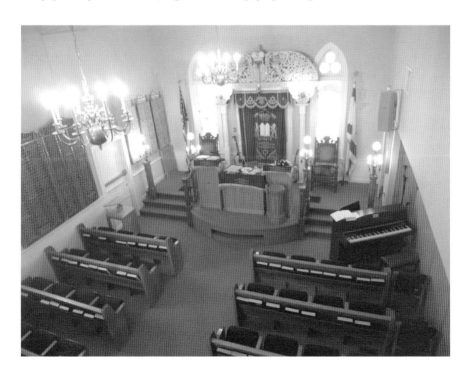

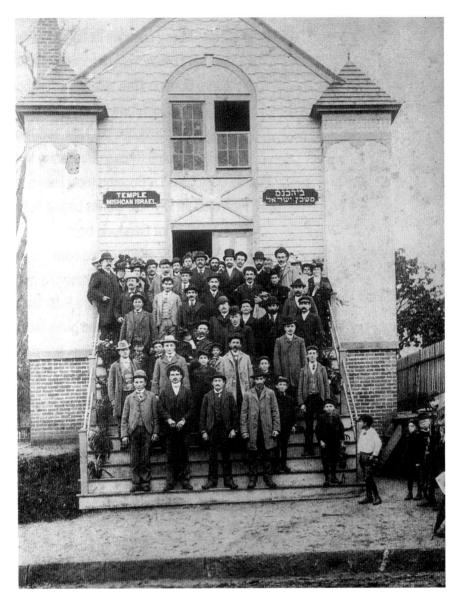

Above and opposite: Congregation Mishcan Israel, which evolved into Temple Adas Israel, Sag Harbor, circa 1900. *Courtesy of Eileen J. Moskowitz.*

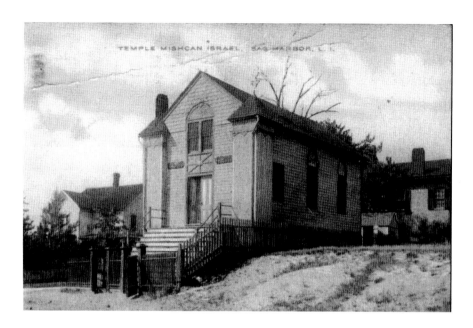

were followed by shops on Main Street and houses on South and Suffolk Streets. Like many American factory owners, Fahys relied on immigrant labor, including Russian, Polish and Hungarian Jews. Per the 1900 Sag Harbor census, about one hundred Jewish men worked in the factory. In 1889, the death of a child created a concern for spiritual matters. There was no Jewish cemetery east of Lindenhurst (where a corner of a Protestant cemetery was set aside for Jews). The Sag Harbor Jews organized a Jewish Cemetery Society. There was an initiation fee of twenty-five cents, with weekly dues of five cents. In 1890, they purchased land for fifty dollars and cleared it themselves. This marked the beginning of Jewish spiritual life in the area. The cemetery, which is still located on Route 114 between Sag Harbor and East Hampton, is now run by the Chevra Kedisha Society of Temple Adas Israel.

Once they were organized to serve other religious needs, they decided to build a synagogue. This required increasing the weekly dues to ten cents. In 1896, Nissan Meyerson purchased the property where the synagogue now stands. The temple, built at a cost of $2,500, combined the architectural form of a wooden colonial church and an eastern European synagogue. The first services were held on Rosh Hashanah in 1898.

The exterior of the temple was painted white. It had a peaked roof and two plain white pillars that stood on either side of the entrance door. Unlike a church, "there is no steeple, cupola, or bell on the tabernacle."

Logo of Temple Adas Israel, Sag Harbor. *Courtesy of Adas Israel and Eileen J. Moskowitz.*

Tall Gothic windows with colored stained-glass panels "let in light," per an article in the *Brooklyn Eagle*. Inside, in European tradition, there were also two altars, one in the center of the synagogue where the rabbi and cantor read the Torah and another on the east wall facing Jerusalem containing the Holy Ark, the Eternal Light and the Tablets of Commandments. The seating capacity in the main sanctuary was one hundred, and since the temple was originally Orthodox, women were not permitted to worship with men. A "Ladies Gallery," with additional seating for sixty, and a private entrance were built. The basement contained a mikveh. There was also an apartment for a janitor, later used by resident and itinerant rabbis.

There were about fifty member families. Formal dedication ceremonies were held on October 28, 1900, and "the church was packed," per the *Brooklyn Eagle*. Religious services were held weekly on Fridays and Saturdays, with the officers wearing robes and solid gold medals. Since there were very few ordained rabbis in the United States during this period, lay rabbis would lead the congregation. The "lay" rabbis would journey from Manhattan to Sag Harbor and the other East End towns, where they were housed in comfort by the members of the temple, in exchange for leading Shabbat and other traditional observances.

Temple Mischa Israel attracted Jews to Sag Harbor from towns all over the East End, a pattern that continued until the 1960s. The 1920s marked both the beginning of an economic decline in Sag Harbor, as well as the decline of Temple Mischa Israel. New quotas were established on immigration, cutting the numbers of new Jews. These restrictions were favored by many elite families and descendants of colonial settlers who felt that their way of life was being threatened by the new ethnic groups.

In 1925, another crisis hit the townspeople of Sag Harbor when a major fire consumed large portions of the Fahys factory and the Alvin Silver factory. It forced both companies to lay off hundreds of workers and cease production. The Jewish population of Sag Harbor then dwindled to fewer than a dozen families. Despite the decline in population during the Depression, most of Sag Harbor's Jewish businesses survived. There was, however, a catastrophic effect on the temple. There was no money to pay a visiting rabbi, and the structure began to deteriorate. The mikveh fell into

disuse and was finally boarded up in the early 1940s, not to be seen again until it was accidently discovered in 1977.

Also in the late 1940s, the temple was severely affected by long-term population and economic decline and was open only for the High Holy Days. Although Jewish-owned stores still dominated Sag Harbor's Main Street, only a few Jews attended services. A big change came in 1948, when the temple abandoned its Orthodox roots and became Conservative (United Synagogue of Conservative Judaism). The name was changed to Temple Adas Israel. After World War II, young professionals, artists and writers moved to the East End, searching for a cultural and economic environment conducive to their creative energies and ideals.

By 1950, Sag Harbor's Temple Adas Israel was once again a center of Jewish life. Shabbat services were held on Thursdays because the visiting rabbis had to tend to their own congregations on Shabbat. A Sunday school, taught by temple members, was started and attracted many members from surrounding towns. Although still without a full-time rabbinic presence, the temple underwent extensive renovations thanks to successful fundraising by the area's Jews and sympathetic Christians alike.

In 1956, the temple acquired an adjacent lot for $1,500. Today, it is the social hall and expanded sanctuary during the High Holy Days. Long-term member David Lee recalled, "Back in the 1950s, I was outside the Temple fixing a window on the eastern wall of the shul, and I got into a conversation with the owner of the overgrown and undeveloped lot next door. His name was Philip Harboy. While our conversation was of a general nature, I thought I would plant a seed for Temple Adas Israel's future. We had very little in our treasury at that time, so I casually mentioned that someday I would like to buy the property for future growth. We settled on the fair market value of the property, $1,500. That weekend, Mr. Harboy, was killed in a skating accident. Two weeks later, his widow, Florence, called and advised me that her husband had told her about our agreement. She said she would abide by our agreement…and that enabled us to expand our facilities. It's amazing how things happen."

In the late 1950s, though it could only afford a part-time rabbi, Temple Adas Israel again began to thrive. In 1977, shortly after extensive renovations began, a member discovered the traditional mikveh in the basement that had not been seen for more than thirty years. Other improvements included the replacement of the stained-glass windows by new ones created by Sag Harbor artist Romany Kzamoris, a new entrance from the parking lot and the removal of the long staircase.

A new era evolved when Reform religious practices were adopted in 1955 and Vera Sims became the first woman ever to stand on Temple Adas Israel's bema. The temple also became more socially conscious, initiating a community outreach program of interfaith services with the village's other religious institutions on Thanksgiving. Temple Adas Israel was quickly earning the reputation as a center of liberal Judaism and began attracting hundreds of summer residents to its High Holy Day services. To this day, it retains its Reform affiliation with the Union for Reform Judaism. Many well-known rabbis—including Arthur Gilbert, George B. Lieberman and Paul Steinberg—have occupied the pulpit. Throughout the years, several fine student rabbis have also led Adas Israel's services. It has been a tradition to recruit student cantors from the Hebrew Union College's School of Sacred Music, some from as far away as Russia, Brazil and Israel. They all have enhanced the temple's services.

Until 2003, the temple met only from Shavuot through the fall festivals. The Jewish population in the area has again grown, and many members became year-round residents. A Hebrew school was started again in 2003, and a lay-led winter activities program started in 2006. In the spring of 2010, Temple Adas Israel became a year-round congregation. Rabbi Leon

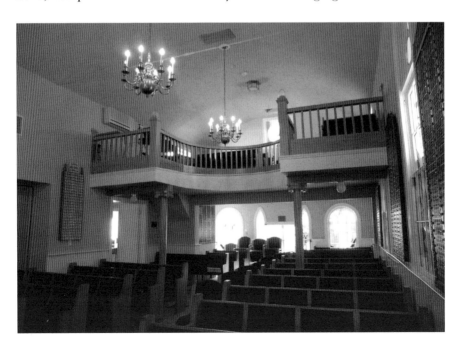

Balcony of Temple Adas Israel, Sag Harbor. *Photograph by Eileen J. Moskowitz.*

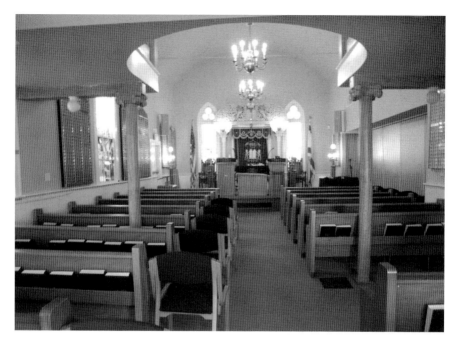

Holy Ark of Temple Adas Israel, Sag Harbor. *Photograph by Eileen J. Moskowitz.*

Morris, who has served the temple for ten years on a part-time basis, moved to Sag Harbor with his wife and children and became the full-time rabbi. After he made Aliyah to Israel, Rabbi David Geffen, the current spiritual leader, arrived.

Jewish life on the East End of Long Island has evolved continuously since the building of the temple more than 120 years ago. Areas of the Hamptons once restricted from Jews were now full of Jewish summer-only and year-round residents. Adas Israel has been joined by several other synagogues. Adas Israel today is not only a thriving, forward-looking Reform synagogue, but it is also visited by thousands of tourists each summer.

SAYVILLE

SAYVILLE JEWISH CENTER, 225 Greeley Avenue, Sayville, 11782 *O*

The Sayville Jewish (Community) Center, previously known as both Temple Sholom and Tifereth Israel Congregation, was founded as a Conservative

congregation in 1955 using the Community House on Gillette Avenue for services. The land for the current building was donated in August 1957 by Jason Greene and his son, Lawrence. The building was completed in 1960.

Rabbis Gottlieb and Wartenberg each served the congregation for long terms. Currently, an Orthodox rabbi, Abraham Sorchor, leads the group, and the services follow Orthodox ritual using an Artscroll prayer book. The wife of the late Rabbi Wartenberg, Mrs. Rosalie Wartenberg, serves as synagogue administrator.

SEAFORD

SEAFORD JEWISH CENTER, 2343 South Seamans Neck Road, Seaford, 11783
C/REC (Closed)

A group of six Jewish men who met each week for a game of cards is credited with starting this synagogue in 1970. Although it was affiliated with the Conservative movement, it had a Reconstructionist rabbi. The founders, each with young families of their own, had recently moved to Seaford from Brooklyn or Queens, and they were concerned about a Jewish education for their children because there was no synagogue in the community.

When the group incorporated as the Seaford Jewish Center later that year, it had a membership of thirty-five families. It immediately bought a private home at 2343 South Seamans Neck Road with plans to convert it to a synagogue. The neighbors balked at the move, and the congregation was prevented from renovation because of zoning and variance regulations. The synagogue's attorney, Norman Feldherr, challenged the regulations in court, and in 1975, the New York State Supreme Court of Appeals set aside lower court orders that for five years had stalled the congregation's renovation plans.

During the court battle, the congregation hired a part-time rabbi who left in 1971 after becoming upset that services had to be held in the auditorium of the local Methodist church. Two years later, the congregants hired their first full-time spiritual leader, Rabbi Esor Ben-Sorek, who called media attention to the swastikas that were painted on the building while the court battle dragged on.

After the congregation won the court approval to renovate the building, members set to work redecorating the interior into a sanctuary and classrooms. One of the congregants, Eugene Feder, crafted fifteen stained-

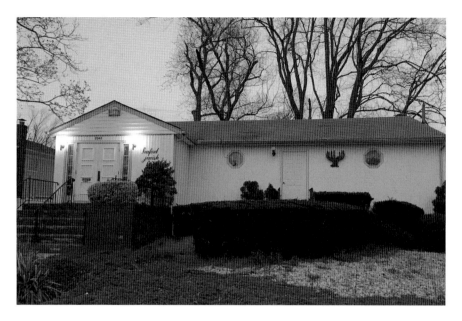

Former Seaford Jewish Center, Seaford. *Courtesy of Seaford Public Library.*

glass windows, and another member, sculptress Rita Coppel, designed the bronze menorah that adorned the building. The bronze memorial boards and the Tree of Life in the sanctuary were designed by congregant Lawrence Klein.

Under the guidance of Rabbi Ben-Sorek, who in 1986 was granted life tenure, the congregation grew to a membership of 175 families. It was one of the first Conservative congregations in Naasau County to grant women equal religious rights. Its motto was "The small temple with the big heart." Like many other South Shore congregations, Seaford Jewish Center became a victim of changing demographics and closed. The building and signage remain on South Seamsns Neck Road.

SMITHTOWN

CHAVURAT EMET, 811 West Jericho Turnpike, Suite 104W, Smithtown, 11749 *Unaffiliated*

Chavurat Emet is led by Cantor Neal Spivack. In 1963, four couples committed to their Jewish community sought an alternative way to celebrate

the High Holy Days. They envisioned an intimate Jewish experience that would embrace the needs of adults with grown children, many of whom were about to start their own families. Shortly thereafter, nine couples who had been active in synagogue life at Temple Beth Sholom joined together and established Chavurat Emet, a Circle of Friends. Its first High Holy Day services were held in a conference room at a local hotel and attracted more than fifty families. The lively spiritual service, filled with traditional and modern melodies, inspired the founders to find a permanent home for Chavurat Emet. Beit Chavurah was generously donated by one special couple. Other members donated new prayer books and furnishings, and an entire community joined together as it acquired the first two Torahs at a community-wide dedication.

Chavurat Emet now has social, educational and social action events. It joins each month for a lively service in its own unique style. It is located in a suite within an office building.

TEMPLE BETH SHOLOM, 433 Edgewood Avenue, Smithtown, 11749 *C*

Temple Beth Sholom, a constituent of the United Synagogue of Conservative Judaism, was founded in 1956. Its first synagogue was in a converted home at 5 Glamore Court. The current building was constructed in 1965. The membership hit its peak of four hundred in 1972.

In 2013, the congregation sold its building to Ministerio Jesucristo Vive, a church. It now leases back a portion of the building. Current membership is about one hundred. Rabbi Jonathan Waxman is the spiritual leader.

SOUTHAMPTON

CHABAD OF SOUTHAMPTON, 214 Hill Street, Southampton, 11968 *O*

Chabad of Southampton, also known as Southampton Jewish Center, was established in 1994. A private home was purchased for use as a synagogue in 1999. The center is an affiliate of Chabad of Long Island. Rabbi Beryl Lerman is the leader.

The center is most active during the summer month. Besides daily services, the center offers adult education courses, a "Mommy and Me" program for young mothers and toddlers, a Hebrew school and other educational and social programs.

STONY BROOK

CHABAD AT STONY BROOK, STATE UNIVERSITY OF NEW YORK, 31 Mount Road, Stony Brook, 11790 *O*

Chabad at SUNY–Stony Brook is a constituent of Chabad of Long Island. The director is Rabbi Chaim Grossbaum. Mrs. Rivkie Grossbaum is the preschool and Hebrew school director. Rabbi Adam Stein, Mrs. Esther Stein, Rabbi Shalom Ber Cohen, Mrs. Chanie Cohen, Rabbi Motti Grossbaum and Mrs. Chaya Grossbaum are also on the professional/ educational staff.

Weekday morning services are held at the Chabad synagogue at 821 Hawkins Avenue, Lake Grove. Friday evening and Saturday morning (followed by Kiddush) services are held at 23 Cornwallis Road, East Setauket (Rabbi Grossbaum's residence). Sunday and Legal Holiday morning services are held at Chabad of the East End in Coram.

Rabbi Grossbaum's residence is often referred to as "Chabad House." The group is a very important part of the campus and the community generally.

CHABAD HOUSE AT STONY BROOK, STATE UNIVERSITY OF NEW YORK, 23 Cornwallis Avenue, Stony Brook, 11790 *O*

Described previously.

STONY BROOK HEBREW CONGREGATION, 51 Hawkins Road, Stony Brook, 11790 *O*

Rabbi Ori Bergman and his wife, Mrs. Nora Bergman, lead this Orthodox group. The founder is Dr. David Eben, a faculty member at the State University of New York–Stony Brook. The group was founded in 1979 and meets in a modest building on Hawkins Road. Stony Brook Hebrew Congregation also maintains an on-campus office at room 249 of the Student Union Building.

TEMPLE ISAIAH, 1404 Stony Brook Road, Stony Brook, 11790 *R*

Temple Isaiah was incorporated on July 15, 1965, and held its first service in the Suffolk Museum (now the Museum at Stony Brook). Shortly thereafter, services were moved to the Stony Brook Community Church, where the synagogue remained for two years. During that time, the first Sefer Torah was donated to the temple. Student Rabbi Ira Youdovin led the congregation.

In June 1967, ground was broken for its first building (now the school building). It was expanded a few years later. In 1967, the temple acquired a Holocaust Memorial Torah from Czechoslovakia.

From 1969 to 1971, Rabbi Gordon Geller served as the first full-time rabbi. Rabbi Fisher came in August 1971. In May 1976, the main sanctuary hall was dedicated, and in 1984, a third Sefer Torah was purchased. In February 1986, the new school wing was completed.

Rabbi Fisher retired in 2002 and was given the title Rabbi Emeritus. He was succeeded by Rabbi Stephen Karol, who retired in 2014 and was also given the title Rabbi Emeritus. Rabbi Sharon L. Sobel assumed the leadership of the synagogue in July 2014. The cantor is Carol Chessler, and Michael Trachtenberg is Cantor Emeritus. Ms. Penny Gentile is the synagogue administrator.

Interior of Temple Isaiah, Stony Brook. *Image by author.*

SYOSSET

CONGREGATION SIMCHAT HA LEV, 421 Split Rock Road, Syosset, 11791 *Unaffiliated*

Congregation Simchat Ha Lev was founded in 2001 by Rabbi Jay Weinstein. His daughter, Jenn Weinstein, is the associate rabbi. Eric Komar is the cantorial soloist. Both rabbis are part of the Jewish Renewal movement. The synagogue is in a beautiful converted carriage house.

EAST NASSAU HEBREW CONGREGATION, 310A South Oyster Bay Road, Syosset, 11791 *O* (Closed)

East Nassau Hebrew Congregation was founded in 1956 by thirty-five families. The converted home that had been their synagogue was destroyed by a fire in 1964, and a new synagogue was built. In the meantime, St. Edward Confessor Catholic Church allowed the congregation to use its classrooms for a religious school.

A new building was constructed in 1967, and there are stories of up to two thousand people at certain services. By June 1965, the congregation had a membership of six hundred families. There was a Sisterhood, a Men's Club, a religious school, a Couple's Club, a youth group, a library, Hebrew high school, adult education and a summer day camp. The congregation sponsored a summer camp in the Catskill Mountains. In 2006, after some controversy between the rabbi and some of the congregants, the congregation suddenly closed. To this date, the building is empty, and the future of the congregation's assets is in the hands of the courts.

Former East Nassau Hebrew Congregation in Syosset, now vacant. *Courtesy of Special Collections Department, Hofstra University Library.*

MIDWAY JEWISH CENTER, 330 South Oyster Bay Road, Syosset, 11791 *C*

This United Synagogue of Conservative Judaism affiliate was founded by ten families in 1953. In October, a meeting was held attended by sixty families at Shaare Zedek in Hicksville. They adopted the name Midway because they chose to follow the midway between Reform and Orthodox Judaism.

In 1954, they purchased a plot at 330 South Oyster Bay Road in Hicksville. This address was later changed to Syosset. The congregation temporarily used the existing buildings on the lot but later built its present large synagogue. By 1958, membership was over four hundred families. By the mid-1980s, the peak membership of slightly over seven hundred was recorded.

In 2007, Bethpage Jewish Center merged with Midway Jewish Center. Presently, Midway is one of the largest Conservative congregations in Nassau. Perry R. Rank is rabbi, Joel Levenson is associate rabbi and Ezra M. Finkelstein is Rabbi Emeritus. Adam Frei is cantor.

Recently remodeled sanctuary of Midway Jewish Center, Syosset. *Photograph by Mark Friedman.*

MiYad, 235 Robbins Lane, Unit "N," Syosset, 11791 *O*

MiYad is an affiliate of Chabad of Long Island. The center was founded by Rabbi Chanan Krivisky. Mrs. Krivisky is the rebbetzin and program director. Rabbi Krivisky has been in Syosset since 2009.

North Shore Synagogue, 83 Muttontown/Eastwoods Road, Syosset, 11791 *R*

This Reform synagogue traces its roots to an article published in October 1952 in a weekly newspaper, the *Oyster Bay Guardian*. The article asked that all Jews interested in starting a synagogue meet later that month at the Community Church in Syosset.

During the meetings that grew out of the initial meeting, discussions were held about the nature of the synagogue to be established. Although most of the founding members were from Orthodox or Conservative backgrounds, the majority decided on Reform Judaism because they said it was more consistent with their current lifestyle and beliefs.

One of the founders, Nathalie Bernstein, wrote in the synagogue bulletin years later that there was also a great debate over what to name the synagogue. After much debate, North Shore Synagogue was chosen.

In February 1953, the first service of the new congregation was held at the Community Church of Syosset. At that service, the first baby born to a synagogue member was named Charles Muskat. He was the son of Sid and Beverly Muskat. Stanford Jarashow was the student rabbi who conducted the service. He later became the spiritual leader of Temple Judea in Massapequa.

The congregation had a membership of thirty-five families by the time it was chartered by the Union for Reform Judaism in April 1953. Just one month earlier, the first religious school classes began in the stables at the homes of Seymour Cohen and Sylvan Lawrence in Brookville.

For the High Holy Days in 1954, the congregation moved its services to the American Legion Building in Oyster Bay. The Methodist church in East Norwich became the site of regular Sabbath services. A portable Ark was made by congregant Irving Malchman, and it traveled with the congregation to each place of worship.

The property for the congregation's current location on Muttontown Road was bought in the name of Sylvan Lawrence to minimize any community

opposition to the location of a synagogue in the area. Construction began in early 1955 and was completed by Rosh Hashanah. The original part of the building is used today for a library, cloakroom and small classrooms.

The synagogue was dedicated on September 11, 1955. Congregant Connie Kraus recalled in the synagogue bulletin that "Friday night services in the new one-room synagogue were eagerly looked forward to, and not only to worship, but, to be among friends."

Membership began to grow, and soon it was necessary to raise funds to expand the building. Between 1959 and 1963, membership grew from 75 to 275 families. At that time, a separate sanctuary and a new social hall were built along with permanent classrooms.

In January 1957, the Union for Reform Judaism granted a charter to another Reform synagogue, Temple Or Elohim. Jonas Egert, a former president of the congregation, recalled in the synagogue bulletin that the Temple Or Elohim presented a drain on his congregation's membership. He noted that the new synagogue was less than two miles away. (See Temple Or Elohim under "Jericho" section.) "Instead of one flourishing congregation, we had two struggling ones," he said. A merger was attempted in 1963, with the proposal being to give Or Elohim people ten of the twenty-four board seats, that being the membership proportion. This failed.

"Later, I heard that the URJ was considering a charter application for a Reform congregation in Oyster Bay. As president, I remonstrated with the URJ, and hope this had something to do with the fact that I never heard another thing about it." That group, instead, affiliated with the Conservative movement.

In 1972, a new school building with twelve classrooms, a youth lounge and offices was built. It was dedicated to George Taback, who spearheaded the effort to get it built and died shortly after its completion.

By 1978, the congregation had 500 families and reached its peak at 650 families in 1988. It has since leveled off at around 450. Jaime Shalhevet is the senior rabbi. Rachel Maimin is the associate rabbi, and Kyle Kotler is the cantor. David A. Whitman, Daniel Fogel, Robert M. Benjamin and Louis Stein are Rabbis Emeritus.

Uniondale

Uniondale Jewish Center, 760 Jerusalem Avenue, Uniondale, 11553 *C* (Closed)

Uniondale Jewish Center was formed in May 1952 by five families, and when it was incorporated in October 1953, it had twenty-five charter families.

The congregation, also known as Congregation Lev Torah, held services throughout the community from 1952 to 1957. It appointed Rabbi Harry Roth of Flushing as its first spiritual leader. Such places as the local library, a firehouse, a local church and the Little Theatre of Hofstra College were used. A portable Aron Kodesh was carried from one location to the other. Membership had grown to eighty-five families by 1954.

In 1957, the congregation's synagogue was built, and in 1967, the mortgage was paid off. By 1972, membership peaked at a high of 120 families. By 1984, the number was down to 60.

In 1982, after thirty-five years of service to the community, the synagogue closed and merged with Suburban Park Jewish Center in East Meadow. Uniondale Jewish Center was a United Synagogue of Conservative Judaism affiliate.

Valley Stream

Chabad of Valley Stream, 550 Rockaway Avenue, Valley Stream, 11581 *O*

Chabad of Valley Stream occupies the building of the former Sunrise Jewish Center. Sunrise was founded in 1960, but in 1994, the group then known as Congregation Beth Sholom turned over operation of the building to Chabad. Rabbi Yitzchak Goldshmid is the director.

Congregation Tree of Life, 502 North Corona Avenue, Valley Stream, 11581 *C* (Closed)

Congregation Tree of Life was also known as the Alden Terrace Jewish Community Center. This United Synagogue of Conservative Judaism affiliate was founded in 1952 by fifty families, some of whom broke away from the nearby Temple Gates of Zion.

One of the synagogue's former presidents, Chaim Rosov, said that those attracted to this new congregation were more Orthodox than those at Temple Gates of Zion. The sudden influx of Jews into the community following World War II made it possible for these more traditional Jews to form their own congregation.

The new congregation also attracted those for whom Gates of Zion was too far a walk. As a result, the new congregation held services near its members' homes in a storefront on Hendrickson Avenue.

During the first year of operation, the new congregation held merger talks with Gates of Zion. A neutral site for both synagogues was bought on North Corona Avenue. Four years later, the congregation reached its peak membership of 240 families, with 120 students in the religious school. The merger talks were scrapped, and both congregations moved forward.

In 1971, the congregation paid off the mortgage on its Corona Avenue building. In 1973, women were recognized as equal members when they were granted the right to vote in congregational meetings. Jerome Dattlekramer, a rabbi with an Orthodox background, became the congregation's spiritual leader in 1978. Under his direction, the congregation maintained a traditional Conservative approach to Judaism. Women were not called to the Torah, and Bat Mitzvahs were held on Friday evenings or Sunday mornings. Indeed, the first adult Bat Mitzvah class did not take place until 1982 due to resistance in the congregation to women becoming Bnai Mitzvaot.

The synagogue closed its religious school in 1976. Members with children sent them to Gates of Zion for school. In 1985, the membership was still two hundred families, but the leaders saw that the membership was aging and attracting younger families was difficult. The group held on for another twenty-five years until finally merging into Gates of Zion to form Valley Stream Jewish Center. The former building is now the Gateway Christian Center.

Sunrise Jewish Center (Beth Sholom), 550 Rockaway Avenue, Valley Stream, 11581 *C/O* (Closed)

This is the former congregation that gave way to Chabad of Valley Stream.

TEMPLE GATES OF ZION, 322 North Corona Avenue, Valley Stream, 11581 *C*

Temple Gates of Zion, now part of Valley Stream Jewish Center as described earlier, was founded in 1929 by twenty-five families who gathered in a room over a garage in Valley Stream to conduct religious services. Temple Gates of Zion has been the victim of two devastating fires. After each blaze, the congregation has rallied together and raised the money needed to rebuild.

Like most other congregations on Long Island, this United Synagogue of Conservative Judaism affiliate grew slowly during the prewar years. By 1932, membership had grown to only forty families. It was during that year that the group was chartered by the State of New York.

In the early years, the congregation met in several places. It met in a converted building on East Mineola Avenue (now Amity Church), in a building on Sunrise Highway and in the Corona Avenue firehouse.

By 1939, the membership had risen to eighty families, and the congregation bought a building of its own at 12 East Fairview Avenue for $9,000. It secured a $5,000 mortgage on the property and immediately began to remodel it. To raise funds for the building, the congregation sold High Holy Day tickets for $5, and a family membership fee was set at $30. Two holiday tickets were included with family membership, which also included religious school classes and adult education programs. Associate memberships were available for $12 and included only holiday tickets.

With its own building, the congregation began to increase, and by 1941, it had 200 families out of a total population of 16,679 in Valley Stream. In 1941, it started a Boy Scout troop.

In 1942, a pre-kindergarten program began. The congregation started a memorial plaque program to raise funds. Plaques were sold for thirty-five dollars each. Temple Gates of Zion had now developed into a viable congregation. In 1943, a fire caused extensive damage to the building. The group moved to the local firehouse while repairs were made.

Records from the first report from the religious school committee, dated 1945, showed fourteen students in the weekday program and thirty-one in the Sunday morning program. The following year, the first confirmation class was held for five boys and five girls.

After World War II, many young Jewish families moved to Valley Stream. In 1951, a group of Jews in neighboring Elmont indicated a desire to form their own Conservative synagogue. An effort was made to have them merge with Gates of Zion, but the idea was dropped and the Elmont residents began their own synagogue.

Another group wanted to start their own Conservative congregation in Green Acres. The members were helped by Gates of Zion's rabbi, but congregants were seriously opposed to another congregation so near. The group's members were persuaded to join Gates of Zion, which by now had 190 students in its religious school. The year 1951 saw the hiring of Cantor David Mann as the first full-time cantor. In 1952, Rabbi Simon Resnikoff arrived and stayed until his death in 1987.

In April 1953, the congregation bought the property that it occupies today on North Corona Avenue. The building was erected over a two-year period, during which High Holy Day services were held at the former Valley Stream Theater.

The site for the synagogue was selected to accommodate members of Congregation Tree of Life, which had been formed by former Gates of Zion members because they didn't live within walking distance. The informal merger was short-lived and scrapped.

To celebrate the dedication of the building in 1955, the Village of Valley Stream proclaimed September 9, 10 and 11 as "Temple Gates of Zion Weekend." The new building, which was still not complete, was to include a sanctuary, a social hall, a gymnasium, classrooms, a library and offices. It was not completed until May 1963.

In 1966, there was, for the first time, a decline in membership. Membership hit a peak of 750 families in 1965, and there were 850 children enrolled in the religious school. In 1970, poor attendance forced the discontinuation of the Sunday school.

Disaster again struck in the form of fire, this time on Thanksgiving Day 1980. The blaze ruined much of the interior, and it was not until September 1981 that congregants could even reenter their building, meeting in the gymnasium in the rear of the synagogue. Eleven firemen were injured in the blaze, including two who later died from their injuries. A young man wanted his Bar Mitzvah conducted in the only available room, the gymnasium, rather than in a beautiful sanctuary in another synagogue because his father and grandfather had both been Bnai Mitzvaot at Gates of Zion.

The renovated synagogue was dedicated in September 1982. Tribute was paid to the members of the Valley Stream Fire Department at the dedication for saving all the Torah Scrolls. Rabbi Resnikoff was appointed chaplain of the fire department, the first rabbi so appointed.

By 1975, membership was 350 families, with an additional 100 or so associate members. There were just 44 children in the religious school. The

congregation stayed strong as the membership continued to decline because of an aging and changing population. In 2009, the group merged with Congregation Tree of Life to form Valley Stream Jewish Center.

TEMPLE HILLEL (SOUTHSIDE JEWISH CENTER), 1000 Rosedale Road, Valley Stream, 11581 *C*

The first service held by the founders of this congregation was on Rosh Hashanah in 1955. It was formed in a large part through the efforts of Herbert Shumer, who moved to North Woodmere in October 1954.

Soon after settling in the community, Shumer enrolled his children in the afternoon religious school program at Temple Gates of Zion in Valley Stream, which was the closest in the area. He quickly became tired driving the long distance to Valley Stream, and he learned that many Jews were not buying homes in North Woodmere because it didn't have a synagogue.

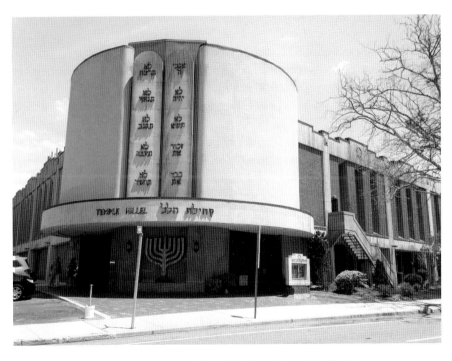

Temple Hillel, Valley Stream. *Courtesy of Jewish Heritage Society of the Five Towns.*

In June 1955, Shumer spotted a large, unused garage in the rear of Hoeffner's Gas Station on Rosedale Road in North Woodmere. When he learned about it, Anthony Hoeffner told him that the building had been used as a storage shed for vehicles and had even been the site of old-time barn dances. Shumer asked to rent it so he could hold Shabbat services there, but Hoeffner would accept no money and offered the building at no charge.

Shumer then set to work with other area Jews to distribute leaflets and postcards describing High Holy Day services at the garage. At a meeting held at the home of Hy Shecter, it was decided to incorporate as a Conservative synagogue. Shumer was elected president. They also hired a rabbi and a cantor and, with the help of at least forty friends, converted the garage into a synagogue. The walls were draped, chairs were set up, a bima was built, a Holy Ark was installed and Torahs were purchased.

High Holy Day tickets were sold, and 250 persons attended. In appreciation for his generosity, Hoeffner—a non-Jew—was presented with a gold watch and thanked for his exceptional display of what Shumer called "brotherly love."

Sam Davis was appointed to find a site for a permanent synagogue. The synagogue was known as North Woodmere Jewish Center at the time. Davis and his committee found a plot on Rosedale Road not far from the Hoeffner garage, and it was purchased. A modest building was quickly designed containing a sanctuary, classrooms and meeting rooms.

Groundbreaking ceremonies were held on July 1956, and the foundation was poured the next month. Six weeks later, the building was erected at a cost of $16,000. High Holy Day services were held there just days after the building was up, even though the interior walls were not completed. After the holidays, the building was partitioned to form classrooms, and the religious school began.

On January 20, 1957, the synagogue was dedicated. It was now known as Southside Jewish Center, sometimes referred to as Valley Stream South Jewish Center. By the High Holy Days of 1957, the larger numbers compelled the congregation to flatten the land next to its new building, so a tent could be erected to accommodate the seven hundred persons who attended services. Dues that year were fifty dollars per family, which included two adult High Holy Day tickets.

In June 1958, the name of the congregation was changed from Southside Jewish Center to Temple Hillel—Southside Jewish Center. Membership in 1958 reached four hundred families, and a tent to accommodate one thousand persons was used for Rosh Hashanah and Yom Kippur.

On March 12, 1958, an architect was selected to begin work on a larger, more permanent synagogue. The building that the congregation had built so quickly was demolished, and work on a new synagogue began on April 12, 1959. During the construction period, a building at 950 Park Lane was found to house all congregational services, classes and activities. During the High Holy Days, 1,000 persons worshiped under a tent at the corner of Flanders Drive and Park Lane. By 1960, the religious school had an enrollment of 250 students, and there were upward of 400 children in the youth program.

On September 17, 1960, dedication ceremonies were held for the new building. More than 500 persons attended. High Holy Day services in 1960 attracted 1,200 persons, and all were accommodated within the confines of the new building. Membership increased to 600 families by 1961.

The rapid increase in membership made it obvious that an expansion was needed. Plans were made to add a second floor, and $40,000 in pledges were raised during Kol Nidre and building fund appeals.

The addition would cost $100,000, and time was becoming important. Bonds in $250 denominations were sold to be repaid in five to ten years. The congregation's members bought enough bonds to permit construction of the second floor. The bonds were repaid in full within two years—three to eight years ahead of schedule.

Religious school enrollment increased in 1960 to more than four hundred children, and an additional eighty children attended just on Sundays. The forty children who graduated in 1960 were forced to take comprehensive exams, and seventeen of them continued on to a Hebrew high school.

In September 1963, the congregation welcomed Rabbi Morris Friedman, who was granted life tenure in 1970. In September 1965, the membership was 850 families, and there were 600 children in the religious school. In 1967, the peak membership of 900 families was reached.

In 1977, the synagogue building got a new façade. The new design included a replica of the Ten Commandments and new front doors. On May 14, the minyan group gathered and affixed a mezuzah to the front door post. In 1978, a Holocaust memorial, consisting of six stained-glass panels shaped like the burning bush, was installed.

In 1984, while serving as president of the New York Board of Rabbis, Rabbi Friedman entertained President Ronald Reagan. The event took place just a few weeks before Election Day, and Reagan addressed an overflow crowd in the synagogue. It was the first appearance by a sitting president

in a synagogue since George Washington visited the Touro Synagogue in Newport, Rhode Island, in 1790. Regan then dined with the rabbi and his wife, Addi, at their home.

Demographics were changing in Valley Stream, and Temple Hillel was not exempt. Numbers started to drop in 1989, and the membership leveled off at about 350 in 2000. It remains strong, and its building is spacious and well kept. Rabbi Steven M. Graber and Ritual Director Steven Blitz lead the congregation.

TEMPLE JUDEA, 195 Rockaway Avenue, Valley Stream, 11581 *R* (Closed)

No information was found about this former Reform congregation.

VALLEY STREAM JEWISH CENTER, 332 North Corona Avenue, Valley Stream, 11581 *C*

Valley Stream Jewish Center represents the merger of Congregation Tree of Life (the Alden Terrace JCC) into Temple Gates of Zion in 2009. The merged group occupies the building of the former Gates of Zion. The individual histories were recorded earlier.

WANTAGH

CONGREGATION BETH TIKVAH, 3720 Woodbine Avenue, Wantagh, 11793 *C*

Congregation Beth Tikvah (CBT) is the result of two mergers consolidating three former long-standing Conservative congregations. In 2007, the Farmingdale Jewish Center and the Wantagh Jewish Center combined to become the Farmingdale-Wantagh Jewish Center. Farmingdale's building was sold, and the merged congregation consolidated all activity to Wantagh's building. In 2010, Israel Community Center (ICC) of Levittown joined the merger. In August 2012, the congregation officially changed its name to Temple Beth Tikvah.

On October 29, 1950, the group known as the Wantagh Jewish Community Group was formed and voted to affiliate with the United Synagogue of Conservative Judaism. Rabbi Moredecai Rubin was hired as

a weekend rabbi, as well as for the High Holy Days. In May 1953, ground was broken for the synagogue.

Max Shapiro was elected the first congregational president. Claire Rogoff was the first Sisterhood president, and Ted Rothenberg was the initial Men's Club president. The years 1953–54 saw the first bazaar and the first Hebrew school commencement. On December 6, 1953, the building was dedicated.

The groundbreaking for a new, more permanent building took place in 1957. In 1958, the group hired an educational director and a youth director. On March 20, 1965, the congregation held its "Bar Mitzvah Celebration" in honor of Rabbi Rubin and the congregation's early presidents. Rabbi Max Routtenberg of Rockville Centre, president of the Rabbinical Assembly, was the guest speaker.

Rabbi Howard Morrison, who led the congregation for nine years, succeeded Rabbi Rubin. In 2003, Rabbi Alan Lavan joined the synagogue and continues as rabbi to this day. On April 15, 2007, at separate meetings, the congregants of Farmingdale and Wantagh Jewish Centers, by large numbers, approved a merger. It took effect on July 1, 2007. In 2010, Israel Community Center of Levittown joined the group to form the newly named Temple Beth Tikvah. The individual histories of Farmingdale Jewish Center (under "Farmingdale") and Israel Community Center (under "Levittown") are discussed earlier in this volume. The congregation is a longtime affiliate of the United Synagogue of Conservative Judaism.

TEMPLE BNAI TORAH, 2900 Jerusalem Avenue, Wantagh, 11793 *R*

Temple Bnai Torah is the result of the merger of Temple Judea of Massapequa into Suburban Temple of Wantagh in 2008.

The 1950s were an eventful time for Jews on the South Shore of Long Island. There was a giant influx of young Jewish couples, primarily from Brooklyn, the Bronx, Manhattan and Queens. Most of the new residents came from Orthodox or Conservative homes. Many discovered that they preferred something different and established Reform congregations.

In Wantagh and Massapequa, the Suburban Temple and the Massapequa Jewish Center (later called Temple Judea in 1970) were created. Their histories were very much alike.

Both temples experienced great growth during their early years. Both temples had a series of part-time rabbis. Rabbi Harold Krantzler (in 1958) and Rabbi Robert Rush (in 1962) were installed as the first full-time religious

leaders of Temple Judea and the Suburban Temple. At the time of transition, in 2008, Rabbis Michael Kramer and Jeffrey Gale were the leaders.

Both temples started building their facilities slowly. Both temples had policies that discouraged the wearing of tallesim or yarmulkas in the sanctuary. Education and youth groups were always important in both congregations.

Numbers started to fall in the late 1990s as the demographics of the area started to change. The leadership of both congregations saw the future and recommended to both their memberships a merger in Wantagh's building. The merger was approved and took effect in 2008 with the sale of the Massapequa building. Numbers have leveled off in the past ten years, and the congregation remains vibrant under Rabbi Howard Nacht and Cantor Steven Sher.

Water Mill

Chabad of Water Mill, 40 Winding Way, Water Mill, 11976 *O*

Chabad of Water Mill, under the direction of Rabbi Levi Baumgarten, is an affiliate of Chabad of Long Island. It is truly a "shul with a pool," as there is a beautiful swim facility on the grounds.

Westbury

Community Reform Temple, 712 The Plain Road, Westbury, 11590 *R*

The Community Reform Temple was founded in 1958. The first synagogue was the old building of Westbury Hebrew Congregation at 275 Ellision Avenue. When the congregation left Ellison Avenue for its current building in 1975, the Holy Ark was removed and given to the Union for Reform Judaism Camp in Warwick, New York. The group absorbed Temple Beth Avodah of Levittown through a merger in the early 1970s. It is an affiliate of the Union for Reform Judaism. Rabbi Judy Cohen-Rosenberg has led this congregation since 1992.

TEMPLE BETH TORAH, 243 Cantiague Rock Road, Westbury, 11590 *C*

Temple Beth Torah was founded by twenty families in 1959 who broke away from Temple Sholom of Westbury because it was too far to walk and the services were a bit too traditional for their tastes.

The members of the group held the first services in a converted barn they bought, and by their second year of operation, membership had increased to eighty families. The congregation operated a religious school from the beginning.

In 1962, the congregation razed the barn to make way for construction of a new building. Then, in 1972, an extension was built to house a large social hall and additional classrooms.

The congregation reached a membership of 230 families in 1976. It then lost about 50 families before experiencing a resurgence in the early 1980s as young Jewish families began to move into nearby Jericho, Brookville and Muttontown. Membership climbed to a new high of 255 families, and 104 children were enrolled in the religious school. Unlike neighboring Temple Sholom, Temple Beth Torah was early in calling women to the Torah and counting women in minyanim.

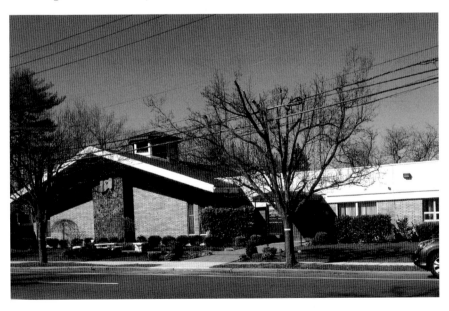

Temple Beth Torah, Westbury. *Photograph by Mark Friedman.*

Rabbi Michael Katz has served the congregation since 1979. Cantor Kalman Fliegelman has been with the congregation since 1962. Ms. Oma Sheena is the educational director. TBT, as the congregation is sometimes referred to, is a longtime affiliate of the United Synagogue of Conservative Judaism.

TEMPLE SHOLOM, 675 Brookside Court, Westbury, 11590 C

Temple Sholom, also referred to as Birchwood Jewish Center, was established in 1956, and the first organizing meetings generated an attendance of over 100 persons. Almost immediately, the group affiliated with the United Synagogue of Conservative Judaism and stayed in the organization until 2006. By 1967, the membership was at its highest, at more than 350 families. For many years, Maurice Aranov served as rabbi, and Rabbi Michael Scholar assisted him. The congregation had an active Sisterhood, Men's Club and youth group throughout the '60s and '70s. In 1980, the group reported about 200 families.

Temple Sholom, Westbury. *Photograph by Rabbi Simcha Zamir.*

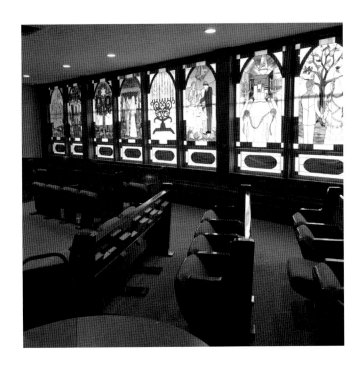

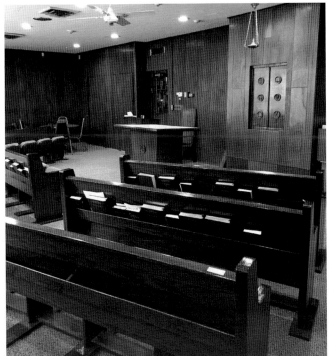

Top: Temple Sholom, stained-glass windows, Westbury. *Photograph by Rabbi Simcha Zamir.*

Bottom: Temple Sholom, daily chapel, Westbury. *Photograph by Rabbi Simcha Zamir.*

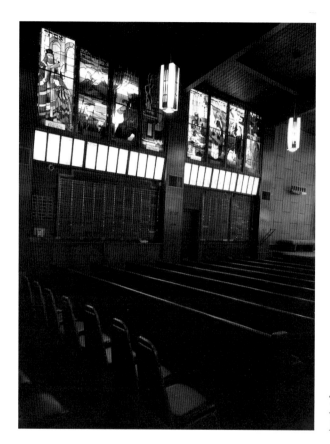

Temple Sholom's windows. *Photograph by Rabbi Simcha Zamir.*

Starting in the very late 1990s, the demographics of the surrounding neighborhoods (Temple Sholom is in a residential neighborhood) changed dramatically. By 2016, membership had fallen to about thirty families, mostly senior citizens. It is only through being able to rent part of its building to a nonprofit organization, proper planning and a full-time rabbi, Simcha Zamir, who is truly dedicated to his small congregation, that Temple Sholom remains a strong, vibrant little group. The building is extremely well kept and, in most ways, looks exactly as it did in 1965.

Temple Sholom was always a very traditional Conservative synagogue and was among the last to become egalitarian.

WESTHAMPTON BEACH

THE HAMPTON SYNAGOGUE, 154 Sunset Avenue, Westhampton Beach, 11978 *O*

The Hampton Synagogue was founded by Rabbi Marc Schneier in 1990 by holding minyanim in his home. The Village of Southampton sued to stop services from being conducted there, but the synagogue prevailed in the state appellate court.

In 1994, the synagogue building on Sunset Avenue was dedicated. It is a beautiful, modern synagogue. The congregation and its rabbi are often referred to as the "Synagogue of the Stars," as many famous and important people have been members, guest speakers or guests there. Cantor Netanel Hershtik is responsible for the melodic services, and Mr. Izchak Haimov is the choral director.

During the summer months, the congregation has myriad social events and guest lecturers. Services follow modern Orthodox ritual. There is slightly more emphasis on nusach and choral singing than in most Orthodox synagogues. The congregation is responsible for the eruv around Westhampton, Westhampton Beach and Quogue.

WEST HEMPSTEAD

CHABAD OF WEST HEMPSTEAD, 411 Hempstead Turnpike, Suite L-1, West Hempstead, 11552 *O*

This affiliate of Chabad of Long Island was originally located at 223 Windsor Lane. The center offers minyanim, women's and children's programs and religious education programs.

CONGREGATION ANSHEI SHALOM, 472 Hempstead Turnpike, West Hempstead, 11552 *O*

Anshei Shalom is a modern Orthodox synagogue under the leadership of Rabbi Elon Soniker. Yehuda Pearl is the Rabbi Emeritus, and Benyamin Rosenstock is president.

The congregation meets in a modern building with daily minyanim and several Shabbat minyanim, including a Sephardic minyan. The

congregation enjoys a beautiful Kiddush each Shabbat with the rabbi. There is a Sisterhood, a youth department and a Chesed Committee.

CONGREGATION ETZ CHAIM OF DOGWOOD PARK, 661 Dogwood Avenue, West Hempstead, 11552 *O*

Etz Chaim is an Orthodox congregation located in the Dogwood Park section of West Hempstead. The synagogue, in addition to minyanim and Shabbat services, offers a Sisterhood, a large array of adult education programs for both men and women and a youth program. There is a mikveh and an active social program.

CONGREGATION SHAARAY SHALOM, 711 Dogwood Avenue, West Hempstead, 11552 *C*

Shaaray Shalom represents the 2014 merger of Franklin Square Jewish Center and West Hempstead Jewish Community Center in West Hempstead's building. The Franklin Square building was sold, and the new congregation took the name Shaaray Shalom. The history of the Franklin Square Jewish Center is in this volume under the heading of "Franklin Square."

There were 6 founding families of this United Synagogue of Conservative Judaism affiliate in 1951. They were all from Franklin Square and were known as "the Patterson Avenue 6." They operated out of a storefront until Percival Goodman designed their present building, which opened in 1958. In 1970, the congregation hit 750 families, a high. In 1986, the membership was 375 families. Today, with the additional Franklin Square people included, membership has leveled off at about 300. There is an active Hebrew school that also educates the students from Malverne Jewish Center, which no longer operates a Hebrew school.

The synagogue boasts a collection of Jewish art that includes large stained-glass windows featuring the twelve tribes of Israel and a Holocaust Memorial Case containing a Torah that survived the Holocaust. There is also a Sisterhood, Men's Club, Couple's Club, Senior Citizens Group, a youth department and a library.

Rabbis Art Vernon and Ed Goldstein and Cantor Todd Rosner lead the congregation.

Congregation Zicron Kadosheem, 271 Dogwood Avenue, West Hempstead, 11552 *O*

Congregation Zicron Kadosheem is an Orthodox synagogue under the leadership of Rabbi Binyamin Baras. The congregation has a full schedule of minyanim and a mincha-shalas/maariv minyan on late Saturday afternoon.

Nassau Community Temple, 240 Hempstead Avenue, West Hempstead, 11552 *R* (Closed)

Nassau Community temple represented a merger of Temple Judea of Laurelton, Queens County and Nassau Community Temple of West Hempstead. The synagogue disbanded in 1993 and sold its building to the Hebrew Academy of Nassau County.

At the time this Reform congregation was formed in 1945, the closest synagogue to West Hempstead was the Conservative synagogue in Hempstead. Many of the young couples moving to this area preferred to join Reform synagogues.

The impetus for the creation of a Reform synagogue came about after several unaffiliated families met at a social club run by the Hempstead synagogue. When a group of forty non-members expressed an interest in starting their own Reform congregation—in part to provide their children with a Jewish education and social life—a committee of five set to work on the details.

The project was almost stopped in its tracks when an emissary from the Union for Reform Judaism (then known as the UAHC) met with the forty families and tried to convince them to join Reform synagogues in neighboring towns. He argued that it was better to have fewer but stronger synagogues.

But when the UAHC saw that these couples would not take no for an answer, it helped them form a new congregation. Initially, services were led by a student rabbi provided by the UAHC. The group met above a real estate office in Hempstead. Later, services were held at an American Legion Hall near the Lakeview railroad station. Religious school classes were also held there.

After a few months, the group bought a parcel of land and built a Quonset hut–style building on Woodfield Road for $60,000. The auditorium had seating for three hundred persons, and the building had six classrooms. The acoustics were terrible, the building was inadequate and plans were soon

made to once again find a new home. The last building was constructed in 1960.

The congregation initially relied on part-time student rabbis, but in 1951, it hired Rabbi Sidney Ballon on a full-time basis. He was later given life tenure and assisted the congregation in absorbing Temple Judea of Laurelton into the congregation. Several rabbis followed, including Leonard Troupp and Linda Henry Goodman. The peak membership of five hundred families was attained in 1968. By 1986, it was down to three hundred. By the time the group disbanded in 1993, there were only ninety-five families.

YOUNG ISRAEL OF WEST HEMPSTEAD, 630 Hempstead Avenue, West Hempstead, 11552 *O*

Nine families are credited with establishing this Orthodox synagogue in 1954, just one year after the Hebrew Academy of Nassau County opened its doors in the community. They began as the West Hempstead Synagogue.

The synagogue grew because the Hebrew Academy, a yeshiva, was attracting Orthodox families to West Hempstead. The families met at the academy until 1965, when they built a small building at 240 Hempstead Avenue. Rabbi Yehudah Kelemer has been the spiritual leader since 1983, and in 2013, Rabbi Josh Golier joined the congregation as assistant rabbi.

By the late 1990s, the building had become too small, as membership was at three hundred families. A new, much larger and modern building was constructed at the present address. The congregation maintains minyanim, a Sisterhood, a large young families program and a youth department. There are many educational opportunities for men, women and children.

WEST ISLIP

CHABAD CENTER OF THE SOUTH SHORE, 6 Myson Street, West Islip, 11795 *O* (Closed)

This former affiliate of Chabad of Long Island was founded in 2000 and is no longer active.

WEST ISLIP JEWISH CENTER, 804 Udall Road, West Islip, 11795 *C* (Closed)

This group began around 1964 as Young Israel of West Islip and held 1964 High Holy Days services at the American Legion Hall, 340 Union Boulevard. In April 1965, the affiliation was changed from Orthodox to Conservative. It is no longer active.

WOODBURY

MAKOM CONGREGATION, PO Box 383, Woodbury, 11797 *Unaffiliated*

Makom is an independent congregation following Reform ritual. Rabbi Deborah K. Bravo was ordained by the Hebrew Union College–Jewish Institute of Religion, the Reform seminary.

Makom does not have a specific, permanent home. Makom usually meets for Shabbat services at the Bethpage Community Center (former home of the now defunct Bethpage Jewish Center). High Holy Day services in 2016 were held at Woodbury Convention Center. During the summer, services are usually held in the Syosset-Woodbury Park on Jericho Turnpike. An informal Hebrew school is available, and Bar and Bat Mitzvah training is available as well.

TEMPLE SHOLOM, 7600 Jericho Turnpike, Suite 308, Woodbury, 11797 *R*

Temple Sholom is an independent congregation with Reform but traditional ritual. The congregation was founded in 2011 by Rabbi Alan C. Stein, who is also a practicing attorney. Rabbi Stein's son, Stephen, serves as cantor.

TOWN OF OYSTER BAY CHABAD, 678 Woodbury Road, Woodbury, 11797 *O*

Rabbi Shmuel Lipszyc leads this affiliate of Chabad of Long Island. The center conducts daily services, social activities, adult education classes and a Hebrew school. Mrs. Brocha Lipszyc is also active in all parts of the center, including leading special women's programs.

WOODBURY JEWISH CENTER, 200 South Woods Road, Woodbury, 11797 *C*

Woodbury Jewish Center is a constituent of the United Synagogue of Conservative Judaism. In March 1989, Mark Anesh, Steven Carl and Michael Fass called together twenty individuals at the Anesh home to discuss the need to form a Conservative synagogue for Woodbury.

There was no other Conservative synagogue within five miles, and at that time, no other synagogue in Woodbury at all. Several did not want to drive on the Sabbath.

To start, they met and held services at the Mid-Island Y. There was local opposition to using the Y as a synagogue. The founding 20 families grew to 175 within two years. By the fall of 1990, 500 people were meeting in a tent for High Holy Day services.

They bought their present lot on South Woods Road from a Catholic church. Again there was local opposition to a synagogue. Swastikas were painted on their sign. After a battle with local authorities, the group found a caterer to assist them in raising funds, and their building was ready in September 1991. In 2002, an expansion project called "L'dor Va'dor," "From generation to generation," was completed.

Rabbi Robert I. Summers was the first rabbi. Present leaders of the congregation are Rabbi Neil Tow and Cantor Aaron Cohen.

WOODMERE

BAIS MIDRASH OF WOODMERE, 305 Forest Avenue, Woodmere, 11598 *O*

Bais Midrash of Woodmere was founded in August 2013 by a group of enthusiastic individuals in the hope of establishing a synagogue where Talmud Torah would infuse their lives and the lives of their families. The congregation is led by Rabbi Akiva Wiling (formerly of Riverdale, New York). It is in the midst of a fundraising drive and hope to construct a new building as soon as possible.

CONGREGATION AISH KODESH, 353 Woodmere Boulevard, Woodmere, 11598 *O*

Congregation Aish Kodesh was the dream of two of its founders in the fall of 1992. They knew that a rabbi with strong leadership, teaching and

educational skills was necessary for the type of synagogue they envisioned. They were fortunate to find an inspired and inspiring young rabbi in Moshe Weinberger.

On December 4, 1992, they met at the Woodmere Academy for their first Shabbat service. Rabbi Weinberger chose the name Aish Kodesh to honor the name of the late Rabbi K.K. Shapiro, author of *Aish Kodesh*—a stirring, thought-provoking sefer the rabbi wrote during his tragically brief tenure as Rebbe of the Warsaw ghetto. The congregation continues to grow.

CONGREGATION BAIS EPHRAIM YITZCHOK, 812 Peninsula Boulevard, Woodmere, 11598 *O*

This synagogue was founded in 2002 under the guidance of Rabbi Sholom Rosner, who led the congregation from 2002 to 2008. In 2008, Rabbi Zvi Ralbag succeeded Rabbi Rosner.

CONGREGATION BAIS TEFILAH, 409 Edward Avenue, Woodmere, 11598 *O*

In the winter of 1988, a small group of Orthodox Jews living in the Woodmere-Cedarhurst area began holding services in people's homes with singular purposes in mind: to pray in a proper fashion, with concentration and devotion to God, and to learn and study Torah in a proper environment.

Later that same year, a synagogue was established on the corner of Peninsula Boulevard and Edward Avenue. In keeping with their ideals, the synagogue took on the name Bais Tefilah. With barely a minyan in the first few weeks, the synagogue has slowly grown over its twenty-five-year history. Rabbi Ephraim Polakoff is the spiritual leader.

CONGREGATION ETZ CHAIM, 732 West Broadway, Woodmere, 11598 *O* (Closed)

This synagogue closed in 1956.

CONGREGATION SONS OF ISRAEL, 111 Irving Place, Woodmere, 11598 *C*

This United Synagogue of Conservative Judaism affiliate was founded by fewer than 50 families in 1926 and grew to 150 in less than two years. By 1986, it had reached a high of 805 families. In 2015, it reported a membership of about 450 families as the neighborhood became Orthodox and Conservative Jews were moving away.

Bruce Ginsberg serves as rabbi, and the cantor is Moshe Weiss. Harriet Gefen is now in her thirtieth year as educational and executive director. They join many distinguished past clergy. Rabbi David Rubin (1932–42), Rabbi Elias Blackowitz (1942–46), Rabbi Irving Miller (1946–63) and Rabbi Saul Teplitz (1963–91) all have served Sons of Israel.

WOODSBURGH

WOODSBURGH MINYAN, 850 Keene Lane, Woodsburgh, 11598 *O*

This is an Ashkenazi minyan led by Rabbi Lewis S. Weinurker. Although Woodsburgh shares a zip code with neighboring Woodmere, it is a separate incorporated village. The group meets for Friday mincha and maariv and Shabbat morning shacharit, mincha and motsei Shabbat services.

CONCLUSION

Long Island was an excellent area to study because the Jewish population went from thirty thousand before World War II to hundreds of thousands less than twelve years later. The reasons for this tremendous rise were discussed throughout the book. What will things be like in ten years? In twenty-five years? In fifty years?

The author has discussed this subject with many rabbis and lay leaders of synagogues and other Jewish groups on Long Island. Some are deeply pessimistic, feeling that all we will see is more mergers until there are a few "Last Man Standing" congregations in each quadrant of Long Island among the Reform and Conservative movements. All agree that most Orthodox congregations will remain because they operate with a much smaller base within a particular erev. Some even feel that the Reform and Conservative movements may morph into one movement by 2065. As to the Reconstructionist and Independent synagogues, each will probably have to stand on its own merits. Others are optimistic, feeling that communities have a habit of changing demographically and then changing back.

As we go to press, three more mergers are being discussed. Two or three other mergers are seen by most as inevitable. The question is not *if* but *when*.

We can all help keep Jewish institutions alive in one particular way: supporting them. We must support them not only financially but also by participating in the activities they sponsor.

TRANSLITERATIONS, TRANSLATIONS AND DEFINITIONS

Following are some of the synagogue names referred to in this volume and their meanings:

AGUDATH ISRAEL: Union of Israel
AHAVAT YISROEL: Love of Israel
AM ECHAD: One Nation
BAIS MIDRASH: House of Study
BETH CHAIM: House of Life
BETH DAVID: House of David
BETH EL: House of God
BETH SHOLOM: House of Peace
BETH TEFILLAH: House of Prayer
BNAI ISRAEL: Children of Israel
CHOFETZ CHAIM: Desirer of Life
EMANU EL: God is with us
KEHILATH SHOLOM: Congregation of Peace
KEHILLAS BAS YISROEL: Congregation of the House of Israel
KEHILLAS CHOVEVI TZION: Congregation of the Lovers of Zion
L'DOR VA'DOR: From Generation to Generation
SHAAREI TEFILLAH: Gates of Prayer
SHAAREI TZEDEK: Gates of Justice
TIFERETH ISRAEL: Glory of Israel
TORAH OHR: Torah Is Light

GLOSSARY

Aliyah: the honor of being called to the Torah.

ark: the place in the synagogue where Torah Scrolls are kept; in Hebrew: *aharon kodesh*.

Bar Mitzvah: a term denoting the transition from childhood to adulthood and acceptance of the responsibilities of observing the precepts of Judaism for boys.

Bat Mitzvah: a term denoting the transition from childhood to adulthood and acceptance of the responsibilities of observing the precepts of Judaism for girls.

Brit Milah: religious circumcision of male child, usually on the eighth day after birth.

cantor: one who officiates with the rabbi at synagogue services and sings cantorial music during prayers; in Hebrew: *hazaan*.

chupah: a ceremonial canopy used for Jewish weddings.

Conservative: a movement within Judaism, governed by United Synagogue of Conservative Judaism.

diaspora: any place outside Israel where Jews live.

eruv: a symbolic extension of individual or town boundaries (such as a highly placed cable around an area) that would allow various forbidden activities to be performed, such as carrying objects, wheeling a baby carriage or cooking on Shabbat.

kosher: a term for things ritually faultless, especially food.

mechitza: a Hebrew term for a screen or drape used in Orthodox synagogues to separate men and women during services.

minyan: a quorum of at least ten men (Orthodox) or men and women (Reform, Conservative, Reconstructionist) over thirteen years of age required to be present for public services to be held.

Oneg Shabbat: social collation after Shabbat services.

Orthodox: a movement within Judaism (Chabad, Young Israel and AISH are examples); generally, it is the most traditional.

rabbi: a leader of a synagogue; the actual definition is teacher.

Reconstructionist: a movement within Judaism, governed by Reconstructionist Rabbinical College; it broke away from the Conservative movement.

Reform: a movement within Judaism, governed by Union for Reform Judaism.

tallit: a prayer shawl.

yarmulke: a head covering.

yeshiva: an institute for Talmudic or/and rabbinic study.

MEMBER SYNAGOGUES OF THE UNION FOR REFORM JUDAISM IN NASSAU AND SUFFOLK COUNTIES

Central Synagogue of Nassau County, ROCKVILLE CENTRE
Community Reform Temple, WESTBURY
Community Synagogue, PORT WASHINGTON
Garden City Jewish Center, GARDEN CITY
North Country Synagogue, GLEN COVE
North Fork Reform Temple, CUTCHOGUE
North Shore Temple, SYOSSET
Port Jewish Center, PORT WASHINGTON
Temple Adath Israel, SAG HARBOR
Temple Am Echad, LYNBROOK
Temple Avodah, OCEANSIDE
Temple Beth David, COMMACK
Temple Beth El, GREAT NECK
Temple Beth El, HUNTINGTON
Temple Beth Torah, MELVILLE
Temple Bnai Israel, OAKDALE

Logo of the Union for Reform Judaism.

Temple Bnai Torah, Wantagh
Temple Chaverim, Plainview
Temple Isaiah, Great Neck
Temple Isaiah, Stony Brook
Temple Judea, Manhasset
Temple Sholom, Floral Park
Temple Sinai, Massapequa
Temple Sinai, Roslyn Heights
Temple Tikvah, New Hyde Park

UNITED SYNAGOGUE OF CONSERVATIVE JUDAISM CONGREGATIONS IN NASSAU AND SUFFOLK COUNTIES

Bellmore Jewish Center, BELLMORE
Chevrat Tefilah, PORT WASHINGTON
Congregation Beth El, MASSAPEQUA
Congregation Shaaray Shalom, WEST HEMPSTEAD
Congregation Tifereth Israel, GLEN COVE
Congregation Tifereth Israel, GREENPORT
Conservative Synagogue of the Hamptons, EAST HAMPTON
Dix Hills Jewish Center, DIX HILLS
East Meadow Jewish Center, EAST MEADOW
East Northport Jewish Center, EAST NORTHPORT
Huntington Jewish Center, HUNTINGTON
Kings Park Jewish Center, KINGS PARK
Lake Success Jewish Center, GREAT NECK
Manetto Hill Jewish Center, PLAINVIEW
Merrick Jewish Center, MERRICK
Midway Jewish Center, SYOSSET
North Shore Jewish Center, PORT JEFFERSON STATION
Oceanside Jewish Center, OCEANSIDE
Old Westbury Hebrew Congregation (Shir Ami), OLD WESTBURY
Plainview Jewish Center, PLAINVIEW
Shelter Rock Jewish Center, ROSLYN
South Baldwin Jewish Center, BALDWIN
South Huntington Jewish Center, MELVILLE

Logo of the United Synagogue of Conservative Judaism.

Temple Beth Chai, HAUPPAGUE
Temple Beth El, CEDARHURST
Temple Beth El of Bellmore, NORTH BELLMORE
Temple Beth Israel, PORT WASHINGTON
Temple Beth Sholom of Roslyn Heights, ROSLYN
Temple Beth Sholom of Smithtown, SMITHTOWN
Temple Beth Tikvah (Farmingdale-Wantagh Jewish Center), WANTAGH
Temple Beth Torah, WESTBURY
Temple Bnai Sholom—Beth David, ROCKVILLE CENTRE
Temple Hillel (Southside Jewish Center), VALLEY STREAM
Temple Israel, GREAT NECK
Temple Israel, RIVERHEAD
Temple Israel of South Merrick, MERRICK
Valley Stream Jewish Center, VALLEY STREAM
Woodbury Jewish Center, WOODBURY

MEMBER CONGREGATIONS OF THE CENTRAL SUFFOLK JEWISH ALLIANCE

The mission of the Central Suffolk Jewish Alliance is to strengthen and enhance the identity of the Jewish community of Suffolk County, Long Island. We coordinate events and programming to encourage engagement with Jewish life and affiliation with synagogues and temples" (from CSJA website, www.centralsuffolkjewishalliance.org).

Bay Shore Jewish Center, Bay Shore
Bnai Israel Reform Temple, Oakdale
East Northport Jewish Center, East Northport
Kehilla Chovevi Tzion, East Setauket
Mastic Beach Jewish Center, Mastic Beach
North Shore Jewish Center, Port Jefferson Station
Temple Beth Chai, Hauppague
Temple Beth David, Commack
Temple Beth El, Patchogue
Temple Beth Sholom, Smithtown
Temple Beth Torah, Melville
Temple Isaiah, Stony Brook

MEMBER CONGREGATIONS OF THE EAST END JEWISH COMMUNITY COUNCIL

The East End Jewish Community Council was founded to unite Jews, synagogues and organizations on Eastern Long Island for mutual benefit, to serve as one voice representing the local Jewish community.

The Council is here to serve you, and we invite you to become a member of our exciting group. Through your participation, you can have a voice in all that we do. Indeed, the success of the Council depends on you!

Membership information can be found at www.eejcc.com. For further information feel free to contact us. If you have a question that needs an immediate response call us at 631-353-0803. You may also write us at: EEJCC, P. O. Box 2849, Aquebogue, NY 11931" (these three paragraphs were reprinted from EEJCC website).

CONSERVATIVE CONGREGATIONS

Congregation Tifereth Israel, GREENPORT
The Conservative Synagogue of the Hamptons, BRIDGEHAMPTON/SAG HARBOR
The Jewish Center of the Moriches, CENTER MORICHES
Temple Israel, RIVERHEAD

Orthodox Congregations

Chabad of Coram, CORAM
Chabad of Southampton Jewish Center, SOUTHAMPTON
Chabad of the Hamptons, EAST HAMPTON
The Hampton Synagogues, WESTHAMPTON
Young Israel/Chabad of Patchogue, PATCHOGUE
Young Israel of Coram, CORAM

Reform Congregations

Jewish Center of the Hamptons, EAST HAMPTON
Mastic Beach Jewish Center, MASTIC BEACH
North Fork Reform Synagogue, CUTCHOGUE
Temple Adas Israel, SAG HARBOR

MEMBER CONGREGATIONS OF THE EASTERN LONG ISLAND JEWISH ALLIANCE

ELIJA—74 Hauppague Road, Commack, NY 11725 (631-452-9800)

Bay Shore Jewish Center, BAY SHORE
Bnai Israel Reform Temple, OAKDALE
Chabad of Huntington Village, HUNTINGTON
Chabad of Lake Grove, LAKE GROVE
Chabad of Mid-Suffolk, COMMACK
Chabad of Southampton, SOUTHAMPTON
Chabad of Stony Brook, STONY BROOK
Chabad of Suffolk County, COMMACK
Chai Center, DIX HILLS
Congregation Beth Sholom, BABYLON
Congregation Kehilath Sholom, COLD SPRING HARBOR
Congregation Tifereth Israel, GREENPORT
Conservative Synagogue of the Hamptons, SAG HARBOR/BRIDGEHAMPTON
Dix Hills Jewish Center, DIX HILLS
East Northport Jewish Center, EAST NORTHPORT
Fire Island Synagogue, OCEAN BEACH
The Hampton Synagogue, WESTHAMPTON
Huntington Jewish Center, HUNTINGTON
Jewish Center of the Hamptons, EAST HAMPTON
Jewish Center of the Moriches, CENTER MORICHES
Kehilat Chovevi Tzion, EAST SETAUKET

Kings Park Jewish Center
Mastic Beach Hebrew Center, Mastic Beach
Melville Chabad Center, Melville
North Fork Reform Syangogue, Cutchogue
North Shore Jewish Center, Port Jefferson Station
South Huntington Jewish Center, Melville
Stony Brook Hebrew Congregation, Stony Brook
Temple Adas Israel, Sag Harbor
Temple Beth Chai, Hauppague
Temple Beth David, Commack
Temple Beth El, Huntington
Temple Beth El, Patchogue
Temple Beth Emeth, Mount Sinai
Temple Beth Torah, Melville
Temple Isaiah, Stony Brook
Temple Israel, Riverhead
Young Israel of Commack, Commack
Young Israel of Coram, Coram
Young Israel of Huntington, Huntington
Young Israel of Northport, Northport

CHABAD LUBAVITCH OF LONG ISLAND

65 Valleywood Road, Commack, New York, 11725

Chabad Centers

Chabad at Adelphi University, West Hempstead
Chabad at Hofstra University, Hempstead
Chabad at State University of New York, Stony Brook
Chabad Lubavitch of the East End and Hamptons, East Hampton
Chabad of Brookville
Chabad of Coram
Chabad of East Hills
Chabad of Great Neck
Chabad of Hewlett
Chabad of Huntington, Melville
Chabad of Huntington Village
Chabad of Islip Township, Bay Shore
Chabad of Lake Success
Chabad of Merrick
Chabad of Mid Suffolk, Commack
Chabad of Mineola
Chabad of Oceanside
Chabad of Old Westbury
Chabad of Oyster Bay Township, Woodbury

Logo of Chabad.

Chabad of Patchogue
Chabad of Port Washington
Chabad of Roslyn, ROSLYN HEIGHTS
Chabad of Southampton Jewish Center
Chabad of South Bay, MASSAPEQUA PARK
Chabad of Stony Brook, SETAUKET
Chabad of the Beaches, LONG BEACH
Chabad of the Five Towns, CEDARHURST
Chabad of the Hospitals, NEW HYDE PARK
Chabad of Upper Mid Nassau, EAST NORWICH
Chabad of Valley Stream
Chabad of Water Mill
Chabad of West Hempstead
Chabad Torah Community Center, LAKE GROVE
Lubavitch Chai Center of Dix Hills

ESTIMATED JEWISH POPULATIONS

Village	1940*	2016**
Babylon/Bay Shore	150	360
Cedarhurst/Lawrence/Woodmere	2,500	22,000
East Meadow	50	6,500
Farmingdale	120	100
Floral Park/New Hyde Park	200	200
Franklin Square/West Hempstead	280	5,000
Freeport	1,440	600
Great Neck	1,500	16,500
Greenport	150	270
Hempstead	1,185	400
Huntington/Dix Hills	1,225	5,150
Long Beach/Island Park	2,260	4,600
Lynbrook/Malverne/East Rockaway	2,180	1,700
Patchogue	675	250
Plainview/Syosset	50	7,500
Riverhead	270	600

Village	1940*	2016**
Rockville Centre/Baldwin	3,600	1,150
Roslyn/Roslyn Heights	70	12,350
Sag Harbor/The Hamptons/Far East End	175	3,500

*American Jewish Yearbook of 1940 and other local sources
**local sources

Year	Nassau	Suffolk	Total
1939	25,000	5,000	30,000*
1948	178,000	7,000	185,000**
1957	329,000	10,000	359,000**
1975	395,000	33,000	428,000*
2000	295,000	41,000	336,000**
2012	230,000	86,000	316,000**

*American Jewish Yearbooks of 1940 and 1976
**local sources

Population is trending downward in Nassau County and slightly upward in Suffolk County.

BIBLIOGRAPHY

Bassett, Preston R., and Arthur L. Hodges. *The History of Rockville Centre.* Uniondale, NY: Salisbury Printers, 1969.

Cohen, Dr. Steven, Jacob B. Ukeles, Ron Miller, et al. *Jewish Community Study of New York: 2011 Comprehensive Report.* New York: UJA-Federation of New York, 2011.

Cousens, Beth. *Connected Congregations: From Dues and Membership to Sustaining Communities of Purpose.* New York: UJA-Federation of New York, 2013.

Devlin, Marilyn M. *A Brief History of Rockville Centre.* Charleston, SC: The History Press, 2011.

Elcott, David, and Stuart Himmelfard. *Should We Stay or Should We Go? Synagogue Empty Nesters on the Edge.* New York: UJA-Federation of New York, 2016.

Goldstein, Judith L. *Inventing Great Neck: Jewish Identity and the American Dream.* New Brunswick, NJ: Rutgers University Press, 2006.

Grumet, Louis, with John Caher. *The Curious Case of Kiryas Joel.* Chicago: Chicago Review Press, 2016.

The History of Uniondale. Uniondale, NY: Uniondale Public Schools, 1975.

The Jewish Heritage Society of the Five Towns. *Jewish Communities of the Five Towns and the Rockaways.* Charleston, SC: Arcadia Publishing, 2016.

Kaufman, David. *Shul with a Pool: The Synagogue-Center in American Jewish History.* Hanover, NH: University Press of New England, 1995.

Lauder, William T. *Amityville History Revisited.* Amityville, NY: Amityville Historical Society, n.d.

Mattson, Arthur S. *The History of Lynbrook*. Lynbrook, NY: Lynbrook Historical Books, 2005.

Miller, Ron, and Jacob B. Ukeles. *A Profile of the Jewish Community of Long Island, New York*. New York: UJA-Federation of New York, 2002.

Purcell, Edith M. *Across the Years: The History of Floral Park, New York*. Uniondale, NY: Salisbury Printers, 1958.

Purdy, Seth, Jr. "Amityville Jewish Center Section." In *A Walk Through a Community Named Amityville*. Amityville, NY: Amityville Historical Society, n.d.

Rosenblum, Dr. Herbert. *Conservative Judaism*. New York: United Synagogue of America Press, 1983.

INDEX

ABOUT THE AUTHOR

Ira Poliakoff is a retired small business owner who grew up in Manhattan and Rockville Centre, Long Island. He served as a youth director at the Oceanside Jewish Center, Temple Sholom of Westbury and Queensboro Hill Jewish Center in the 1960s. He has researched and traveled extensively throughout Long Island in order to catalogue the history of its many synagogues and congregations, past and present. Ira has lived in Wynnewood, Pennsylvania, with his wife for forty years and is an active member of Temple Beth Hillel–Beth El.